EX LIBRIS

Alexia Flick

VINTAGE CLASSICS

OTHER BOOKS BY T. H. WHITE

The Once and Future King Series:
The Sword in the Stone
The Queen of Air and Darkness
The Ill-made Knight
The Candle in the Wind
The Book of Merlyn

T. H. White

MISTRESS MASHAM'S REPOSE

VINTAGE BOOKS
London

Published by Vintage 2014

2 4 6 8 10 9 7 5 3 1

Mistress Masham's Repose was first published in Great Britain
by Jonathan Cape in 1947

Vintage
Random House, 20 Vauxhall Bridge Road, London SW1V 2SA

www.vintage-classics.info

Addresses for companies within The Random House Group Limited can
be found at: www.randomhouse.co.uk/offices.htm

The Random House Group Limited Reg. No. 954009

A CIP catalogue record for this book
is available from the British Library

ISBN 9780099595175

The Random House Group Limited supports the Forest Stewardship
Council® (FSC®), the leading international forest-certification
organisation. Our books carrying the FSC label are printed
on FSC®-certified paper. FSC is the only forest-certification
scheme supported by the leading environmental organisations,
including Greenpeace. Our paper procurement policy can be found at
www.randomhouse.co.uk/environment

Printed and bound in Great Britain by
Clays Ltd, St Ives plc

For Amaryllis Virginia Garnett

'I took with me six Cows and two Bulls alive, with as many Yews and Rams, intending to carry them into my own Country and propagate the Breed ... I would gladly have taken a Dozen of the Natives ...'

Gulliver's Travels

1

MARIA was ten years old. She had dark hair in two pig-tails, and brown eyes the colour of marmite, but more shiny. She wore spectacles for the time being, though she would not have to wear them always, and her nature was a loving one. She was one of those tough and friendly people who do things first and think about them afterwards. When she met cows, however, she did not like to be alone with them, and there were other dangers, such as her governess, from which she would have liked to have had a protector. Her main accomplishment was that she enjoyed music, and played the piano well. Perhaps it was because her ear was good that she detested loud noises, and dreaded the fifth of November. This, however, with the cows, was her only weakness, and she was said to be good at games.

Unfortunately she was an orphan, which made her difficulties more complicated than they were with other people. She lived in an enormous house in the wilds of Northamptonshire, which was about four times longer than Buckingham Palace, but was falling down. It had been built by one of her ducal ancestors who had been a friend of the poet Pope, and it was surrounded by Vistas, Obelisks, Pyramids, Columns, Temples, Rotundas, and Palladian Bridges, which had been built in honour of General Wolfe, Admiral Byng, the Princess Amelia, and others of the same kidney. Maria's parents had made a desperate attempt to keep the grounds in order. They had been killed in an accident, however, and after that there had been no money left, not even enough to live on respectably in a boarding-house, somewhere else. The rates and so on had used up all the available income, and nobody could be persuaded to buy the place for a school nor for a hospital. Consequently she and her governess had to sleep in two bedrooms which still had a bit of a roof over them, the governess using one of the smaller drawing-rooms to live in, and they had a cook to look after them, who dwelt in the kitchen. It is literally true that this cook had a bicycle in the basement corridor, which she used to ride along the corridor, when she had to answer the bell.

The house had 365 windows, all broken but six, 52 state bedrooms, and 12 company rooms. It was called Malplaquet.

Maria's governess was a Miss Brown. She had been appointed by the local Vicar, who was Maria's guardian. Both the Vicar and the Governess were so repulsive that it is difficult to write about them fairly.

The Vicar was five feet seven inches in height, and looked as if he were fifty years old. His face was red, with hundreds of little veins of a purple colour, because he suffered either from blood pressure or from a weak heart or from both. It was difficult to see his eyes, partly because they were of the same general colour as the rest of his face, and partly because he wore thick spectacles, behind which they lurked like oysters. His hair was parted in the middle and brushed flat. He had rather pouting bluish lips, and he walked upright and slow, giving a faint humming noise from the back of his nose, like a bee. He had been a housemaster in a public school before he got the job as Maria's guardian, and his only pleasure then had been in caning the boys but he had not been able to do so much of this as he would have liked to do, owing to his heart. His name was Mr Hater. He was a bachelor. It was suspicious that he had a Rolls-Royce, and spent much of his time in London,

while Maria had to live in the ruined house on sago and other horrors.

Miss Brown had been Mr Hater's matron at the public school. She must have had some mysterious hold over him, for it seems impossible that he could have chosen her freely, considering what she was. Her nose was sharp and pinched, with a high bridge, but the rest of her was podgy. When she sat down, she spread, as a toad does on one's hand. Her eyes were pebble-coloured and her hair was yellow. It was drawn in a tight bun. She wore rimless pince-nez. She was about the same age as the Vicar, but a good deal shorter. She was cruel in a complicated way. For instance, when Maria's last uncle had been alive, he had sometimes remembered to send the child a box of chocolates for Christmas. Miss Brown's arrangements for any such parcel had usually been fixed in stages. First, Maria had not been allowed to open it when it came, 'in case it had germs'. It had been sent down to the kitchen to be baked. Then Maria had been sent for, to the North-northwest Drawing Room, in which Miss Brown resided, and the ruined parcel had been placed before her to be undone. The next step had been to claim that Maria had dirty hands, untruly, and to send her back to the kitchen, a ten minutes' walk, to wash them. When she had got back at last, agog with expectation, and the poor melted chocolates had been unstuck from

the brown paper, Miss Brown used to condemn them as improperly packed and throw them into the nearest lake with her own fair fingers 'for fear they would make the child ill'.

It is difficult but important to believe that this precious pair may have been trying to do the best they could, considering the kind of people they were.

Maria had two real friends, the Cook and an old professor who lived in a distant part of the grounds. She was sometimes very unhappy and sometimes very happy, because people fly between wider extremes when they are young. Her happiest times were when the Vicar was in London and Miss Brown was in bed with a headache. Then she would be mad with pleasure, a sort of wild but earnest puppy rushing about with the slipper of her imagination, tearing the heart out of it.

It was on a summer day such as this, with her tormentors well out of the way, that she decided to visit the Quincunx, to try some piracy at sea.

The Quincunx was one of the lakes at the foot of the lawn on the South Front. It was overgrown with trees, huge alders and beeches and wild cherries and sequoias and cedars, all planted by the numerous acquaintances of the poet Pope, and its surface was matted with water lilies, and there was a decayed wooden boat-house with a punt in it, which leaked. In the middle of the lake

there was a small island choked with brambles, and, on the island, there was a plastered temple in the shape of a cupola, or rather to give it its proper name, of a monopteron. It was a dome like the top of an eggshell, raised on five slender columns, and it was called Mistress Masham's Repose.

But nobody had ever reposed there since the death of Queen Anne. Nobody had cleared the nettles from the little island, nor swept the deep leaf-mould from the marble steps, nor cut back the laurels and rhododendrons and blackberries which crowded round the forgotten temple, even seeming to climb the pillars. All the dainty elegance which had once been made so carefully, by hands which had intended it to stay elegant, had been abandoned in the March of Mind. The lake itself was silted with weeds, because there was no money left to cut them, and the island had become a sort of Atlantis, lost in the seas. Maria was the only person who knew the weed lanes by which it could be reached. She had never landed there, however, because of the tangles.

It was a glorious day in June – for that matter it was the Glorious First of June – and the sun was resounding on the great, green sweep of the lawn. The farmer who rented the land was chasing his sheep about, with a hot-buttered face, waving a bottle of lotion for maggots; the grey squirrels were chattering and cursing in the

Chestnut Avenue: the bullocks in the Jubilee Field, safe on the other side of the Quincunx, were flicking their tails and occasionally thundering off elsewhere, because the clegs bit them; cuckoos were changing their tunes; the insect world was humming in the wilderness of shining evergreens; there were rabbits, and long grass, and small birds, and Maria was as brown as a berry.

She lay face downwards in the punt, looking over the stern into the deep water. Her knees, and most of the front of her, were green with slime; the water from the bailing scoop had run up her sleeve. She was happy. When the boat dawdled to a stop, she gave it a stroke to keep it going. Under her nose, she watched the mare's-tail and other flora of the ocean floor, as the prow edged its way between the water lilies. Dragonflies, like blue needles, and damsel flies like ruby ones – the husband keeping his wife in order by gripping her tightly round the neck with a special pair of pincers on the end of his tail – hovered over the surface. By going gently, she could sometimes pass above a flight of perch without disturbing them. Or rather, they would raise their spiky fins, blush out the dark anger of their bars, and make mouths at her. Once or twice, she passed a pike, only six inches long, basking under the flat green leaves, and once she came close to the meeting-place of the tench – who made themselves scarce with a loud plop. They

7

had been lazily scratching their backs on the lilies, like a school of elephants.

The lakes of Malplaquet were, in fact, a wonderful place for coarse fishing. In the old days, before they were weeded up, the Northampton Anglers used to go there twice a year for competitions. The tench ran big, up to five pounds or more, which was practically the record weight, and there was sometimes taken a pike of twenty pounds. The perch were fair, but not impressive. There were also some small roach.

When she had come abreast of the little island of Mistress Masham's Repose, she began to feel piratical. Swouns and Slids, she said to herself, but you could stap her vitals if she did not career there, and perhaps dig up some buried treasure while about it. She felt that she could do with a couple of skellingtons, or with a cross marked in dry blood on the wrinkled parchment of a map.

The island had lilies all round, mixed with frogbit and water crowfoot, so dense that it was difficult to push against them.

She paddled round, looking for a place where she could shove through. She laid her matchlocks handy on the thwart, first blowing on the priming so that the rum in her breath nearly caught fire. She loosened her hanger in the scabbard, and paced the poop.

The only place for landing was a fallen larch – which had dropped there as a cone since Lady Masham had died ennobled, had grown to its full stature, rotted, and blown down. It lay outward from the isle, bridging the worst part of the lilies. Some of its branches still tried to dress themselves in green.

Maria laid her bark alongside the end of the larch, and tied it up so that it could not drift away – an Inconvenience, as Gulliver tells us, which all prudent Mariners take special Care to provide against. Then she took off her shoes and stockings, thinking that she could climb more easily in bare feet. She boarded the tree bole, brandishing her cutlass, and swarmed ashore with the battle cry of a Maria, her spectacles twinkling fiercely in the sun.

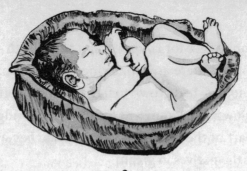

2

THE island on which she found herself was about the size of a tennis court. It had been carried there on boats, when the first duke had been beautifying his park, and it had risen from the water two hundred years before, an artificial emerald of green grass, crowned by the white dome of its cupola. There, perhaps, the Mistress Hill who was to become Mistress Masham – or even Mistress Morley herself – had sat in silks and laces, in the summer weather, drinking tay. If Mistress Morley had been there, she probably enjoyed a dash of brandy in the smoking Tyde.

But now the island was tangled with every kind of briar. It had a boma round it, an outer ring of black-berries and nettles, choking the jungle of the shrubbery which faced the visitor. There seemed to be no way of reaching the little temple without pain, for the nettles

were ready to sting and the briars were ready to prick, and what she really needed was a machete – or any similar instrument used by Indians, in cutting their trackways through the Bush.

If she had been a gamekeeper with thick clothes and leather leggings, she might have been able to push her way through; if she had been a farm labourer, she could have cleared a path with her brish-hook; as she was neither of these, but a determined person all the same, except for cows, she bashed her way with the punt scoop. When she had beaten down a bramble, she trod on it reluctantly; when they caught in her dress, she stopped and took them out – sometimes; when they scratched her face, she swore the appropriate oath; and so, slowly but surely, she burrowed her way into the forest belt. She tore her skirt in three places, and scratched the brown legs horribly, until she had to go back to the shoes.

The tanglewood stopped suddenly, several yards from the steps of the temple, and the intruder came to a halt with a blackberry branch in her hair.

Where the brambles ended, the grass began: the same neat, artificial grass which Lady Masham must have known. It was still kept as short, or even shorter. It was as smooth as a bowling green.

Indeed, the place was like a bowling green. It was hedged with the thicket, as such greens often are with

yew. In the middle, there was the beautiful, sun-drenched temple, rising airily on its pillars.

But what was strange – and here Maria's heart went Pat, she knew not why – the strange thing was that everything was neat.

She looked everywhere, but not a soul was to be seen. Not a leaf stirred in the little amphitheatre, nor was there any trace of a hut to live in. There was no shed to hold a lawn mower, nor any mower standing on the lawn.

Yet somebody had mowed the grass.

Maria took the bramble out of her hair, disentangled herself from the last branches, and went forward to her doom.

The plaster inside the dome had fallen in some places; but the wooden slats, which were visible in most of the ruined ceilings of her home, were not exposed in this one. It looked as if the roof had been repaired from inside, with clay or paper, as if it had been done by wasps. Also, and this was strange again, there was no plaster on the floor. It had been cleared away.

Everything was so clean, so different from the wasteland which she had come through – so square and round and geometrical, just as it had been when first erected – that her eye was drawn to details.

She saw: first, a square opening, about eight inches wide, in the lowest step, which she took to be the ventilator of a damp course – but there was a path leading to it, trodden in the fine grass, a path for mice; next, she saw a seven-inch door in the base of each pillar, possibly also connected with the damp course – but, and this she did not notice because they were nearly as small as match heads, these doors had handles; finally, she saw that there was a walnut shell, or a half one, outside the nearest door. Several walnuts grew in the park, though none were very close. She went to look at the shell – but looked with the greatest astonishment.

There was a baby in it.

She bent down to pick up the cradle, which she took to be some kind of toy, a toy made more beautifully than any she had ever seen. When the shadow of her hand fell across the baby, which was nearly an inch long, it wagged its head on the minute cushion of moss, put out its fists in both directions, pulled up its knees as if it were bicycling, and gave a thin mew, which she could hear.

She did not snatch away her hand when the creature mewed. On the contrary, she grabbed the walnut. If there were one thing now in all the world which Maria was inclined to snatch, it was the baby.

She held it tenderly in the palm of her hand, not breathing for fear of spoiling it, and examined its

wonderful perfection as well as she could. Its eyes, which were as small as a shrimp's, seemed to have the proper marble-blue for babies; its skin was slightly mauve, so that it must have been a new one; it was not skinny, but beautifully plump, and she was just able to distinguish the creases round its fat wrists – creases which looked as if the thinnest hair had been tied round in a tight bracelet, or as if the hands had been fitted, on the ball-and-socket principle, by the most cunning of all the dollmakers there had ever been.

It was truly alive, and seemed to be fairly pleased at being picked up, for it held out one hand towards her nose and chuckled. At least, by listening to it like a watch, with her head on one side, she was certain that it made a noise.

While Maria was in a rapture with this windfall, she felt a sharp pain in her left ankle, as bad as if she had been stung by a bee.

Like most people whose ankles are stung, she stamped her foot and hopped about on one leg – a useless procedure, so far as bees are concerned, because it only annoys the others, and the first one cannot sting again.

She held the cradle with the greatest care while she hopped, clapped her spare hand to the hurt ankle, and confronted her assailant from a safe distance, standing on one leg.

There was a fat woman, about five inches high, standing on the marble pavement of the temple, and brandishing a sort of harpoon. She was dressed in rust-coloured stuff, like the breast of a robin, and she was wild with rage or terror. Her little eyes were flashing, her hair had come down at the back, her bosom was heaving, and she was shouting in an unknown language something about Quinba Flestrina. The harpoon, which was as sharp as a needle, had a steel head half as long as the baby. Some blood was trickling between the fingers of Maria's spare hand.

Now in spite of the homicides or other torts which she might have committed as a pirate, who was partial to the Plank, Maria was not the kind of person who bore malice for injuries, and she was certainly not the kind of kidnapper who habitually stole babies from their heartbroken mothers, for the mere cynical pleasure of hearing them scream. She guessed immediately that this was the mother of the baby, and, instead of feeling angry about the harpoon, she began to feel guilty about the baby. She began to have an awful suspicion that she would have to give it back.

Yet the temptation to keep it was severe. She would never drop on another find like this, she knew, not if she lived to be a thousand.

Think to yourself, truly, whether you would have returned a live one-inch baby to its relatives, if caught fairly in the open field?

But Maria did her best.

She said: 'I am sorry if this is your baby. Please, I have not done it any harm. Look, you can have it safe.

'And really,' she added, almost tearfully, 'it is a beauty.'

She leaned forward to put the cradle at the mother's feet.

The fierce little woman was either too hysterical to listen, or else she did not understand English, for she slashed at the huge hand with her weapon as soon as it came within reach, and cut it across the thumb.

'Oh, you would, would you?' cried Maria. 'You little viper!'

So, instead of giving up the baby, she wrapped it in her handkerchief, cradle and all, and put the bundle in the pocket of her skirt. Then she took a second handkerchief out of the other pocket, waved it in the face of the mother so that she fell on her back, dropped it over her head, flicked away the fallen harpoon, and gathered her as well. She so seldom had two handkerchiefs, or one for that matter, that she felt that the hand of the Lord must be upon her. Then, hearing a kind of hum in the

pillar beside her, like the hum of a hive, she felt also that it would be wiser not to tempt the Lord's hand further.

Stuffing the larger bundle into the other pocket – it was kicking as hard as it could – she made for her passage through the brambles. When she got there, she turned round for a last look at the temple. She saw a group of three men struggling at the pillar door. Two of them were holding the third by the arms, to keep him back, and he was fighting them to follow her. He was a splendid fellow in a fur tunic, made of moleskin, and well over six inches high.

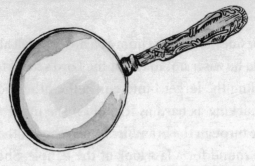

3

WHEN she had pushed off the punt and paddled to a safe distance, she laid down the scoop and took the larger package from her pocket. The woman had been kicking all the time, with fluttering skips and flops, so that it had felt like a small bird trying to get free. As soon as Maria had unwrapped and set her down on the slimy bottom of the boat, she stood panting, with a hand pressed to her heart. It was like a carving in ivory. Then she ran for the side, as if she were meaning to leap into the water, but checked her-self, and stood glaring at her captor, the very picture of a wild thing fallen into human hands. Maria produced the other bundle and laid the baby, still in its cradle, not far from the mother's feet. This brought her back from the side. She ran to the cradle, snatched the baby out of it, and began talking to it in a foreign language, examining it all over to see if it

were hurt. It was clear that she was telling the baby that it was Mammy's Wazzums Oodlums, and did a nasty female mountain try to steal it then, the precious pet?

Maria licked her wounds, washed them in the cool water of the lake, dried them with the handkerchiefs, and kept a tight eye on the maternal scene.

It was getting on for tea-time, and she had a lot of things to fix. She was determined never to be separated from her treasures – or at least, not from the baby – but she knew perfectly well, on the other hand, that Miss Brown would refuse to let her have them. Either she would confiscate them, and keep them in a box with Maria's penknife and sixpenny compass, or else she would take them for her own use, or she might even arrange to have them drowned, as she used to do with the favourite kittens. None of these things was going to happen, if Maria could help it.

Where could she hide them? Miss Brown was constantly peeping about for faults, and there was not a private place in all the palace of Malplaquet which our heroine could call her own. There were no longer any toys in the toy cupboard, so that to keep them there would only call attention to it. Her bedroom was ransacked once a week.

'I will put them,' she said, 'in the little drawer of my dressing-table for tonight at any rate, since Miss

Brown's headache will prevent her from interfering until tomorrow.'

This time she made a bag from the wet and gory handkerchief, and, after cornering her captives, she put them both in this together, loose. She tied it round the top with string – for she was a handyman who generally carried string, having been told by her professor that efficient people always had a penknife, a shilling, and a bit of this useful article. She kept the cradle separate, thinking that it would be a bruising thing to be with, if one were bumping about in a bag with a baby. Then she made for the boat-house, put up the punt, and hurried home for tea.

She looked in as she passed the kitchen, which had ovens, spits, and ranges suitable for serving a twelve-course dinner to one hundred and fifty persons – but now they cooked on a primus stove – and inquired about Miss Brown from Cook.

'Lawks, Miss Maria, them stockings! And, glorious me, them rents all over the dress!'

'Yes, I know. I was wondering if Miss Brown . . .'

'You won't see her tonight, my lamb, and for which we may thank our tender stars. You run up to your room now quiet-like, and bring me back them stockings when you have 'em changed. You'd best put on the dressing-gown, until I mend the skirt.'

'Is there anything for tea?'

'Yes, Miss, there's strawberries.

'Seeing as She,' continued Cook, tossing her head, 'was took bad-like, as we might say, I presumed the little liberty for to beg a pound on 'em from your professor, and this, with just a touch of condensated milk, which we was asaving of for Christmas, should make a dish, however humble, as might be savoured by the Mistress of Malplaquet.'

It is needless to explain that Cook was an Old Retainer, who bore with Miss Brown as well as she could. She lived her life in the gloomy kitchen, with nobody to love but Maria, except for a fat collie dog who had been left to her by her deceased husband, and whose name was Captain. He used to fetch the newspaper from the village every morning, in his mouth, and sometimes he went shopping with a basket.

Maria said: 'Cook, if you are ever captured by pirates, or surrounded by Indians, or if you should fall into the sea and be chased by a shark, I will see to it that this day's work is not forgotten, if it costs me the last drop of my blood.'

'Thank you, Miss Maria,' said Cook, 'I'm sure.'

She climbed the Grand Staircase and trotted down the Ducal Corridor, mounted the Second Best Staircase and passed the Corridor for Distinguished Strangers,

plodded up the Privy Stairs in Ordinary and tiptoed down the Third Best Corridor Once Removed. At the end of this, where part of the main roof was still sound, there were the two small bedrooms in which she and Miss Brown were accustomed to sleep. It used to take Cook about three-quarters of an hour to get there from the kitchen, because she had Bad Legs, and Captain panted dreadfully as he padded up the stairs behind. But Miss Brown made them do the bed for her, all the same.

She peeped in at the open door.

There lay the tyrant on the bed, with her nauseous nose erect. She was reading a mauve book with a stuffed back, like a cushion, which was called *The Daily Light*. In her other hand she held a handkerchief soaked with eau-de-Cologne, and with this she occasionally fanned *The Daily Light*, and occasionally patted her nose-tip, which had grown pink and polished under these attentions.

Miss Brown's personality lay about her. There, beneath Maria's fearful eye, stood the thirty pairs of pointed shoes, sharp as builder's trowels, wrinkled at the toes, dressed in a neat line under the dressing-table. There, on top of the wardrobe, stood the grey toque hats with pins in them. On the bedside table stood the range of books which Miss Brown considered delightful: the *Journal* of George Fox, *Holy Living* by J. Taylor, and *The Pilgrim's*

Progress, about which Huckleberry Finn once remarked that 'the statements were interesting, but tough'. In a corner of the room there was a cupboard, containing the fichus and frills with which Miss Brown adorned her bosom; the dressing-table was covered with sharp things or hard things; and the whole place smelled of unused purses locked away in lavender or naphthalene.

On the window-sill there were some instruments for spying: the telescope with which she watched from the window, and the magnifying-glass with which she looked for dirt.

Her pupil went down on hands and knees. She crawled past the bed, below Miss Brown's line of vision, and reached the window unobserved. She put the magnifying-glass between her teeth, where pirates keep their cutlasses, except when drinking. She crawled back to the door, dropping a drawing-pin, which she kept handy for such occasions, into one of the shoes while passing, and regained the corridor without mishap.

Then she hurried to her room.

In the bare room, where all the furniture was made of iron, she took the precious bundle out. She opened it upon the bed. The little woman lay like a suffocating frog, still clutching her baby, and Maria examined them at leisure, with the glass.

The dress was poor. It was a simple garment, tied at the waist like a monk's, and it seemed to have been knitted from silky wool. It was ravelled in some places and worn, but serviceable. The woman's face was red and healthy. The baby, as she had suspected, had blue eyes.

Maria put them in the small drawer when she had finished, made a bunch of her own spoiled clothes, and tiptoed down to tea.

4

BUT when the Mistress of Malplaquet got up next morning, she was not feeling happy. Not a scrap of the strawberry and cream had been touched, though she had left a saucer in the drawer, and she could get nothing from her prisoner but scowls. It was out of the question to play with her.

'Cook,' she said at breakfast, 'do you think Miss Brown's headache will be better today?'

'No, Miss Maria,' said Cook.

'She has left me some mathematics to work out, before dinner – it seems to be about Algebra.'

She twiddled her spoon nonchalantly, and looked from the corner of one eye.

'I wanted to see the Professor.'

'Run along and see him, luv. If Somebody wakes up, I'll tell her as how you'm busy with them

Algerians, whatsoeverashowsobe as which she might inquire.'

'Cook . . .' began Maria.

'Yes, luv. You told un about the sharks.'

The Professor was as poor as a church mouse, and he lived by himself in one of the Ridings, in what had once been a gamekeeper's cottage.

All around the ruined place there were immense avenues, stretching in every direction, down which the departed dukes had been accustomed to drive in state when they had felt like an airing, or when the Comte de Paris and Queen Victoria had dropped in for the week-end. These avenues had developed into Ridings which had once been thought the finest pheasant coverts in Europe, and in them King Edward had often popped away. Finally, when the carriage roads had vanished altogether, they had become green fields between the woods, long and thin, which were hired to grazing farmers by the solicitors who represented the Estate.

Such was the Riding in which the Professor lived.

He was a failure, but he did his best to hide it. One of his failings was that he could scarcely write, except in a twelfth-century hand, in Latin, with abbreviations. Another was that, although his cottage was crammed with books, he seldom had anything to eat. He could not tell from Adam, any more than Maria could, what

the latest quotation of Imperial Chemicals was upon the Stock Exchange.

In the daytime, he used to chop wood and cut some slices of bread and butter. In the evenings, having lighted the choppings, he would sit before the fire and quaff a glass of liquor, pondering the remarks of Isidore, Physiologus, Pliny, and similar people. His tipples were Cowslip, Dandelion, Elderberry, and sometimes Gooseberry Wine, which he brewed himself. Inflamed by these, in the kind glow of the green ash, he would dream of impossible successes: imagining that the Master of Trinity had referred to him by name in a lecture, or that Dr Cook had offered to mention him in a footnote to Zeus, or even that one of the poorer colleges had given him a sort of supernumerary fellowship of the lowest class, carrying a stipend of about five pounds a year, so that he would no longer have to cut his bread and butter.

On the second of June, the Professor had got up early to pick dandelions. He was wandering up and down the Ridings with a sack, nipping off the yellow heads with his fingers, and popping them inside. He did not notice Maria's figure stumping up the avenue.

'What ho!' she cried. 'Avast! Belay!'

'Go away,' said he promptly.

'Do you know who you are talking to?'

27

He straightened his aching old back, adjusted his spectacles, and examined her with care.

'Yes, I believe I do. It is Black Maria, the Terror of the Tortugas.'

'Then you had better keep a civil tongue, and know your station.'

'Why?'

'Because.'

'Because what?'

'Look here,' she said. 'I can't indulge in childish argument. I came on business.'

'If you mean that you have come for breakfast, I fear that I have nothing left but half a pound of mustard.'

She put her hand on the bottle-green sleeve and made him drop the bag. The reference to breakfast had touched her, for she knew he seldom had enough to eat. She put her arm, a little shyly, round the creaking waist.

'I have found something.'

'What sort of thing?'

'I can't show it here. I have brought it, but it might escape in grass. I want to show you in the cottage.'

He said: 'Dear me, Maria, well, dear me. I must say I am glad to see you. Come in, come in. I hardly noticed it was you at first. Certainly you may come inside my

cottage, although I ought to tell you that I have not done the washing up.'

She put the five-inch woman on the kitchen table, in the bread crumbs. The only tea cup was full of ink. She told the story and explained her difficulties – how Miss Brown would be against it, how there was nowhere safe to hide the manikins, how they would not eat, and the rest of the trouble.

'H'm,' said he. 'Let me see. It is one of these modern writers, I believe. Martin or Swallow or . . . Yes, yes, dear me, it must have been our Dr Swift. He was conscious of the similarity himself. Indeed, his nickname with Ld Treasurer was Martin, if I have my facts. Yes, yes. Now Dr Swift was at Malplaquet, as we know, in 1712. He came here straight from Twit-nam, with the poet Pope. But that was long before the Travels. H'm, h'm, h'm.'

'I don't . . .'

'Please hold your tongue, dear girl. It interrupts the flow. Now what more natural than this, that the immortal Dean should finish off the *Travels* here for Motte – could he have come again in '25? – and what place could there be more suited to the toils of literature than the cool, quiet arbour on the Masham Isle? No doubt he left some Lilliputians there behind him, by mistake. We know that authors suffer from the absent mind.'

'Gulliver's Travels?'

'Gulliver! The very name! This will be an addition to the annals of Malplaquet, to know that *Gulliver* was finished here, and that they left the people too. Excuse me while I look it up.'

She dangled her legs on a soapbox, keeping a good lookout to see that the supposed Lilliputian did not run away, and the old gentleman brought down one first edition after another, with grunts and puffs of dust, but always with tender fingers. His findings were a disappointment.

'It distinctly says that not one single citizen was carried off. Gulliver brought "six Cows and two Bulls alive, with as many Yews and Rams". One of the sheep was eaten on the voyage by a rat, and he gave one cow and one sheep to Captain John Biddel, who brought him home. H'm, h'm.

'Wait a bit,' he added hastily. 'It says that Gulliver left Blefuscu, in his rowing-boat, on the twenty-fourth of September, 1701. He was picked up at sea by this Captain Biddel, on the twenty-sixth, in latitude thirty degrees south. Mark you, it was only two days later. He told his story to Biddel – he even gave the pair of animals to prove it – and, on their return to England, he was able to sell the remaining cattle for six hundred pound!

'Believe me,' continued the Professor, taking off his spectacles and pointing them at her, 'in those days, six hundred were six hundred. Why, Stella herself contrived to live in genteel comfort, with a capital of little more than twice that sum.

'If you,' said he, 'were a captain who had picked up such a castaway, within two days' rowing of a known latitude, carrying a dozen cattle worth six hundred pound, old style, what would you do?'

'I should go back to search the latitude.'

'Then?'

'I should bring back plenty more. My goodness, I should bring back men!'

He shut the book with a bang, which he immediately regretted, wandered off to return it to its shelf, and began to think of something else.

'All the same,' she said, 'even if this creature – this, er, little lady – even if she did come originally from Lilliput or Blefuscu, I don't see how it helps.'

'No?'

'She won't eat.'

'No?'

'She won't do anything.'

He put his hands behind his back, shuffled on the floor, and scowled.

'She isn't any fun.'

He stuffed his beard in his mouth, rolled his eyes, and glared. Then he unrolled them, liberated the whiskers, and looked haughtily upon his visitor.

'Why should she be fun?

'Why should she do anything?

'Why should she eat?

'Is she yours?'

Maria twiddled her fingers nervously, but he sat down on the soapbox and took her hand.

'My dear neighbour,' said he, 'there is one thing which I promise, and that is that I will not say, How would *you* like to be wrapped up in a handkerchief? I am aware that it is not a question of you being wrapped up in one, but of this person. I will, however, make a suggestion. As we all know, I am a failure in the world. I do not rule people, nor deceive them for the sake of power, nor try to swindle their livelihood into my own possession. I say to them: Please go freely on your way, and I will do my best to follow mine. Well then, Maria, although this is not a fashionable way of going on, nor even a successful one, it is a thing which I believe in – that people must not tyrannize, nor try to be great because they are little. My dear, you are a great person yourself, in any case, and you do not need to lord it over others, in order to prove your greatness.'

'I would not do her any harm! I would not lord it!'

'But would she do the harm to you? Think what may happen, for a minute. Suppose you managed to tame her, suppose you even managed to tame all the other people from the Island of Repose. No doubt there are several more. You would be a Big Bug then, however kind you were, and they would be little bugs, without the capitals. They would come to depend on you; you would come to boss it over them. They would get servile, and you would get lordly. Do you think that this would be good for either of you? I think that it would only make them feeble, and make you a bully.'

'I wouldn't bully them!'

'No?'

'I would try to help.'

'But God helps those who help themselves.'

She produced her battered handkerchief, and began to twist it into shreds.

'Then what am I to do?'

He stood up stiffly, went to the cobwebbed window, and stared out.

'It is not for me to say.'

'What would you do, Professor?'

'I would put her on the island, free, with love.'

'But not have People any more?'

'No more.'

'Professor,' she said, 'I could help them, if I saw them sometimes. I could do things for them. I could dig.'

'No good. They must do their own digging.'

'I have nobody to love.'

He turned round and put on his spectacles.

'If they love you,' he said, 'very well. You may love them. But do you think, Maria, that you can make them love you for yourself alone, by wrapping prisoners up in dirty handkerchiefs?'

5

SHE sculled the punt towards the island with a heavy heart. Once there, she tied it to the larch and produced her bundle feeling as if she would like to drop, as she did so, an unpiratical tear. She put the captive on the tree.

The small lady of Lilliput stood for a moment, clutching the baby. She was creased and rumpled from her adventures. Her hair was in disorder and her mind confused. However, when she had at last got her bearings, she did do one thing which made up for much. She curtsied to Maria. Immediately afterwards she spoiled the effect, by turning round and running for dear life.

Our heroine paddled round the island despondently, noticing that the path, which she had broken down, had been blocked up. The brambles had been pulled into place again, and woven together, to make a screen.

'After all,' she thought, 'it is my own island. I did discover it, and I have as much right to look about it as anybody else. Even if I have to turn them loose, I don't see why I should be warned off from my own island.'

So she tied to the larch again, and sat there meditating. She wanted to go ashore, to explore the temple, for she felt certain that there would be interesting things to find, even if the people stayed in hiding.

While she was meditating, she looked at the tree, and, while she looked, it struck her more and more that there was something queer about it. The roots were still on dry land, and the larch lay outward into the lake until its top was under the surface. The straight bole gradually rose from the water at a gentle angle; the branches which stuck up with their small cones had put on a summer green; and there was a greenness along one side of the bole also, a misty curtain, like the bright strands of the larch itself, which hung into the water. It was like a camouflage net.

Maria scrambled to the other end of the punt, which brought her close enough to lift it. Underneath, in a dock between the net and the tree-trunk, dozens of canoes were moored. They were the best kind of canoe: the kind in which, because they have a watertight deck, the Eskimos can button themselves and turn somersaults in the water, without sinking. The only difference was

that these Lilliputian boats, which were about eight inches long, had collapsible outriggers on both sides. She examined them closely – they were folded back, for convenience in mooring – and, by fiddling with the nearest one, which she took from the water, she discovered that the outriggers ran in a slot. By pushing them forward and down, they could be made to fold astern like the wings of a gull; by pulling them back and up, they were locked into position outboard, like the legs of a 'water boatman'. She did not know that at the time, but these boats were used for fishing on the lake, and, by throwing the outriggers into position, it was possible to play fishes of a pound or more, without being upset.

She put the canoe at its mooring again and dropped the net.

For all I know, she thought, there are things like this all over the island. For instance, what about the sheep and cows? Evidently the People defend themselves by hiding. The barrier of brambles is to keep stray humans off. I bet the bowling green was full of cows when I arrived – that was why it was cropped short – and, while I was hacking my way through the blackberries, everything was driven away. So far as that goes, what about the square door in the bottom step, the one with a path leading to it? I shouldn't wonder if the cattle were

driven into that. Perhaps the step is hollowed out, for cowsheds. Yes, and I suppose the cradle got left behind in the hurry, and then naturally the mother came to defend it. If it hadn't been left, I should never had noticed anything.

They must have sentries, continued Maria. If I wanted time to hide things on the island, I should post a sentry. Then, if I saw myself getting out a punt, I should be able to warn myself that I was coming, with plenty of time to spare. I bet they were hiding things from the minute they saw me climb into the boat-house.

The best place for a sentry, she thought, looking at it, would be the top of the cupola.

There was something on the top. Very small, not easy to see, perhaps lying flat on its face, there was something not much bigger than an acorn. It might have been the sentry's head.

Maria shook her fist at it cheerfully, for she had suddenly seen her future plan before her. She paddled off, feeling happy once again, to consult the Professor for the second time that day, before Miss Brown's headache got better.

He was translating some remarks by Solinus, and, when he saw her, he merely raised his eyebrows thus:

?

She nodded.

'Good.'

'I came about the language.'

He pointed to the table.

On it, laid open at the title page, was a beautiful octavo volume in brown calf, which was dated 1735. It said:

A General Description of The Empire of
Lilliput,

from its first Erection,
through a long Series of Princes,
with a

Particular Account
of their Wars and Politicks, Laws, Learning &
Religion, their Plants and Animals,

their peculiar Manners and Customs,
with other Matters very curious and useful,

to which is added

A Brief Vocabulary

of their Language, together with its English
Correspondencies

By Lemuel Gulliver, first
a Surgeon, and then a
Captain of several
Ships.

'It's rare,' said the Professor, modestly. 'In fact, I don't suppose there are any other copies in existence. You will find it mentioned in the *Travels*.'

She turned to the vocabulary:

QUINBA, s., f., a female.
QUINBUS, s., m., a male.
RANFU-LO, s., m., no sing., the breeches.
RELDRESAN, s., n., a secretary . . .

'It is not very easy to learn a language from a dictionary.'

'It is all we have. There are some idioms at the end.' So she sat down beside him, and, while he muttered about Solinus, she muttered 'the correct Modes of Address'. She was surprised to find that the idioms were not the usual ones about 'Have you (got) some cheese?', 'Is my aunt in the shop of the barber?', 'Please give my pen to

the greengrocer', and so on; but were about such matters as 'Pray order me a Dish of Coffee', 'Odd-so! I have broke the Hinge of my Snuffbox', 'Come, Gentlemen, are you for a Party at Quadrille?' and 'Madam, the Chairs are waiting'.

6

MISS Brown's headache had left her worse than ever. She questioned Maria venomously about the Algebra, cross-examined Cook, and even sent a sharp note to the Professor, on suspicion, requesting him not to interfere with the education of her Little Charge. It was because Maria had looked happy, which made the Governess think she must have been doing wrong. She confided this fear to the Vicar, who agreed that hers was a truly Christian attitude, but luckily they did not discover anything which they could punish.

For the remainder of that week, it was nothing but exercise books and knuckle-rapping, with Miss Brown's quick pounce of the ruler, like a toad's tongue catching flies. Several new tortures were invented. One was that Maria had to lie down for two hours every afternoon, with the blinds half drawn and nothing to read, for

the sake of her health. This was called 'having a rest'. Another was that whenever Miss Brown pronounced the grass to be wet, which was always, she had to wear an enormous pair of football boots, which had been bought in a jumble sale by the Vicar. They were too large for her, and made her feel ridiculous, and on Sunday she had to walk up the aisle in them, wishing that the earth would swallow her. Miss Brown knew that children are conservative about their clothes, and dread to seem outlandish, so she had invented this ingenious torment in order to take advantage of Maria's shyness. While she was clumping up the aisle she felt that all the choirboys would be thinking that she was too poor to have proper boots, and Miss Brown knew this also.

There were no more strawberries for tea.

All the same, Maria was far from miserable. She had a secret life of her own now, thinking about her plans for the conquest of Lilliput, and at night she stayed awake for hours, reading under the bedclothes with Cook's electric torch. The Professor had kindly lent her a first edition of *Gulliver's Travels*, as well as the phrase book, and she was learning the language. She had a faraway look of private content, which drove her governess half mad. On the Monday they had a scene about Ingratitude, in which Miss Brown stated that it was sharper than a serpent's tooth to have a thankless

child, and this brought on a new headache, sooner than was expected.

Maria hurried down to the lake next morning. She went by the Professor's cottage on the way, to pick up some articles which he had bought for her, by secret arrangement through Cook.

The passage past the brambles had been plaited up, but she forced her way for the second time, and stood in the middle of the empty cupola with a beating heart.

'Glonog,' she said, furtively consulting a piece of paper, though she had been repeating the sentence since the night before, 'lumos Kelmin pesso mes?'

She said this three times, in a loud, uncertain voice, hoping that the construction would be right. (It was meant to mean, 'Please, will you swear a peace with me?')

Almost immediately, a small man was pushed from one of the column doors. He was dressed in shabby clothes, and had an agitated, determined look, as if he were sure that he was due to die for his country.

'Glonog,' shouted the man, in a high, clear voice, as you would do if you had to hail somebody three or four times higher than your house, 'advuntos!'

She hastily produced the Professor's vocabulary, and was already looking up 'glonog' when she realized that she had said it herself. Come, thought she, we are not

getting on so badly if he begins with 'please'. So she began looking up 'advuntos' and was not long in finding it: 'ADVUNTINTIMMY, v.i., intrans., To go away, Get out, Remove oneself.'

'You horrid little pig,' she cried. 'Why should I get out, when it's my own island?'

The little man grew pale, but stated firmly, in good English: 'It has been our Island, Ma'am, Y'r Honour, Miss, during the Course of nearly thirty hundred Moons.'

'I don't care how long it has been your island. It was my ancestor, the first duke, who built it. It said so in a book in the Library, before the books were sold.'

'Indeed,' said the little man, looking interested for half a second – he was middle-aged and fattish, as if he might have been a lawyer or a member of parliament, if he had owned some better clothes. 'It has long been a Topick for Speculation among our Sages, to determine the Origin of so prodigious a Structure.'

'You talk English!'

'It has remain'd our second Language, Ma'am, since the Exile under Captain John Biddel.'

'Then the little woman must have understood . . .'

At this point their conversation was interrupted by an urchin, about three inches high, who was pushed from the pillar, and ran to the spokesman with a message.

There was some brief whispering, and then the urchin went back with a dignified pace; which failed him, however, at the end, for he ran the last few inches in a panic.

'In short, Ma'am,' said the spokesman coldly – he had evidently been told not to gossip with giants – 'I am instructed by my Countrymen to desire your Complaisance in leaving these poor Territories forth with.'

'Well,' said Maria. 'I see. Please don't be frightened when I move. I am sitting down.'

She seated herself carefully on the bottom step and leaned her elbow on the top one, which brought her head fairly close to his, and saved him the trouble of shouting. The messenger drew back.

'Now,' she said, 'I have been talking about this business to my Professor. You people are hiding on the island – why? Evidently because you are afraid of being captured by human beings, and the Professor says he doesn't wonder. He says that you are only protected by secrecy, for you could never escape us if the secret were to leak out. But it has leaked. What is the good of ordering me off, when I know it already? The Professor says that Accident Has Delivered You Into My Hands, and it is no good Shutting The Stable Door When The Horse Has Bolted. He says you may just as well make friends with

me now, so that I won't tell anybody else. In fact, he said it is your Only Hope.'

'Ma'am . . .'

'And honestly,' said Maria, 'I won't tell anybody. I won't even tell Cook.'

'The Accident, Ma'am . . .'

'Listen. Please go and explain what he says, inside the pillar. Tell them that I will Defend The Secret With My Life, whether your friends are kind to me or not. The Professor says that I am not to Threaten With Discovery. He says that the secret must be kept in any case, and that any Decent Person must leave the rest to you.'

'The Professor, Ma'am . . .'

'Your little woman knows about him. I bet she didn't miss a word. Now go and talk it over, please, and the Professor says that I must Walk About Politely while you do.'

The messenger looked as if he were going to say several things at once, but he pulled himself together, thought it over in a muddled way, remembered the Topick which he would have liked to discuss, opened his mouth, shut it, glanced at the pillar door, bowed, and withdrew. At the door, he turned, opened his mouth again, shut it, and disappeared.

Maria went round the green, with her eyes skinned, but without making any discoveries. She did find that

there were four stone walls, about three inches high, which divided it into fields for the cattle. On her other visit she had taken them for drains. They looked as if they had been made of rubble from the inside of the temple, which, as she was beginning to suspect, was probably hollow. Ants, she knew, would sometimes eat away the furniture from inside, in tropical countries – or perhaps it was termites – and it looked as if the People had been doing the same thing. At any rate, there were no houses or other buildings of any sort, which might have given them away.

When she had finished with the green, she went on and sat on the steps for nearly half an hour, but there was no sign of the conference in the cupola having come to an end. So she went round the green for the second time, visited the camouflaged dock for canoes, and took a look at the shrubbery. There was little to discover. It did seem that the lowest parts of the tangle, what we might call the undergrowth of the forest, had paths in it, leading in various directions towards the shore, but only a rabbit would have noticed these. One thing she found, and that was a robin caught by a noose of horsehair, on one of the higher branches. It was dead. Maria did not mind this, as she had no illusions about the habits of robins, and she saw that it had evidently been caught for somebody's dinner.

After these trips she sat on the steps again, for still another half-hour, and wished very much that the Parliament would rise.

When it did rise at last, the original messenger came out alone, looking pleased, important, and slightly out of breath. He bowed politely, mopped his brow with a small handkerchief, and announced that the Professor's case was won! If she would kindly sit here, at a safe distance from the cowsheds, the People were prepared to show themselves.

She sat where she was told, holding her breath with excitement, and the messenger stood beside her, as if she were his private discovery. Wonderful things began to happen.

First the gate in the lowest step was opened, and out of this the cattle came, each one led by a cowman holding a rope, for fear that they should bolt on seeing Maria. They were black cattle, like Friesians, and, curiously enough, they showed no sign of being afraid. Probably she was too big for them to notice. They took her for a tree, and left it at that. The sheep came next, all baaing, with their lambs bleating and frisking. When the lambs had a drink, their tails went round like propellers, and this could be distinctly seen. The cattle were about four inches high, the sheep about an inch and a half. There were some small sheep dogs, like something out of a

Noah's Ark, which ran round the sheep and yapped in squeaky voices, evidently enjoying the performance very much.

When the farm animals had been promenaded round the green and driven back for safety in the step, there came a procession of fishermen from the same entrance. These marched round, peeping sideways at the Giantess, carrying paddles for the canoes, harpoons like the one with which she had been attacked, small gaffs, and minnow rods with horsehair lines complete. They had leather thigh boots, tanned from the skins of mice.

While the fishermen had been making their parade, the population of the island had been coming from the doors in the five pillars, without being noticed. She turned round when the last fisherman had disappeared, and there they were on the top step of the temple, in hundreds. (She found out later that there were more than five hundred. This was a greater number than could be supported by the green, but they lived by fishing and hunting and also by using secret pastures on the mainland at night, as we shall see.) When she turned round, all the People said with one voice: 'Ooo!'

They were in rags.

It was not exactly rags, when she looked closer, but poor working clothes made of knitted wool from the sheep, and from moleskins or mouse skins. Some of

the women had sewn themselves capes, from the breast feathers of small birds.

They all stood gazing at her with their mouths open, and the mothers held their children tightly by the hand, and the men stood rather in front, in case of emergency.

Nobody knew what to do.

Finally she remembered her instructions. She called out that she was going to stand up, so they must not be afraid. When she did stand, there was another 'Ooo!' She told them to stay where they were as she would be back in a minute, and then she rushed to the punt to fetch her package. When she got back she warned the crowd to stand away from the middle of the pavement – some of the babies began to howl – and laid the package in the centre, only staying to undo the string.

She stood off gently, being careful to look behind her for fear of treading on somebody, and said: 'See what it is.'

The Lawyer, or whatever he was, was the coolest person, for he had already passed his own fears, so he called up a team of fishermen, who pulled back the brown paper under his directions. Maria was interested to see that they did not tear the paper off, but treated it with care and admiration. Indeed, a piece of thick cardboard covering about half an acre seemed to them

a useful article. When it was off, the People began to come forward slowly, hesitating between curiosity and suspicion, and the Lawyer – he was the Schoolmaster really – looked at her, to find out what was going to happen next. She pointed to him, to spread the presents out.

It was the silk handkerchiefs which did the trick. When the women saw these, they came quickly to finger them, and to love the bright, smooth colours. There were six threepenny ones, from Woolworth's, of artificial silk, the thinnest kind, for ladies, very gay.

They did not pull them about. They spread them reverently on the step. They were the loveliest things they had ever seen, since their forebears had been carried off from mighty Lilliput, two hundred years before.

Then there was the packet of needles. The men fingered these weapons, trying their temper and their points, with wagging heads and learned comment.

Twopenny worth of nails were dragged aside by one party, evidently smiths, and these rang every bar of metal with a hammer, lifting separate nails and dropping them with the smallest clangs, pointing out their beauty in thoughtful tones.

A packet of razor blades, the useful kind with only one edge, so that one does not cut one's fingers when sharpening pencils, proved a puzzle to undo. But, when

they had been undone, and their greasy paper stripped, there was a universal cry of admiration. For those two hundred years and more, there had been no metal for the People, except the rusty nails holding the laths inside the plaster dome: only these, and six cutlasses which had come with them from Lilliput, but which were now harpoons.

The final glory was in a paper bag. Maria opened it herself, the People standing back in wonder, and laid the contents out in rows. It was a shilling's worth of chocolate creams.

She had gone through a tussle with the Professor about these. He, with his giant's obsession about choosing small things for small people, had wanted to buy an old-fashioned sweet which was sometimes used on cakes, called Hundreds and Thousands. They were tiny pellets of hard sugar, coloured pink or white or blue. Maria had insisted on full-sized chocolates. Which would you have preferred, then: a hard piece of sugar about the size of a toffee apple, or a chocolate cream the size of a pram?

There was no doubt about the kind which the people of Lilliput admired. Half the chocolates were quickly cut into slices with one of the razor blades, and in a minute everybody was nodding his head, smiling at his neighbour, rubbing his waistcoat, and taking another bite.

It was a pushover.

But suddenly there was a movement of dismay. All the eaters stopped eating the slice in their hands, all the ladies dropped tears on the silk handkerchiefs, everybody went off into a corner of the pavement and began to argue with the Schoolmaster. Maria watched them with a worried eye.

Presently the Schoolmaster came back.

'The People, Ma'am,' he said awkwardly, 'have call'd to Mind, that Transactions of this Complexion were carry'd out for Currency among the Nations of the civilized Globe. Four hundred Sprugs, Ma'am, Y'r Honour, Miss, were all the Treasure ever brought away from our unhappy Country, and these we have retain'd as old Mementoes of our former Greatness . . .'

Maria knew about sprugs. She had been reading the famous *Travels* madly, ever since she had found the People, and she knew that these were the golden coins of ancient Lilliput – each about the size of a sequin or spangle.

'Goodness me,' she said. 'But this is a present. Nobody has to pay. I robbed my money-box, and the Professor bought them, and when Miss Brown finds me out she will take my life. We bought them for you freely, with our love.'

'A Present, Ma'am,' said the Schoolmaster with unexpected pathos, shedding a tear like the smallest dewdrop on a spider's web into his right sleeve, 'a Gift of such Magnificence, Ma'am,' he shed three more, 'is, after all these Moons, is, Ma'am, Y'r Honour, Madam, Miss, is . . .'

And the poor fellow dissolved completely. It was from having too many shocks in one day.

Maria, very sensibly, turned round and left them to recover.

7

MISS Brown's headaches sometimes lasted three days, one in getting them, one in treating them, and one in recovering from the treatment. Consequently our heroine was able to pay the island a third visit.

It was a different affair from the others. She had scarcely tied at the larch, noticing that the brambles had been trained across her avenue, when the branches began to lift of their own accord. The passage had to be closed when she was away, for fear of other humans, but the People had secured a number of horsehair ropes to the trailers, and on these a picked gang of engineers was hauling lustily. In a minute, there was a clear road.

She bowed to the engineers and proceeded towards the temple, only to stop dead as she reached the green. The People were drawn up on three sides of the pavement, perfectly silent. Some horsehair cables

had been stretched from pillar to pillar, fluttering with little wisps of red and green and yellow bunting. In the centre the Union Flag was flown, which she was able to recognize as the standard of England, although the red stripes were missing on the diagonals. The real Union Jack did not come in until long after Hogarth's time, although Maria did not know this fact. Under the old-fashioned flag, a band of music was arranged. It was a queer, eighteenth-century band, with flutes, violins, and drums. When they saw her, the fat bandmaster waved his arms excitedly, and the music struck up. They played 'The British Grenadiers'!

She stood still, while the whole tune was playing twice – the tiny horsehairs sawing away at the mouse-gut, the reeds, and they were really rushes, twinkling gaily under ivory fingers, and the acorn drums rolling across the square. Then, at the last note, with an inspiration from the memory of the female Lilliputian whom she had first captured, Maria dropped a curtsy, with all the skill at her command. She remembered to do it slowly, and, as this was the first one which she had ever wanted to make, she did a beauty.

When she lifted her head, there was a scene of wonder. All the little women had curtsied too, and were still down! All the little men had put forward their left feet, placing the other foot behind at right angles, and were

bowing to her, or, rather, as they used to say in the old days, were 'making a Leg'.

Then, when they had recovered themselves with a gentle rustle, the bandmaster whirled his stick in several complicated parabolas, the drummers gave some terrible bangs, and the whole band countermarched to the tune of 'A Right Little, Tight Little Island', revealing the Surprise which had been laid out behind.

It was a cask of wine with the top broached, about the size of a tumbler; a complete bullock roasted whole, or buccaneered and placed on three green laurel leaves; six loaves of grass-seed bread, each one as large as a walnut; and one of her own chocolates kept on purpose, although they would have dearly loved to eat the rarity themselves.

They had invited her to dinner.

She was so charmed that she did not know what to say. So she curtsied again, a smaller one, mounted the steps in a stately manner, and knelt down to her repast.

The wine was elderberry, better than the Professor's; the bullock had nearly as much meat on it as a young partridge; the loaves were newly baked and were delicious. While she was eating, the People stood round in tense silence, not missing a thing, but remembering carefully not to say Ooo, and not to make Personal Remarks about the size of teeth, etc.

She had scarcely finished, and was just wondering whether she ought to say grace or to stand up, when the Schoolmaster, who had been waiting officiously to see that everybody behaved, waved to her to keep kneeling. A party of ladies was trying to make its way from the back of the crowd with a heavy bundle, about the size of a ship's sail. It was a ship's sail, as we shall see. Maria remained where she was, and the bundle was laid before her knees. A dozen willing hands unrolled it.

It was a handkerchief.

The People had been as anxious to choose something coarse for her, as the Professor had been anxious to choose something small for them, so that this handkerchief was not so fine as an ordinary linen one would have been. It had more the texture of cheesecloth. But the charming thing about it was that a motto had been worked round the border, in cross-stitch, like a sampler, with the finest green and yellow wool.

The motto said:

A Humble PRESENT to OUR FEMALE MOUNTAIN + From The CITIZENS and BOROUGH OF LILLIPUT IN EXILE + With Hopes of Continued HEALTH AND PROSPERITY + GOD Save The King +

They must have been working all night to have finished it.

Maria found that she was afflicted with the Schoolmaster's weakness. She said: 'Oh, what a lovely handkerchief! Is it to blow my nose?' And, without further ado, for fear that they would notice something like a tear, she put her nose in the middle of it and blew.

It was a great success. Everybody clapped respectfully – they had never heard such a blow – and a little boy who began to howl was promptly smacked.

'The final motto,' explained the Schoolmaster, 'has been preserv'd in our Archives, since the Days of Captain John Biddel. He taught our Ancestors to pronounce it, Ma'am, to entertain your Countrymen, and this particular Circumstance caused us to feel the Hope that it might prove acceptable.'

'How kind of you,' said Maria, wiping her eye, 'how kind to think of something which would prove acceptable to me.

'And, of course,' she added, blowing her nose again, 'the King will be delighted too.'

When this tender scene was at an end, the Schoolmaster explained that he had been chosen to be her guide. He had leave to show her anything she wanted to see, or to explain anything she wanted to have explained, and

he trusted that their simple Oeconomy would prove to be of Interest, however Rude. Maria replied that she would endeavour to merit their Confidence and Esteem – goodness, she thought, I have begun to talk in capitals too – and she repeated to the crowd that she would keep their secret. They looked hopeful but wistful when they heard this from her own mouth, not knowing Maria well enough, as yet, to be sure that her word was her bond. However, they were willing to make the best of it. To tell the truth, the thing which had impressed them most about her had been her curtsy. However small they were, they liked to be treated with respect, even by a Mountain, and the politeness of their new giant had created a favourable impression.

The first thing was to show her the national treasures. These were few and simple, and were housed in the highest room inside the Cupola. (Maria's only regret about the wonders of the island was that she could never see the actual rooms in which the People lived. They had feared to build a town for themselves, because of the danger of discovery, and were compelled to exist in crowded conditions inside the shell of the temple. Her Schoolmaster told her later that she was missing little by not seeing the interior, for he said that it was like a tenement house, cold and dark and draughty, but it was the best they could safely do. The three steps

were hollowed out, so that they were like a squat, three-storied house, and there was a staircase leading up the inside of each pillar. There were 240 steps in each stair. Inside the dome itself, there were other rooms, and a flight of eighty steps led to the tiny platform on the summit, where the sentry stood. All these rooms and staircases were only lit by small air holes through the joints of the stone, or through the plaster of the dome, and the whole of the lowest step was kept for cowsheds, granaries, storehouses, and the communal kitchen. They used charcoal for cooking, and to warm the rooms in small pans, so that there would be no smoke to give them away. The charcoal was got by burning laurel bushes on the mainland, in a part of the grounds which was known to Maria as the Wilderness. The only decent room they had was the highest one of all, directly under the sentry post. It was circular and was used for the Parliament room, or for dances, though the floor was slightly curved, and it was in this that the national treasures were preserved.)

Six porters carried them down, one by one, and displayed them in front of Maria, like the assistants at an auction. The greatest was the ancient portrait of the Emperor of Blefuscu, full length, which is mentioned in *Gulliver's Travels*. There was also a chest containing the two hundred sprugs of gold. Maria would have loved

to own just one of these, but she did not like to ask – so that she was charmed when they did give her one of their own accord, on her next visit. To complete the humble list, there was a collection of the original clothes worn by the captives of Captain John Biddel, when he had been exhibiting them round England. They were threadbare, but not moth-eaten, any more than your clothes would ever get owl-eaten, and they consisted of a few skirted coats of blue silk, white pantaloons, white stockings, buckled shoes, three-cornered hats, and ladies' dresses. Most of the musical instruments used by the band were also national treasures. They had been made to Captain Biddel's instructions, and his prisoners had been forced to play upon them, to amuse the crowds.

When these articles had been shown, the Schoolmaster told Maria the history of the People, since the days of Gulliver. The bystanders listened politely, being pleased to hear their own story, however often it had been told.

'A Student of your Talents, Ma'am,' said the Schoolmaster, 'and One who has become acquainted with the earlier Annals of our Race, besides mastering the Elements of our mother Tongue, will be aware that the Empire of Lilliput was visited by a Man Mountain nearabout three thousand Moons ago. The Occurrence took Place during a Period of Hostilities between that

Empire and the neighbouring Realm of Blefuscu, from which two Nations our People here is indiscriminately sprung.

'Little may the Man Mountain have suspected, Ma'am, throughout the Course of his subsequent Travels, and indeed to his dying Day, what Calamities were brought upon our Ancestors by his Visit! For no sooner had he quitted the sister Island in his majestick Vessel, which, you will call to Mind, had fortunately been discover'd by him in a derelict Condition, floating with its Bottom up, than the Emperor of Lilliput was pleas'd to declare a War against his Cousin of Blefuscu, alleging the hostile Conduct of Blefuscu in allowing the Man Mountain to escape from those Realms, contrary to an Embassage particularly sent from Lilliput to restrain him, of which Island the said Mountain was a Subject, a Nardac, and a discover'd Traytor.

'The Campaign, Ma'am, which follow'd the Declaration, was exasperated by the old Bitterness of the Big-Endian Heresy – A Topick of Dissension, which I am happy to say we have since resolved by a Determination to break such Eggs as we are able to find in the Middle – and, no Quarter being ask'd or given by either Schism, the War was signalized by Atrocities and Inhumanities hitherto unexampled in the Legends of our People.

'Corn Fields were burn'd, Cattle were driven away or slaughter'd, the Cities were subjected to a Number of Sieges which reduced the Inhabitants to Starvation, and the Emperors of both Realms died by each other's Hands, in single Combat outside the Walls of Mendendo. The Anarchy which subsequently prevail'd among the Leaders of the rival Factions, each of whom sought to draw the Power of Direction into his own Control, reduced the Hopes of Reconciliation still further; and it was therefore upon a Civilization already tottering from its Foundations, Ma'am, that Captain John Biddel descended, after a lapse of seventeen Moons, all of which had been devoted to Rapine and Destruction.

'For such was the secondary Effect of our Visit from the Man Mountain, whose Name, it was later discover'd, had been Culliver or Gulliban. He, Ma'am, Y'r Honour, Miss, unlike Y'r Honour, had made no Efforts to conceal our Whereabouts from the greater World. He had committed the Indiscretion of confiding the Whole of our Oeconomy to the Mariners who convey'd him Home. He had presented a Pair of our Cattle to the Captain of the Ship, the said Captain Biddel; and the Latter, premising the extreme Value of their Fleeces owing to the Fineness of the Wool, had return'd to Lilliput for his next Cargo, without finding any Difficulty in raising the Island, by running down the Latitude.

'Captain Biddel, Ma'am, according to our Annals, was a Seaman of his Æra and Country, neither better nor worse than others of his Rank. To him, Ma'am, and, I must beg Leave to add with honest Gratitude that we have found no Occasion as yet to notice such a Disposition in Yourself, to him our broken and distrackted People were Creatures not possessed of human Rights, nor shelter'd by the Laws of Nations. Our Cattle were for his Profit, because we could not defend them; our very Persons were an Object of Cupidity, for he had determined to show us in his native Land, as Puppet Shews and Mimes.

'Ma'am, Y'r Honour, Miss, we fled as we could still flee, from the Pyratts of his monstrous Vessel. We conceal'd ourselves in Rocks and Woods, breaking off the internecine, fratricidal Strife too late. Our few remaining Herds stampeded, some finding their own Destruction in the Sea, others falling into the Hands of these unprincipled Mariners, who joyfully collected them into Enclosures or Corrales, made from the grog-barrels of their ship. The capital City of Mendendo was ransack'd for the last Time, in Search of Slaves, but, such had been the Desperation of the People, even before the Arrival of Biddel, that only thirteen Refugees were found surviving, and these promptly empanell'd into the Possession of their future Master. Lilliput, Madam,

and Blefuscu, ceased at that ill-fated Epocha from their Existence among the Nations of Antiquity.'

There was a sign from the listeners when the Schoolmaster had got to this, and he himself looked inquiringly at Maria, as if he were ready to hear some apology. After all, Captain Biddel had been a mountain like her.

'Was nobody left?' she asked.

'That, Ma'am, is a Question which has agitated the Speculations of Lilliput in Exile. Naturally, however, we have no Means by which to reach a Determination. Our Philosophers have hoped, Y'r Honour, perhaps deceived by the delusive Dreams of Hearts which would not wish to be entirely cut off from the remember'd Home of their admired Progenitors, that some small Remnant of our Consanguinity survived, and that perchance, on the old Latitude, there still exists a Lilliput Redivivus, rebuilt, by them, in Splendour suited to the Genius of our kind.'

'When I am rich,' she said, 'we will buy a yacht, and go to find them. The Professor is making a translation of the *Hexameron* of Ambrose, which will make his fortune when it is published, and then we will all go together.'

The People sighed and looked away – they knew nothing about the commercial demand for St Ambrose – and the Schoolmaster continued his story. ('Fetch the

Lock for the Receptacle,' he said to the porters. 'We shall have Occasion for it shortly.' Later, when he was talking about the captivity, it was displayed before her – a cheap, pewter lock with an expression which said: Well, you won't undo me.)

'The Captives of Mendendo,' said he, 'included Flimnap the Treasurer and two Gentlemen of the Rank of Snilpall, beside seven Women and three Men. These Persons, the Ancestors of all here present, together with the Flocks and Herds collected by the Pyratts, were taken to the Vessel. Captain Biddel weigh'd Anchor with a favourable Wind; and proceeded for the distant Shores of his own Land, well satisfy'd with future Hopes of Advancement and Prosperity.

'How miserable, Madam, was the Condition of our Countrymen, cut off from all Recourse to the Cradle of their Fathers, disillusion'd by the long Series of Disasters which had attended the War of Eggs, surrounded by Beings out of all Proportion incompatible with themselves, and convey'd, in an insanitary box, to the Servitude of a foreign Clime!

'For Captain Biddel had caused the Ship's Carpenter to construct a single Receptacle, whose Lock you see, for Man and Beast, in which all together were assembled promiscuously; and there they were kept on a Diet of Ship's Biscuit crumbled in Water, which had previously

been found to answer with the Cattle carried off by Surgeon Gulliban in former Moons.

'Madam and Y'r Honour, I need not distress your tender Susceptibilities, by describing the Hardships of the Voyage, during which the greater Number of the Cattle were lost of a Murrain, nor even by dwelling upon the Indignities to which our Forebears were subjected, after they had landed on the alien Shore.

'Captain Biddel made Sale of his Command, anticipating a larger Prosperity from the Exhibition of his Captives among the Fair Grounds of the Kingdom; and, in this Manner, for more than fifteen Moons, the High Treasurer of Lilliput, the two Snilpally, and the eight surviving Commoners, two of whom had died on Passage, were shown about the Wakes and Ales of Neptune's Isle.

'Musical Instruments, Ma'am, which you have heard already, were constructed to the Directions of their Master. The English Language, to them excessively difficult owing to the Inequalities of Pronunciation, was ruthlessly impress'd upon them by the insatiable Avarice of their Proprietor. The ancient Skills of Lilliput, such as Leaping and Creeping, or Dancing upon the Strait Rope, were exploited for the Entertainment of the Vulgar. And all the Performance, for which the miserable Captives were rewarded with no other Guerdon than

the Lash, their Tyrant being then accustom'd to punish Misdemeanours by a Flogging with a Sprig of Heather, was attended by no other Prospect of Amelioration, than the Amelioration of the Grave. Madam, it was under these Conditions that the Exhibits were taught to cry: God save the King! It was under these Conditions, Madam, that the Banner of St George was flown – a Climax, as we learn, to the Spectacle promoted by the Mariner Biddel.

'These Facts, Y'r Honour,' continued the Schoolmaster kindly, 'are mention'd not from any Thought of Bitterness towards yourself, but merely as a Measure of our own Respect; for we were willing to return your kindness with any Exhibition Calculated to divert the Species.'

Maria bowed.

'Captain Biddel,' he went on, 'was satisfy'd in his Expectation of Profit. Numerous Crowds were collected on every Fair Ground by the Reputation of his Shew; and the Exertions of the People, constantly urged forward to greater displays of their gymnastick Abilities, soon added a handsome Fortune to their Master's Pocket. Captain Biddel, Ma'am, insufficiently educated to the Temptations of a comfortable Station, and passing his Time, as he was forced to do, among the Gin Shops of the country Fairs, now grew addicted to the Bottle. Perswaded as he was that our People fear'd his Race too

much to seek Escape among them and indeed, beside the Annoyance of their Breath, our Ancestors were much terrify'd by the vast Faces which crowded about on every Occasion, by the Stink of their Persons and by the bucolick Covetousness which they exhibited – Captain Biddel had grown remiss in locking the Receptacle at Night, particularly on those Nights, now becoming imperceptibly more frequent, during which he had amus'd himself with Licquor.

'The People, Ma'am, suffer'd, however, in an even greater Measure from their Master's Tyranny, the more his Constitution was exasperated by the Effects of this Debauchery. The aged Flimnap, forced to perform his dangerous Acrobaticks on the Rope, dreaded an Accident with more Reason every Day. The others, long dejeckted by the Toils of their Performance and by the Menace of the Heather Whip, were accustom'd to consider, more and more anxiously, whether Death itself, if attended by the least Chance of Liberation, might not be preferable to the miseries of their Condition.

'It was at this Stage in our History that the Captain was summon'd to the Palace of Malplaquet, in order to demonstrate his Puppets before the Household of the reigning Duke.

'Captain Biddel, Ma'am, dined at Northampton on the Night before the Exhibition, with more than

customary Indulgence. Proposing to himself a handsome Remuneration from so great a Patron, attended probably by a valued Recommendation to the World of Fashion, he celebrated his Fortune in several Bowls of Grog. Then, calling for his Horse and for a final Bottle as a *Vade Mecum*, he set out for Malplaquet, where he was to sleep that Night.

'A Bridge, Ma'am, spans the Torrent, four hundred Blustrugs to our West, below the Other Sea.'

'H'm,' said Maria. 'That would be the Oriental Bridge, I suppose. It is the one on the Northampton Avenue, at any rate.'

'It was at this colossal Structure, Madam, or so our Histories relate, that Captain Biddel fell Victim to Intoxication, and dismounted from his Nag to seek the Safety of the *Terra Firma*, on which he instantly composed himself to Slumber.

'The People, in their horrid Receptacle, which was strapp'd, as usual, to the horse's Crupper, and whose Lock he had omitted to turn, came out upon the Saddle to survey the Night, the Horse meanwhile being content to graze at Ease beside its Owner. It was a moonlit Eve. The Torrent could be plainly seen, issueing from the Other Sea, and all about the Land appear'd deserted. The Resolution to escape was taken on the Spot, all solemnly asseverating their desperate Intention

to perish by their own Hands, rather than submit to Capture.

'Cables were rapidly made fast, the Strait Ropes of their Exhibition proving suitable. The Sheep and Cattle, slung from these, were quickly lower'd to the Ground. And the Receptacle itself, being unstrapp'd with Difficulty, was also taken down. It was the Plan of Flimnap to transport his little World by Sea, until some Refuge on the further Shores could be discover'd.

'I will not, Madam, tire you further with the Tale of our Migration. Towing the Receptacle against the stream, the Torrent was surmounted. The quiet Waters of the Other Sea permitted the driven Cattle to be embark'd within it, and all together made their Way by Navigation to the eastern Bank; where, as the Morning dawn'd, the Expedition was conceal'd beneath the overhanging Branches of a prodigious Tree. Some slight Attempts at Search were noticed during the Hours of Daylight from this Refuge, but without Commotion. It was conjectured that the bemus'd Biddel, having been addled since his Setting Out, might not retain the slightest Recollection of his Actions, and might retrace his Steps at least towards the Tavern where he dined, still seeking the Receptacle along his Way. Next Evening, shelter'd by the Darkness, our Ark, as we may call it, having been hoisted with incredible Pains along the

Cascade to the Upper Sea, a Scout, who had been sent ahead in Order to survey the Country, return'd with Informations about the secret Island where we have ever since continued, and on which, Y'r Honour, Madam, Miss, you stand today.'

MARIA could not help feeling relieved when the History was over. Her head was buzzing with capital letters, and she secretly thought that it was more fun to ask questions, instead of listening to lectures. She was also doubtful about being called 'Ma'am, Y'r Honour, Miss', knowing that her proper name was Maria, and she was determined to keep the proceedings on a less formal level. The best thing would be to get away with the Schoolmaster, so that they could talk to each other sensibly, instead of being a public meeting. On the other hand, she saw at once that there would be a difficulty about exploring with her guide, since even the most versatile human would find it complicated to go for a walk with a person who did not reach much farther than her ankle. For one thing, there was the problem of taking steps. One step of hers would have covered about

twelve steps of his, so he would have been forced to run very fast to keep up. But she did not like to suggest the idea of carrying him. There was something babyish about being carried, and she did not want to humiliate him; for she had a certain amount of good taste, in spite of being only ten. She was also afraid of holding him, for fear of squeezing too much, and she guessed that he would be afraid of being dropped.

Maria had finished her elderberry wine while listening to the History. She now suggested that, if he were going to show her round, he might prefer to stand in the barrel, as seamen do in the crow's-nest of a man-of-war, while she carried it in her hand. He was delighted with the scheme, which saved him from being mauled by the big fingers, and which left him his dignity. While she washed the barrel in the lake, and dried it with the remains of her handkerchief – not the new one – he dispersed the crowds in a short address, advising them not to stare, and not to get trodden on.

With the Schoolmaster in the barrel, there was a good deal more to see as they went round the green, and of course there were a number of questions to be asked.

One of the things which she had not discovered before was the underground rat stable, hidden by part of the shrubbery.

No horses had been brought from Lilliput. Gulliver had not troubled to do so, and Captain Biddel had not been able to obtain any, because the final wars had almost destroyed the breed, in cavalry battles. The people of Lilliput in Exile had therefore been forced to turn to the rats of their adopted country, which were used for farm work at harvest times and for carrying urgent messages on the mainland. They were swift, but not stayers, when ridden; for farm work they were strong and intelligent. The Schoolmaster said that they were not vicious when taken young or bred in captivity, that they were cleverer than the other domestic animals, and that they were not dirty when properly groomed. They were fed on the scraps of the community. Several were brought for her inspection, and promenaded in a circle on the lead rein. They were always ridden on short leathers, as jockeys do for flat races nowadays, because of the shortness of their legs.

She wanted to know about the food of the People: about the way they lived, their enemies and dangers, and about all the other things which her guide insisted on calling Oeconomy.

One thing which interested her was that they ate a good many insects, and that they kept the green fly, as the ants do, for syrup. The difference was that the ants thought of these creatures as cows, while the Lilliputians

thought of them as bees. She did not like the idea of eating insects, at first, but when she remembered that the Professor had told her how a lobster was practically an insect, she began to see that there was not much difference. The Schoolmaster told her that his people used to boil wood lice just as we boil lobsters, and that they turned red when boiled, and gave people bad dreams.

As for keeping the toy cattle and getting food for five hundred people on the green, she learned that the colony owned a proper frigate as well as the canoes – he was taking her to see it – and that, in this, they carried cows to pasture on the mainland every night. Indeed, the whole life of Lilliput was really a night-life – he explained that talking to her in the daytime was like staying up late for them – and they gathered their harvests of Yorkshire Fog or Rye Grass or Cock's Foot, for flour, by cutting them in the Jubilee Field, under a harvest moon, and bringing them back on the frigate. They also fished at night. In the winter the frigate was used as a whaler, to catch pike, because the winter was the main season for living on fish. This also was done at night.

The Lilliputians had trappers. These brave men would go off on long treks into the Park, sometimes being away for a moon, and would come back with stores of furs

or salted meats. They trapped voles, shrews, mice, and even live rats, but were in constant danger from cats and weasels. Every year, one or two of the bravest hunters failed to return. Many of them had been able to snare rabbits; but then they needed to be in bands, to carry back the meat.

One of the foods which they valued most was the leg of a frog, which was eaten, like turkey, for Christmas.

The grass snakes, which are perfectly harmless and beautiful to us, were dangerous to the Lilliputians, because like boa constrictors, they were inclined to eat any animal the size of a frog, on the rare occasions when they were hungry. On the other hand, they were good to eat themselves.

In the winter, when times were hard, the trappers sometimes caught wild ducks on the lake, by leaving baited hooks firmly secured, and of these they often had mallards, tufted duck, pochard, and teal. The coots and dabchicks gave bad meat. Even in the winter, the difficulty of the season was relieved by the greater length of the nights, which left more time for hunting.

Maria's Schoolmaster told her that an interesting experiment had been tried in the lifetime of his father. It had been nothing less than to use the birds of our world as aeroplanes. A young jackdaw had been found, too young to fly, and had been kept alive with difficulty,

on insects and sliced worms. It had grown up tame, though snappish, but had at first refused to fly at all. They had been forced to starve it, and finally to drag it to the top of the cupola, with its wings brailed, and then the man who usually fed it on a lure, as falconers do, had waved the lure energetically from the ground. Finally somebody had pushed it off, and it had flown to be fed. When it had grown accustomed to flight, and had got some power in its wings, a strap had been fitted round the base of each wing, and under and over the breast, and the daring aeronaut had sat on its back for some time every day, gripping the strap, which had loops, like stirrups, for the feet. Of course, it had been kept tethered all the time, except for meals. The aeronaut had been forced to pad himself, as people do who are teaching Alsatians to be police dogs, because it was inclined to peck at him, over its shoulder. In the end, he had flown on it several times, from the top of the cupola, but the experiment had collapsed on the question of navigation. They had found that it was possible to make the bird fly in circles, or to the left or right, by means of a bridle in its mouth, if used with a light hand. But they had never discovered a way to make it start flying, or stop flying, when wanted. So all flights on it had been in the nature of balloon ascents, which might come down anywhere, and the enterprise had been dropped.

In spite of Maria's efforts to keep him talking about the jackdaw bomber, which was an idea that interested her, the Schoolmaster seemed to be ashamed of it, perhaps because it had been a failure, and was more anxious to lecture about his politics.

There were few laws, he said, but a good deal of public opinion, and there was no death penalty. There were no wars, owing to the fortunate circumstance that there was nobody to have a war against. Writers and bards and musicians were rightly regarded as mechanics, like carpenters, and were valued, like carpenters, for the soundness of their work. There was no revealed religion, because it had been destroyed by the War of Eggs. The mothers were considered to be the heads of their families. They believed the most important thing in the world was to find out what one liked doing, and then to do it. Thus the people who liked being hunters, were hunters; those who liked fishing, fished; and anybody who did not like doing anything at all was supported by the others with the greatest care and commiseration, for they considered him to be the most unfortunate of mortals.

They had three meals a night. They went to bed at dawn and rose at sunset. Their children were never taught a word about Algebra, but were, on the contrary, educated in the various sciences of life: that is to say,

in Natural History and in their own History and in Oeconomy and in anything else which dealt with being alive. They were never told that their elders were better than themselves.

Maria could not help feeling that these things sounded wonderful, but she wanted most of all to see the frigate.

The usual way to reach it was along one of the secret paths through the undergrowth of brambles. Unfortunately, it was a path which she could not follow. So they went down to the punt and sculled round the island, to reach it from outside.

It was beautifully hidden.

The channel leading to its harbour was covered with the leaves of water lilies, just like the other lilies round the island, but these leaves were without stems. They were merely flat plates floating on the water, and were renewed once a week. When the frigate was to sail, they were dragged aside.

At the end of the channel there was a bluff of land which masked the dog-legged entrance to the harbour, and the bushes grew above. She had been round the island many a time without discovering it. It was only after following the channel, under her Schoolmaster's directions, that she raised the harbour mouth.

There lay the frigate in her quiet pool. She had gun ports but no guns, no foundry nor gunpowder being available on the island; her cordage was of plaited horsehair stolen from the horses in the Jubilee Field; her canvas was the same as the presentation handkerchief; her Admiral was the tall young husband who had tried to chase her when she first secured his wife and baby; and all the sailors, as a compliment, had gone down by the other path, to man the shrouds.

I T WAS a week after seeing the frigate for the first time that Maria was invited to witness a grand whale hunt, at night. It was not only safer to go by night, when Miss Brown was in bed, but also it was more natural to see the Lilliputians at this season, because they slept by day.

Maria waited in her bedroom, in a fever of impatience to be gone, but she knew that her governess and the Vicar were sitting in Neptune's Temple, over an after-dinner cup of coffee. She could see their motionless figures in the moonlight through her window, two small dots squatting under the silver columns, for the Temple had been built to finish one of the Vistas from the palace itself. What made it worse was that the whales of Lilliput were pike, and these fish would only take the bait at mysterious periods, which they chose for themselves. One of these periods had been reported to

be passing that evening, for the People had noticed the small roach skipping from the water to save their lives, which was an infallible sign that pike were feeding. They had promised to catch a big one for her, if they could, for there was a famous monster of twenty pounds, which had been seen in the deepest hole. She walked up and down the linoleum of her bedroom, afraid to lie down for fear that she might go to sleep, and wished her pastor and mistress at the bottom of the lake.

The Vicar was a constant visitor at Malplaquet, generally for tea. In the afternoon she would meet him in the grounds, humming his way from the Vicarage, his body stiff, his hands behind his back, moving at a slow and steady pace with his lips pursed up in disapproval. It was a mystery to discover why he came, for he seldom spoke to Miss Brown when he was there, and did not enjoy what he ate.

At tea they would sit on either side of the fireplace in the North-northwest Drawing Room, with one of those pagoda-like cake stands between them, and a low table with the silver tea-things. Sometimes they said nothing. At most they said eight sentences: 'This bread is cut too thick', 'I will speak to Cook', 'More tea?', 'Thanks', 'Cake?', 'Thank *you*', 'The child was late for luncheon again today', 'Inconsiderate'. Miss Brown used to eat three cream buns greedily, with a

fork, but the Vicar used to choose the nastiest cake on the pagoda, apparently to spite himself. After tea, he would walk mysteriously for hours through the palace rooms.

So there they were on the steps of Neptune's Temple, in the lovely moonlight, while the precious time was slipping away. It was the famous Temple in which Dr Johnson had written the fourth stanza of his immortal *Pomphoilugoppaphlasmagoria*, the one which begins 'Ponder the aweful Hippopotamos' – but little they cared for this. It was June and the nightingales of Malplaquet were in full voice. They did not hear them. Six fluted columns rose on either side, bearing the pediment on which Neptune, in high relief, was awarding a wreath of seaweed to Viscount Torrington, after the battle of Cape Passaro, amid the applause of several dolphins. They had never looked at it. Before them, on the silver sward of the Arcadian Valley, the thousand wild rabbits of Malplaquet were nibbling and hopping forward and nibbling again, while the owls hunted food for their babies, gliding with soundless feather. The Vicar and Miss Brown stared out with oyster or pebble eye, to where the towering pillar of the Newton Monument closed the sweet curve of the valley with its slender finger, glittering like salt under the moon; but they did not see this either.

They were thinking about Maria, just as she was thinking about them, and they had reason to do so. There was something which they did not want her to find out, but which they wanted to find, or rather to alter, for themselves. They did not like the idea of her talks with the Professor – who was an authority on ancient laws and enjoyed nothing better than a good bout of *nolle prosequi* – because their mystery was connected with a missing parchment, concerning the inheritance of Malplaquet. The Vicar was humming softly.

'It is a question of *mort d'ancestre*,' he said at last.

'No child could understand it.'

'She will come of age.'

'Not for many years.'

'But by talking to the old man, Miss Brown?'

'I shall forbid it.'

'M-m-m-m-m.'

'More coffee?'

A long time afterwards the Vicar said: 'You should watch her.' Then he stood up heavily, and paced off sullenly to bed.

Maria crept down the moonlit corridors, as soon as her governess was safely asleep. Down the various staircases she went, creaking on the bare boards of the less important ones, patting on the bare marble of the company ones, passing from one bar of moonlight

to another. On the ground floor she took a short cut through the Grand Ballroom, where her feet shuffled in the fallen plaster from the Adam ceiling, and the three-ton chandeliers, too big to sell, gave out a mysterious note of crystal; through the Third Duke's Library, which had a monstrous plaster Garter on the ceiling, in gold relief, in celebration of the Order of the Garter which that duke had at last obtained after twenty years of chicanery – and which he had subsequently worn round his neck, even while bathing at Brighton; through the Main Dining Room she went, which had once housed a mahogany table exactly as long as a cricket pitch; through the Little Drawing Room, where the two Grinling Gibbons mantelpieces had been wrenched from the walls to sell, leaving caverns which looked frightening at night; and through the Absolutely Insignificant Morning Room, which was a room with only one fireplace, and that was plain marble. Maria passed from dark to light, and from light to dark, down the rows of shuttered windows, until she began to look like a cinema film, flickering badly. She went too slowly for the Persistence of Vision. At last she came to the great double doors which led to the South Front, hauled them open enough to let herself through, and appeared in full moonshine between two colossal stone caryatids, with an antique frieze, stolen by the Fourth Duke from Herculaneum, thirty feet above her

head, and the forty-five marble steps which led to the Terrace stretched below her feet.

She had been thinking.

Whatever the Professor says, she thought, I don't see why I should not give presents to the People, since they give presents to me.

She had found out that the silk handkerchiefs had been distributed by tickets in a lottery, since there had only been enough material to make dresses for about twenty women. The rest had been forced to go without.

If I were rich, she thought, and could afford to live in some respectable little cottage with a bit of money in hand, how I would like to dress them all! I would give the men old-fashioned dresses like the ones their ancestors had: blue coats and canary waistcoats and white breeches and silk stockings and tiny swords! And the women should have flowered gowns of the same century, and I would get coaches made for them which the rats could draw, or even sedan chairs, and all would look as bright and beautiful as a bed of flowers . . .

Alas, Maria only had three shillings and nine pence halfpenny left. It would not even buy enough handkerchiefs to dress the other women.

One thing, she thought, cheering up, is that I can scrounge things for them from Cook. An old saucepan with the handle broken off might be of value to them,

as a boiler for the farm animals. I must think of all the broken things which are of no more use to humans, but which might be treasures to the People: things like used toothbrushes, for brooms, or jam jars for barrels, or even an ounce or two of salt and pepper, which would go far and scarcely be missed. But the three and ninepence halfpenny must be kept, for a special present, and what is that to be?

Presents can be of two kinds, she decided, flickering once more as she trotted down the Chestnut Avenue: Either they can be useful, or else ornamental. How I wish I had some real money, say a pound!

She was still considering as she sculled the punt towards the Repose, and had only got so far as this: A useful present would be to buy them a pair of guineapigs to breed draught horses, or even for meat, while an ornamental present would be to purchase Christmas cards – so long as they were not sloppy, but showed pictures of sailing ships, or of eighteenth-century coaches in the snow, or of anything else which the People could recognize from their Annals – and to frame these in passepartout, so that they could be hung round the walls of the council room. In the middle, they would hang the ancient portrait of the Emperor, with his *Austrian* lip and costume partly *Asiatick*, partly *European*. They might look grand by rushlight, hoped Maria.

And then she thought again: Or I could teach them to grow potatoes, like Sir Walter Raleigh. You could probably get plenty of potatoes for three and nine.

The People were relieved when she arrived, for they had almost given her up.

The frigate was on the lake – how beautiful she looked, too, with her white sails spread in the silver light – and the sailors were at their stations, and they were only waiting for their guest to let the expedition begin.

The sad thing was that she could not go in the ship. It was hardly five feet long. However, they advised her to stand in the point at the end of the larch, to watch from there, and the Schoolmaster offered to be carried in the barrel, so that he could explain the manoeuvres.

The Quincunx was so overgrown that it was only in the deepest parts, near the middle, that it was free from weeds – for most water weeds, except duckweed, need roots in the bottom, and these cannot grow below a certain depth. It was in the largest of these holes that the big pike lived, and it was consequently to these latitudes that the frigate sailed. When she had got there, a live bait with the appropriate hooks was thrown over from the bows, and the frigate herself sailed to the nearest lilies, where she anchored in deep water. The live bait was on an eight-ply cable of horsehair, which came in through

a hawser in the bows and went over a drum which could be braked.

She had scarcely anchored, and the poor live bait was still wriggling in a baitly way, when there was a snap and a swirl in the water. The drum was allowed to run out while Maria's Schoolmaster excitedly counted ten: then the brake was thrown into gear and the drum crew rapidly began to wind against it, to drive the hooks home. After a dozen of these turns, they put her out of gear and used the brake.

The whole frigate went ahead two or three feet from her moorings – the Schoolmaster said that it was thirty-five glumgluffs – and began yawing one way or the other as the monster tugged. It was given a freedom on the brake when it struggled too hard, but at any sign of weakening the brake was increased, while, if it lay motionless for a moment, the crew began to wind.

The Admiral directed from the poop.

It was a ticklish business in many ways, for the pike was really being played, not from the frigate, but from her anchor. There were two holds which needed attention, instead of one.

After the first minute, the Schoolmaster said sadly that it was not the big pike. He had been able to tell from the splashing, to some extent, for the big one would have been more sullen, and also from the working of the

ship. He added that he thought she would prove to be of about four hundred snorrs, or nine pounds, at which weight they were usually fierce.

The real danger was that the pike's teeth might cut the cable. They needed a metal cable at the end, like a fisherman's trace, but there was no suitable wire to be found in the Park. The barbed wire used by the farmer who rented the land was much too thick.

When the monster had been played for about two minutes, it began to give in. It was towed slowly to the ship's side, made one more dart to get away when it saw its captors, was brought in again, and this time actually rolled right over in the water before it lay on its side, looking vanquished. It was far from being so. Pikes have great vitality, with which they live for hours even after they are on the bank, and the real difficulties of whaling were only beginning.

As soon as the gleaming body was stretched beside the frigate, five picked harpooners set to work. The harpoons were driven deep into its back at intervals of six inches or so, and, by means of the ropes attached to these, it was drawn firmly to the ship's side. Then the Admiral came down from the poop – he always took the last hazard himself – and went over the side on a rope ladder with the sixth harpoon. His business was to drive it through the backbone, near the head.

Now the pike had grown furious as each harpoon drove home, thrashing with a great clap on the water at each thrust. If the Admiral could find a joint in the backbone at the first blow, its spinal column would be cut and the danger would be over. If not, there was a good chance of his being thrown into the water by the commotion, where he would run the risk of being snapped up by the pike itself, for these ferocious creatures would grab at food even as they were dying, and would sometimes seize the bait again, if they had escaped from it.

He chose his place and thrust. The huge body, more than half the length of the ship, bent like a bow, opening its wide jaws, with row on row of skinny teeth. Then it lay slack.

Three of the harpoon cables were drawn up on either side of the vessel, and the sinking body was secured by these, under her bottom, before she sailed for home. The passage of water through its gills made the fish lively as she sailed, but the severed spine prevented it from making a flurry. All it could do was to clash its jaws, which, as the Schoolmaster told Maria, was often felt through the ship's fabric.

In the meantime, the cables were sent ashore. A team of rats, and twenty men on each cable, dragged the still gnashing body through the shallow water to the bank, where the flensing could begin. The Admiral drove his

rapier, tempered from one of the cupola nails, into its brain.

Maria paddled round, to see the capture brought in. She wanted to help with the victory, and was so excited that she nearly trod on the haulers, as the rats strained wisely at the seven ropes, under ships which cracked with a noise she could have made between her finger nails. She cried: 'Here, give it to me! Let me pull! I can get him out!' She snatched several of the cables to tug, and each one broke in her hand. She was too big for them. The many small fists could control the horsehair, which only snapped in hers. The dead fish sank heavily beneath the water-lilies, and was lost. The precious harpoons would have to be dived for. She stopped when she saw what she had done, and the People tried to be polite.

10

MARIA'S misfortunes with the Island of Repose dated from the night on which she had interfered with the whale hunt. Although she was decent, as was shown by her offer to carry the Schoolmaster in the barrel, she was still young. The more she adored and wondered at the doings of her six-inch People, the more she wanted to take control of them. She wanted to play with them, like lead soldiers, and even dreamed of being their queen. She began to forget what the Professor had said, about not being an owner.

But the Lilliputians were not toys. They were grown up, however short they were, and they were civilized. Lilliput and Blefuscu had been countries of high civilization: and so had England been in the eighteenth century, when they had been brought to it by Captain Biddel. They had painters, who did wonderful formal

pictures of old-fashioned shepherds and shepherdesses in pannier skirts and ribbons, painted on stretched puff-ball skins. They had poets who still wrote the original metres of their native land. These latter had found the heroic couplet too cumbrous for them in English, so they wrote the smaller verses of the other language: a highly polished form of poetry. The first words of the line rhymed as well as the last ones, and, as there were seldom more than two words in a line, or four lines in a poem, it was not easy to write. This was one of their love poems:

> Mo Rog
> Glonog,
> Quinba,
> Hlin varr.

It meant: 'Give me a kiss, please, Miss. I like your nose.' Other writers produced Tragedies of five scenes, which observed the Unities, and these were acted by the opera company in the top room of the monopteron – where there was a miniature harpsichord in the orchestra, sounding like the ghost of a ghost, which had been made to the order of Captain Biddel. Still others were famous for their Essays, which were seldom more than two lines long, and generally on a moral subject. 'Nothing fails like

success' was one of the Essays; another was 'Narclabb meeting an Ass with a fortunate Name, prophesy'd Success. I meet many Asses, but none have fortunate Names'.

In short, although, as we shall see later, the People lived hardy and dangerous lives, they were cultured, and could not possibly be treated like lead soldiers. For that matter, they had hidden on the island to escape this very fate.

However, Maria lost grip of herself, and she now proceeded on the road to ruin with the speed of a Rake's Progress.

The first mad thing she did was to make a favourite. This was a beautiful but silly young fisherman, who was too stupid to mind being carried about all day, to the detriment of his fishing. He felt distinguished when chosen to be the man in the barrel, and did not dislike being used as a toy, because he was a vain fellow in any case. (The Schoolmaster, on the other hand, had gone on strike soon after the incident of the pike flensing.) Maria devoted herself to the new favourite, began carrying him in her hands instead of the barrel, and even carried him in her pocket. She took him with her everywhere. Once she took him to sleep in the small drawer of her dressing-table, which was dangerous so far as Miss Brown was concerned, and bad for his character also,

because it made the other Lilliputians look down on him. She would sit for hours in the pasture field on the other side of the Quincunx, inventing exciting stories and making him act them for her. Occasionally she kidnapped one or two others, to act with him, which annoyed them, although it flattered him. She began to grab and snatch like a rough baby greedy for toys, which generally get broken in the process, saying, 'No, no. Do this. Do that. You be the conquered enemy and I will be General Eisenhower. Give it to me. I will be the Queen and you can be my subjects.'

There were no more welcomes when she visited the island. The People began to have a worried look, and to hide when she came.

The next craze which she got into her head was for toy aeroplanes. She had been so delighted by the story of the jackdaw bomber, in spite of the Schoolmaster's diffidence about it, that she borrowed twopence from Cook and persuaded the Professor to buy a model for her in Northampton, with a propeller worked by elastic. It was a cheap and nasty one, having cost only 3s. 11½d., but it looked as if it would carry the fisherman. She just had sense enough to realize that it would need ailerons, tail plane, and rudder, but there was an old copy of the *Illustrated London News* in Miss Brown's drawing-room, which had a diagram of these controls. She helped

herself to this, and called a meeting of the reluctant Lilliputians to plan the conquest of the air. She flew the model for them several times, with the usual stall and crash landing on its propeller, and explained how they would have to make the ailerons according to the diagram, as the work was too fine for her fingers.

The Schoolmaster refused to help. He pointed out that an elastic which lost its power after forty seconds was useless for practical purposes, as it would scarcely take the machine across the lake; that there would have to be a gang waiting after each short hop to wind it up again; that the fishermen did not know how to use the controls in the picture; and finally that it was a conspicuous object, while their whole mode of life in the Repose depended on concealment.

Maria said that she was bigger than they were, and that it had to be done.

They were flatly refusing, when the young fisherman said that he would do the carpentry himself. He felt the importance of a favourite, and the grandeur of flying an aeroplane had gone to his head. The others had to give in. But they avoided Maria completely after that, leaving her and the poor coxcomb to arrange the affair in their own way. The Schoolmaster made one awkward attempt to read her a lecture – but she laughed, and would not listen.

It was only because she was inexperienced and had not thought, not because she was a bully. Besides, she was on fire with her dream of a tiny aeroplane really flown, and she scarcely noticed the reactions of other people.

The fisherman made the new controls beautifully, using horsehair for the wires and sailcloth stretched on twigs of silver birch to make the various flaps. When it was finished, it looked like the first flying machine built by the brothers Wright, except that it was a monoplane. He had to sit on this plane, as the Wrights did, with his legs stretched nearly straight in front.

The great day came for flying it, and the pilot was ready to win immortal fame. Both of them were too enthusiastic to think.

It would not rise from the ground, because of the long grass in the Jubilee Field, but ran in circles, buzzing and skidding on its wings, before it turned upside down. Fortunately the propeller missed the pilot as he was thrown clear.

They tried the controls anxiously, wagging them with the control column, and the horsehair to one of the ailerons had snapped. This was replaced. They chattered as they worked to fix it, agreeing that Maria was to launch the next flight from her hand, as she had done when showing how it flew.

'Are you ready?'

'Yes, Y'r Honour.'

'Are you sure you will be all right?'

'Yes, yes!'

She let it go, and he was off.

It went straight for the ground at her feet, pulled out of the dive when within an inch of crashing, skimmed along faster and faster less than six inches from the grass, with its port wing down, rose with a great zoom when it was twenty yards away, and, at an altitude of twenty feet, turned upside down.

The pilot was still falling, a crumpled mass like a shot partridge, when a gust lifted the starboard wing. The machine slewed sideways and down with a sickle swoop, landed on its wing tip, shed the wing, and lay there thumping feebly as the elastic tried to turn.

He meanwhile had been falling a-sprawl. Before the aeroplane struck, he had hit the ground.

To a man who was six inches high, one of Maria's human feet represented twelve. Twenty of her feet would have been two hundred and forty of his. That was the fall he had.

Her heart rose to her neck, turned over there, and plunged into her stomach. Her blood began to fizz and her fingers to tingle and the bones vanished from her legs. She started to run, wishing she could turn back

time, wishing she could unhappen the awfulness of now.

She had not marked him, and could not find him in the grass.

She ran round searching madly, beating the scutch with her hands; then stood still in agony, realizing that she might have trodden on him. When she was still, she could hear him groan. He was stretched beside a tussock with only one leg! Or with his other leg twisted under him horribly! His face was white, but oh, he must not be dead!

If he had been a human, even from twenty feet, he might have killed himself; from two hundred and forty, he certainly would have done so. But bones are made of much the same material, whatever one's size is, and this is why the small creatures like rats and cats can fall from greater heights than we can. They have less weight to fall, and so the bones are stronger in proportion.

Maria knelt beside him, not knowing what to do, or how to bear the pathetic noise he was making. He had certainly broken his leg, even if nothing else was broken. She tried to remember what little she knew about first aid. People who had broken their backs ought not to be moved, and fox hunters who had broken their legs, she remembered, were sometimes carried home on gates. She felt that she could not dare

to decide. Suppose his back were broken? How was she to find out without moving him? All the time, in another part of her mind, she was trying not to let it have happened.

They had told her not to, but she had insisted. She had let the game run away with her, not noticing that it was growing rougher; and now she was awake from the mad dream, with one of the beautiful People broken, perhaps killed. It came over her like doom.

The responsibility and distress were too much. She began running back to the lake, to get help. After a few yards, she feared that she might not remember exactly where. She went back to find him, knelt again, and touched him with her finger.

The touch cleared her head. Whether I am guilty or not, she thought, I must get him within reach of aid as quickly as I can. His leg ought to be set, but I could not do it daintily enough, nor could I make small splints, nor even, she added with a sob, make any. I must not sob, but I must carry him to the Repose without jerking him. If I keep my hand quite flat and steady, it will do for a gate.

The horror of lifting him to the palm of her hand and of straightening the leg as he groaned unconsciously, for he seemed to have concussion; the nightmare walk to the lake, like some dreadful egg-and-spoon race; the

paddling of the punt with one hand to the island; all these got through somehow.

There was nobody in the Temple.

She called, deathly white, but nobody would answer. She was sure he was dying. She found a large rhododendron leaf for a stretcher, and edged it under him. She made a mattress by folding her handkerchief and laid the stretcher on it, under the middle of the dome. 'He must be helped,' she said. 'You must come.'

The Schoolmaster did come, from one of the pillar doors, and pointed silently for her to go. She went, and as she disappeared the stretcher party came to carry off the murdered man. Half-way across the lake, she laid her paddle down to howl – then sculled away, looking exactly like a retrieving puppy which had eaten its pheasant instead of retrieving it.

11

THE Professor was busy with Camb. Univ. Lib. Ii. 4.26, and was stuck on the first leaf with 𝕿𝖗𝖎𝖕𝖍𝖆𝖗𝖎𝖚𝖒. He had looked it up in Lewis and Short, to no avail, and had also tried to verify it in a charter-hand manuscript called Trin. Coll. Camb. R. 14. 9 (884), where he had found 𝕿𝖗𝖎𝖚𝖒𝖕𝖍𝖆𝖗𝖎𝖔𝖓, partly scratched out. This had made confusion worse confounded.

He motioned the retrieving puppy to his soapbox absently, as it slunk into the cottage with its tail between its legs, and observed: 'It says 𝕴𝖇𝖚𝖏𝖚𝖘 𝕲𝖊𝖓𝖚𝖘 𝕿𝖗𝖎𝖕𝖍𝖆𝖗𝖎𝖚𝖒 𝕯𝖎𝖈𝖎𝖙𝖚𝖗, but the trouble is that a part of the line seems to have been erased.'

'I came about something terrible.'

'Murder?'

'It might be,' said the puppy, blushing all over.

'Whom have you murdered? The Vicar, I hope.

The word has evidently proved a stumbling-block to the other scribes, who either evade it by omitting the sentence, or make wild guesses, or, as in this case, resort to some erasure and to complete obscurity.

'He was an unpleasant man,' he added. 'I never liked him much.'

'It was a man from Lilliput that I have murdered.'

'Indeed! Just fancy! Tripartitum is a possibility, of course, but one hardly cares to divagate so widely from a lucid script.'

'The People are arranging never to see me again.'

'So long as they will arrange it themselves,' he said kindly. 'One has so many calls on one's time, so many little annoyances like this stupid *lapsus calami* I was telling you about. I suppose I shall have to write to Sir Sydney Cockerell or to Dr Basil Atkinson. Even perhaps to Mr G. C. Druce.'

'But you must help!'

'No,' he said firmly. 'I cannot spare the time. On any other day, my dear Maria, but not just now. What with Ambrose and Ctesias and Cnydian, one scarcely knows which way to turn.'

She pulled herself together, took away his manuscript, and put it on one of the bookshelves, upside-down. He winced to see this done.

'Do you know what I have been talking about?'

He took off his spectacles and looked at them painfully, with watery eyes. He did not know at all.

He said: 'I can remember every word. You were telling me that you had murdered the Vicar, and a good job too. How did you dispose of the body?'

She told her story carefully from the beginning, how she had ruined the whale hunt and bullied the People and probably killed the fisherman in her wretched bungee aeroplane.

'Dear me,' he said, when she had finished. 'But this is very inconvenient.'

He considered for some time, then went over to the bookshelf and turned his manuscript the right way up.

'You know,' he said, 'it could easily be some monkish mistake for Trivialis, a common species, except that they seem to have attached particular value to lions – the sentence refers to lions – owing to their association with the gospels. The maddening thing is that I have mislaid Du Cange.'

Maria burst into tears.

'Good heavens!' he exclaimed when he heard the noise. 'Whatever is the matter? My own Maria, anything but this! Allow me to lend you my handkerchief, a dishcloth, a towel, one of the sheets. Have a glass of cowslip wine. Have a sniff of some burned feathers, if I can find any. Have anything, Maria, but do not weep.'

'You won't think!'

'Think!' cried the Professor, bashing himself on the head with Lewis and Short, which looked as if it could weigh about ten pounds. 'Think! Great Powers of Pedantry assist me now!'

After a bit he sat down calmly beside her on the soapbox and waited for the sobs to subside.

'Would you object,' he asked humbly, 'to repeat the subject which we were just discussing?'

She repeated it with hiccups.

'I think we may depend upon it that the pilot was not killed. If he had broken his back or his neck, you would have noticed it when you moved him, by seeing that he was hinged in the wrong places. No, no. He has only broken his leg, and richly he deserved it. You should take him some fruit every now and then, with magazines to read in bed. We shall find that he recovers in no time.'

'I hope he will!'

'Even if he does, you will still be at loggerheads with Lilliput.'

'They sent me to Coventry!'

'Yes, I see. Now, Maria, you must try to look at this from their point of view. It is an exceedingly curious situation. You are a child, but very big; they are grown-up, but very small. Just imagine what you would feel, if you were a grown-up whose head was bothered with

the affairs of a family. Suppose you were off to catch the London train, with your umbrella well rolled, to see a solicitor about some mortgages, and just as you were getting near the station a little girl who was forty-eight feet high stepped over the hedge and carried you away to a distant field, in the wrong direction, where she put you down and told you to be a German, while she was being General Eisenhower. Think how exasperating it would be, as you heard the train puffing off without you.'

'But I only played with a few of them!'

'All the same, they could see the tendency of the position. If they had given in to you, they would never have been able to call their souls their own, and their economic life would have been upset in order to play at queens and subjects. However nice you were to them, it would have been intolerable.'

'I used to help them. I spent all my money buying chocolates and aeroplanes!'

'But they did not want the aeroplanes and they could not live on chocolates. They had a living to earn.'

'I suppose . . .'

'You see, Maria, this is a problem which has only once occurred before, and that was when the small man Gulliver was in the keeping of the huge girl Glumdalclitch, in the land of the Giants.'

'They got on very well.'

'Exactly. But it was because she did not paw him about. Don't you remember how disgusted he was with the other young ladies who tried to make him a plaything? He hated being mauled and messed, and he was grateful to Glumdalclitch because she only behaved as a loving attendant and helper. This is what you will have to do, if you want to make it up with Lilliput. You must never, never force them to do anything. You must be as polite to them as you are polite to any other person of your own size, and then, when they see your magnanimity in not exerting brute force, they will admire you, and give you love.

'I know it is difficult,' he added gently, 'because the trouble about loving things is that one wants to possess them. But you must keep hold of your emotions and always be guarding against meanness. It will be very difficult indeed.'

'The Schoolmaster pointed for me to go away. He meant I was not to come back.'

'I think you may go back once, if it is to apologize.'

'But I don't see why I should apologize! I was only trying to help them fly.'

'They asked you not to.'

An obstinate vanity made her stiffen.

'I have tried to help, and I never struck or forced a single one of them. I *won't* say I'm sorry.'

The Professor got up to fetch his manuscript, dismissing her from his mind.

'Very well, Maria. Certainly I am not going to force *you*. Meanwhile, if you will excuse me, there is this little matter of 𝕿𝖗𝖎𝖕𝖍𝖆𝖗𝖎𝖚𝖒 which I must elucidate as best I may.'

She could not get another word out of him, and went away in the sulks herself, feeling twice as guilty as before.

It took her two days to swallow the lecture which she had been given. Sometimes she protested to herself that she would rather die than apologize to a set of miserable hop-o'-my-thumbs. Sometimes she thought how disgusted the Professor must be feeling with her. Sometimes she swallowed a small piece of the lecture at a time, thinking that perhaps it *had* been a bit annoying for the People, but all the same they ought to have been more grateful. I could have killed the whole lot of them, she thought, if I had wanted to, merely by stamping my feet, and I could have told Miss Brown their secret. Yet they order me off my own land, and won't even speak!

After two days she had swallowed the lecture successfully – a meal of something nasty like cold porridge, taken with rests between the spoonfuls and finished in the end.

She sat down to write a straight and manful letter, in her smallest handwriting. It said:

Dear Sirs,

I am young but tall. You are old but short. I am sorry and will be better. I hope he is getting better.

<div style="text-align: right;">

Yours sincerely

with Tons of love

From Maria

</div>

Then she persuaded Cook to boil a large snail shell for her – there were some *Helix pomatia* in the park, which was very rare for Northamptonshire – and bored two small holes with a pin when it was clean, so that she could give it a handle of thread. This made it into a kind of shopping basket. She found a couple of wild strawberries in the Ridings, put them in the basket, and tore one of the middle pages out of Miss Brown's *Pilgrim's Progress*, which was all she could think of for a magazine. She folded her letter as small as she could, stamped it with a patch of paper like confetti, and set off for the lake.

When she reached the island, she found that the brambles had been woven across her path. She did not beat them down, but left the letter and the comforts for the invalid in one of the canoes.

For three nights Maria went with an aching heart, carrying her fruit and magazines, but on the third night the brambles rose of their own accord. There was the Schoolmaster waiting to welcome her with a beaming smile, and they flew into each other's arms.

THE People gradually recovered confidence as they saw that their child mountain intended to do her best, and the pilot began to get better, as the Professor had foretold. But Maria was careful from then on not to make favourites, and she never again mentioned the subject of indiarubber aeroplanes. She blushed to think of queens.

She used to visit them for an hour or two every midnight, because the days were devoted to Algebra and threatened by telescopes.

It was true that she felt sleepy in the mornings, and Cook said that she was beginning to look peaked; but Miss Brown did not notice anything, as she was busy puzzling about her plot with the Vicar.

Maria cast away dull care and enjoyed herself to the top of her bent. She loved stealing out at the dead of

night, with the dangerous journey past her tyrant's door. She loved the wonderful summer moonlight, silver and velvet black. Above all, she loved being with the old-fashioned People, and wondering at their minuscule Oeconomy.

One thing which she discovered was that it was a mistake for giants to choose small presents for dwarfs. The proper thing for a giant to do was to choose the largest present which a dwarf could possibly use, while the dwarf had to choose the smallest or finest thing which could be of use to the giant. The Professor, with his Hundreds and Thousands, had been astray. For instance, her most successful present – for she tried to take something with her every night – had been the saucepan with no handle. It had been just what they needed, a wonderful farm boiler, which would boil for a week at a time, and, though she had taken it shyly, for fear that they would be offended at the poverty of the gift, she had never been thanked so heartily for anything else. They said it was 'compleat.'

The People found this out as well.

Instead of using a ship's sail for the next presentation to Maria, they decided to make her a spider-web scarf. The silk was taken from the webs of the garden spider, the brown one with a white cross on its back, and it was treated with the juice of gorse blooms to get rid

of its stickiness, which also made it yellow. Then it was knitted in thin strips by a team of volunteers, for they had no looms, and the strips were finally sewn together. Maria was allowed to watch the process, and she had the satisfaction of seeing, in the course of it, one of the things which had interested Lemuel Gulliver. She saw a little woman threading an invisible needle with invisible thread.

It made a wonderful scarf, and the curious thing was that it was as strong as good linen, or stronger. It was resilient, like elastic, and she could stick her finger into it without breaking it, although she could see through. Many years later, she wore it as part of her wedding dress; but meanwhile she had to hide it under a floorboard in the Duchess's Powder Closet, for fear of Miss Brown.

She suddenly realized why, whenever she brought the Lilliputians a present, they tried to give her one. It was because they did not want to be possessed.

Another thing which she discovered was that the People lived a dangerous life, although they did not complain about it. In spite of the fact that there were no wars, they had other dangers. For instance, there had been a family of magpies some thirty moons before, who had taken a fancy to young Lilliputians, and had carried off a dozen babies before they had been mastered.

Magpies were wily, and had good memories; so, when two of them had been wounded with arrows, they had finally given it up.

The bows and arrows were interesting. The wood of our gigantic trees, when it was in twigs sufficiently thin for a Lilliputian bow, had not enough snap in it. So they used the spines from the pinion feathers of large birds, farm hens if they could get them, strung against the curve. The arrows had metal tips, forged from the nails in the cupola, but these were inclined to be soft.

By the way, the ancient Lilliputians were accustomed to use poisoned arrows. But in England they could not find the proper poisons – which had perhaps been fortunate for Maria. They did use the formic acid from bees; but they could not get enough strength on the tip of the arrow, although they boiled it down, for any work more formidable than killing insects.

When they raided hives for the poison, and for honey, which was important to them because they had no sugar, the raiders wore a kind of plate armour made from the wing cases of beetles. The scales were sewn into a mouse-skin foundation, overlapping; but of course they generally raided the nests in frosty weather, and used smoke.

Another danger was owls, worse than the danger of magpies. There were three main kinds of owl at

Malplaquet: the barn, the tawny, and the Lilford, who also hunted by day. Horned owls were rare, though they did come sometimes. These creatures were braver and less wily than the magpies, and they had never learned to keep away. Also, instead of merely pouncing like the crow tribe, they came down vertically like dive-bombers, and it was impossible to slay them. There was no time. Consequently the sentry on the cupola had to do night-watching for owls, and, when he spotted one, he rang a bell. Maria, when she found out about it, realized that she had heard the bell often. But there are such a lot of noises in the country, queer noises like donkeys braying and so on, that we neglectful humans do not properly attend to them. The bell made a deepish tonk-tonk-tonk, and Maria had always thought it was a carrion crow. When the bell was rung, the only hope was to stand still without looking up. If they moved, the owl saw them; if they looked up, it noticed their white faces under the moon. If they stood still, looking straight in front of them, it nearly always passed over.

In the daytime, when they were not so much about, there were kestrels. The procedure was the same for these.

As for the mainland trappers, their lives were in their hands. A fox was about as big as the National Gallery to them, and, as it could easily pounce across Trafalgar

Square, there was nothing to be done. The worst of it was that it could also smell. It was no good shooting at it with their poor arrows. It was no good hiding in the grass, or standing still, because it had a nose. Many ideas had been tried for dealing with foxes, ideas like making a loud noise or a nasty smell, but none of them had been successful. A famous trapper, three hundred moons before, had blinded a fox by shooting an arrow into each eye. Ordinary people could not be expected to have the nerve for that. The common reaction was to stand still and trust to luck, if surprised, but, above all, to keep a weather eye open, and particularly a nose, in case foxes should be about. Even a human, with nostrils as clumsy as two fireplaces, can usually smell a fox. The Lilliputians, with their fine noses, had better warning. Then they had to climb trees.

It was like living in a world full of dinosaurs and pterodactyls, or even bigger creatures, and they had to keep their wits about them.

A result of this, which biologists will understand – and if you are not a biologist nobody cares a fig for you – was that the ladies of Lilliput had begun to have twins. They often had triplets, and were delighted when they did.

Maria wished that she could help them in these dangers.

If she had been rich or grown-up or any of the other things which seem so desirable until one gets them, she could have bought a shotgun to shoot the owls, and could have cleared them out like that. Unfortunately, she was not. She did, however, make sensible suggestions. She said that, if they would show her the fox earths all over the Park, she would put tar in them at the next breeding season, or anything else that was unpleasant, whatever the Master of the Malplaquet Hounds might think. She said that with their local knowledge, and her bigness, there were probably several things which could be done. 'For instance,' said she, 'I can get some petrol from the stove and put it on the wasps' nests, if you will show me where they are. I could even smash up the nests of owls, once you had spotted them.'

The People of the Island were grateful for her kind thoughts, and decided that she was not a bad Mountain after all.

One pearly night towards the beginning of July, with the owls hooting and the twigs cracking and the paw-feet rustling and the great moon reigning over all, Maria crept up the silver stairs to bed. She passed the door of the square eighteenth-century chapel, where the plaster cherubs with fat cheeks like amoretti looked down from the flaking roof between the Royal Arms and the Ten Commandments; passed the much more than full-

length portrait of the Fifth Duke, by Romney, which was unsaleable because it covered half an acre of canvas, and also the water colour of Naples with Vesuvius by Moonlight, equally unsaleable because it was fifteen feet long, the biggest water colour in the world; passed the cold busts of the Main Library, not the Third Duke's, where Sophocles and others looked down with beards like twisted tripe upon the empty shelves which had once housed the Malplaquetian MSS.; passed, with a special tremor, the lofty bedroom in which the Empress Amelia had breathed her last, and also the Duchess's Chamber, where her own ancestors had been brought into the world, in the presence of twelve doctors and any members of the Privy Council who had happened to be disengaged.

Maria was an educated person, and for her the Palace was full of ghosts. She knew where the Wicked Marquis had condemned the two young poachers to death; where the Mad Earl had played the violin at midnight, to Lola Montez and the King of Bavaria; where the Impetuous Viscount had blown off his whiskers with a six-shooter, on discovering that he had sold his Honour to the Jews; and where the nasty little Honourable had lighted his Nannie, to see if she would burn.

She turned up the last corridor and opened the door.

'Good evening!' said Miss Brown smoothly, sitting on the bed. 'So here is our little vagrom, returned from her clandestine tour.'

'Yes, Miss Brown.'

'And what has tempted her to brave the inclement airs of night? What horns of elfland, if one may so express oneself, have summoned the tender cheek to leave its downy pillow? Eh, Maria?'

Miss Brown moved her hand on purpose, and there was the painful ruler which was used at Algebra.

'I went for a walk.'

'The midnight ramble. Yes, indeed. The moonlit constitutional, to coin a phrase. And why this promenade among Diana's minions?'

'I wanted to go out.'

'Exactly. So explicit. And yet, to some ideas, the time would scarcely seem conventional?'

'It was the moon.'

'The Moon! How true! How sweet the moonlight sleeps upon this bank, et cetera.

'And these,' added Miss Brown, opening the other hand to show the spider scarf and the handkerchief and the other presents, which she had discovered by tracking her pupil to their hiding place, 'and these delicious trifles, fairy fragments as one might designate them if devoted to the Essay Form, are these

as well, Maria, nothing but moonshine and Titania's dreams?'

There was nothing to be said.

'Where did you get them?'

'I got them.'

'She got them! Lucid explanation! Where?'

"I won't say.'

'Will not say. The elision is so vulgar, is it not? She will not say. And yet, suppose she is made to say, you ask?'

Maria said distinctly, with some surprise at finding that she was speaking the truth: 'The more you hurt me, the less you'll hear.'

'Indeed?'

'Yes.'

This put the Governess off her stride. One of the best ways to deal with tyrants is to tell them the truth, and to face them, and to let them see how much you hate them plainly, so long as you can make them understand that you will hurt them if you can. It frightens them away.

Miss Brown gnawed her fingers. 'The child's recalcitrant,' she said complainingly. 'Ungrateful . . .'

And, with a sudden swish like a cobra's, which made Maria duck, she was out of the door. She slammed the same triumphantly, and turned the key.

Five minutes afterwards, however, she changed her mind; for Maria was surprised to hear the key turned back again quietly, and to know that she was at liberty after all. Why?

13

NEXT morning was bright and breezy, and there were two expeditions from the ruined palace, in the hours which ought to have been devoted to Irregular Verbs. Miss Brown made an expedition to the Vicarage, while Maria seized the opportunity to visit the Professor.

She found him searching mournfully for his set of Du Cange – which is a dictionary of Medieval Latin, in case you don't know – but this was an almost hopeless task in the chaos to which he had reduced his cottage. There were books in the shelves, which had been filled some fifty years before. Nearly all the floor, except the part around the tea chest on which he used to sit, was taken up by piles and piles of mildewed volumes. Also, alas, as he had been verifying quotations and things of that sort since the turn of the century, and as he was one of those unfortunate people who leave the book open at

the quotation in some accessible place, all the window-ledges, oven-shelves, mantelpieces, fenders, and other flat surfaces were stocked with verified quotations, which had long been forgotten. He had left a narrow path to each door. But the steps of the stairs had proved to be tempting flat surfaces, so it was difficult for the poor old fellow to climb to bed, and the bed itself would have been denied to him – except that it was fortunately a double one, and he was able to squeeze in somehow between Gesner and the eleven tomes of Aldrovandus, counting the extra one on Monsters.

The Professor was crawling about on hands and knees, trying to read the names of the bottom books sideways, without disturbing the piles. He was sick of erudition and only too glad to listen to Maria.

She told him how Miss Brown had found the artifacts of Lilliput, perhaps by tracking her to the Duchess's Powder Closet, with the magnifying-glass, and how she herself had refused to tell where she got them. He was interested.

'Well, now, my dear child,' said he, sitting down absentmindedly on a stack of books, which happened to be the missing set of Du Cange, 'have you ever noticed that when something unusual turns up, you are immediately confronted with a moral problem? For instance, if you were to find yourself in the unusual

position of Alice in Wonderland, who was able to make herself large or small at will, nothing would be easier than to rob the Bank of England. You would simply have to go in small, say about the size of a pin, and come out extra large, through the skylight or somewhere, with a few million pounds in your pockets. Moral problem: shall I become a burglar? Or if you found yourself in the unusual position of the Invisible Man, by my young friend Mr Wells, nothing would be easier than to introduce yourself into the boudoirs of your acquaintances, in order to earn a handsome competence by discovering their secrets. Moral problem: shall I become a blackmailer? Now it is certainly unusual to discover a colony of people six inches high, and so you were immediately confronted with your moral problem, about being their Queen. Shall I interfere with Lilliput's proper freedom and become a tyrant? But, dear me, Maria, this is becoming a lecture. I fear I bore?'

'Not at all,' she said. 'It's quite fun.'

'So now we have your governess on the track of the unusual, with her own moral problem straight ahead of her. How will she solve it?'

'Solve what?'

'About interfering.'

'If Miss Brown can interfere,' said Maria bitterly, 'she will.'

'How?'

'I suppose she will just forbid them or something.'

'Much worse.'

She looked at him anxiously.

'She will sell them,' he said.

'But, oh, she couldn't! They are real! They are People! She couldn't sell them like . . . like hens!'

'Nothing is more likely. Don't you see that they are tremendously valuable? Any big circus would pay thousands and thousands of pounds to get them, perhaps millions. They are the only things of their kind in the world.'

'But . . . But . . . She couldn't. It would be too too beastly. It would be . . . it would be *slaves*.'

'So now you know, Maria, why they did not want to give away their secret.'

'I'll never tell her. She can kill me first, but I wouldn't tell. The beast!'

'Dear me. Yes. But the question is, my dear young lady, whether she would have a right to sell your Lilliputians after all? Just let me think.'

He tottered off to one of the bookshelves, where he had just noticed some brown volumes which might have been Du Cange, but which were not, then wandered back refreshed.

'You see, Maria, the whole situation is wrapped in such unusualness that it is difficult to consider it clearly. For instance, are these creatures human or not? What is the legal definition of a human being? Does he cease to be human when he is six inches high? If they are human, presumably it would be illegal for your guardians to sell them, as there are laws in England against slavery. But again, if they are human, what is their nationality? Should they accredit an Ambassador to represent their interests at St James's? Will they be regarded as British Subjects By Birth, and as being Domiciled in England for the Purposes of Income Tax? Certainly the latter, if what I hear about the Inland Revenue is true. And then, on the other hand, if they are not human, are we to regard them as *ferae naturae*, wild animals which become the property of the land-lord? If so, you are the landlord, but, as you are a minor, Miss Brown and the Vicar could sell them on your behalf.'

'I don't know what they are,' she said sadly.

'Whatever they are, they only have four hundred sprugs in gold. It seems inevitable that if they are to escape being sold, once your governess has found them, they will have to go to law about themselves, and four hundred sprugs, Maria, is not enough. They could never brief a reliable counsel with such a sum, and, under the

due forms of suit and countersuit, I fear that they would be liable to get the thin end of the Law.'

'We won't let her find them then.'

'Last but not least,' said the Professor with a deep sigh, 'here we are talking about their future as if it depended on us. But they are reasonable and civilized beings who must decide their future for themselves. I blame myself for this. I am becoming a barbarian. I must not.'

He patted one of the nearest folios secretly, to cure himself of barbarism, and looked at Maria over the top of his spectacles.

'Personally, I have found that the best way to deal with a dangerous situation is to face it, and to make it happen, and to go through with it, rather than to keep it hanging over one's head. If I were a Lilliputian, I believe that I would prefer to be discovered, and go to law, and to bring the matter into the daylight of some kind of certainty, rather than to creep about in dangerous hiding, under the shadow of discovery.'

'You said they wouldn't get fair law.'

'It is what I fear.'

'Why,' said Maria, 'can't we just prevent Miss Brown from finding them at all?'

'The question is, whether you can. Children are under dreadful disadvantages compared with their elders. If your governess made up her mind to discover where you

got your sprug and the other things, she could nag for weeks on end, she could send you to bed without any supper, she could keep you on bread and water or tog you out in football boots, and I dare say that a person of her calibre might do worse.'

Maria's heart sank at the thought of what Miss Brown might really do. She knew that she was perfectly capable of beating her, and her womanly little heart shrank from the prospect, not only because of the agonizing pain but also because of the humiliation and beastliness. For a few dreadful moments she saw herself as she was, and doubted whether it would be possible to keep even the most important secret under such conditions. However, she said bravely:

'I don't mind if she does.'

'You may think you would not mind, but suppose she kept it up for months?'

They went on debating the problem for more than an hour, without making it much clearer, until it was time for the Conquistador of Lilliput to go home.

Incidentally, talking of Conquistadors the Professor got mixed in a digression towards the end, and insisted that she should take away two books about Conquest by Prescott. He said that they would show her what human beings were liable to do with newly discovered Peoples, when they happened to be valuable.

Meanwhile, in the Vicarage, a different kind of discussion had been going on.

The hold which Miss Brown had over Mr Hater was this. She was a very distant relative of Maria's, and was the only living one. You remember about the missing parchment concerning the inheritance of Malplaquet. The Vicar believed that if it could be found, and altered slightly, a vast sum of money which ought to have been Maria's could be gained for Miss Brown, by means of a suit of *mort d'ancestre*.

This was why he always wandered so much about the palace, looking for hiding places. Had he been able to find the parchment, and to do the necessary forgery, he would have married Miss Brown for her money, although they hated each other. They would have been bound together by the crime. His knowledge and her name were needed to bring it about.

You may think that Vicars are not usually forgers, and sometimes indeed they are not; but the heart of man is a strange mechanism, my dear Amaryllis, and it is astonishing what even Vicars can bring themselves to believe, so long as it is in their own interest. Somehow or other, by strange and crooked bypaths of special pleading, Mr Hater had convinced himself that there would be nothing wrong in altering the ancient title deed, if he could find it. For one thing, he had worked hard,

searching about like a sulky old vulture in the British Museum and the Public Record Office, to discover the existence of the deed, and Maria had not worked at all. In any case he was that kind of person. There are people who will just doggedly avert their minds from wrong-doing, and do it.

The Vicar was like this, and it did not make him preach any less cruelly, about darksome sins, in his shoddy little church on Sundays.

So the conversation in the Vicarage that sunny and windy morning was not about Lilliput. Neither of them was cultured enough to associate sprugs with Gulliver, nor to draw any conclusion from the name of Lilliput which was stitched upon the handkerchief. They had not enough imagination to believe in six-inch people. If you had mentioned *Gulliver's Travels* to them, they would have said: 'Oh, that's a children's book, isn't it?' They had a few instincts about money, and about appearing respectable, but for many and many years they had not had any thoughts on real ideas at all.

They had decided that Maria's three treasures, the sprug, the eighteenth-century handkerchief, and the silk scarf of such fineness as to be obviously of value, must have been found in some secret robing-room of the by-gone Dukes. They thought that the sprug was a sequin from a Duchess's evening dress. Their sagging

cheeks were shaking with greed, when they realized that if Maria had really discovered a secret strongroom full of valuables, then probably their missing parchment would be in it.

Usually they were mumchance villains, but the excitement about the discovery made them chatter.

'Such a difficult child,' deplored Miss Brown, 'obstinate and untrustworthy. She refused to say where she had found them, Mr Hater, in so many words, though I thought it wiser not to make a fuss. Punishment would have only made her still more obstinate.'

'But why should she refuse?'

'Out of naughtiness.'

'This is ridiculous, Miss Brown. We have a right to know of assets at Malplaquet, as a matter of business, as the child's guardians. How can we administer the estate with the extent of it concealed? You must talk to Maria at once, and bring her to reason. You are her governess. Surely you ought to have her under better control than that? You must talk to her seriously, this very afternoon.'

'I will indeed.'

The Vicar looked away and mumbled to the gothic mantelpiece:

'We must think how much depends upon it.'

14

'COME here.'

Maria went and stood in front of Miss Brown awkwardly, looking at the hard rings sunk in the fat fingers on the spreading lap.

'I have decided to overlook your conduct last night.'

She said nothing. It was never possible to tell whether her governess was going to be cruel or kind, for her face wore the same quelling look in either case. She waited to see where the catch was.

'I have been talking to the Vicar about the hidden strong-room which you have discovered.'

This was Greek.

'You know, of course, for I have told you dozens of times, that you spring from a long line of wasters, who only considered their own pleasures, and who thought nothing of going bankrupt, to the ruin of poor tradesmen who had trusted them.'

'My great-grandfather,' said Maria proudly, 'was the Prime Minister of England.'

'I'll thank you not to answer back. You know that Malplaquet has been ruined by your ancestors, and that you yourself are practically supported out of Mr Hater's pocket, a charity brat.'

This was untrue, for the Vicar drew a salary as guardian, and was also stealing most of the money which ought to have been paid into the estate, against Maria's coming-of-age. That was why he had the Rolls-Royce.

'I thought the debts were being paid.'

'So they should be. Would they not be paid the quicker if the ill-gotten gains of your forebears could be brought from this secret chamber which you try to hide from us?

'There was the Coronation coronet,' pursued Miss Brown cunningly, peeping shrewdly at her victim through slit eyes, to see if there was a reaction, 'which went astray in 1797, with the black pearls in it. There was the insignia of the Garter which were never returned to the Sovereign, and the diamond-hilted sword presented to the Second Duke by Catherine the Great. Where are these?'

Maria began to be filled with unholy joy for Lilliput, as she partly understood how far her governess was going astray.

'I don't know anything about a secret chamber.'

'There would be papers in it too, parchments, deeds, which you are too young to understand. You could be sent to prison for keeping such things back.'

'Children don't get sent to prison.'

'Hold your tongue, Maria. Be careful what you say.'

'But I tell you I haven't found a secret chamber.'

Miss Brown searched out her pupil's eyes and fixed them with her own. She had a pleasant trick of staring Maria down, which is not so difficult to do when a child expects to be punished.

'Very well,' she said at last, 'you shall go straight to bed this minute, without your supper, and there you can think it over by yourself.'

It was horrible to be sent to bed on a summer afternoon, when all the park was calling her to be out-of-doors, but she made the best of it. There was the wonder and glory of Lilliput to think about nowadays, and that made up for much.

If only one were rich enough to own a grouse moor, thought she to distract herself in the dreary bedroom, it would be much more suitable for the People. The stems of heather would be natural trees to them – for heather is more like a gnarled and stunted tree than anything I know, a coniferous, not a deciduous one – and there they could live in their small forest, with proper glades, and

bog holes for lakes, and all the tiny mushroom things which you can see, if you lie on your face. There would be millions of insects to hunt in the summer, and they could build themselves real towns, and it would be to scale.

The trouble would be, she thought, that it would be impossible to protect them. The moment they were found out, on their moor, all the big humans would try to catch them, for circuses and so on, just like Captain Biddel and Miss Brown.

On a moor, you see, it would be impossible to keep them hidden. Somebody would find them, walking across it, and then the game would be up.

Even if you put a fence round it, with enormous walls, this would only make people more inquisitive than ever. You would get twice as many trespassers, trying to find out what it was about.

And if you paid an army of guards to stand round the boundary with tommy guns – well then, the trespassers would get half mad with inquisitiveness, and so would the guards for that matter, and the whole thing would be discovered at once.

What you want, she thought hungrily, for tea-time was past, is some island off the west coast of Scotland or of Ireland, some uninhabited island with a watch-tower, so that if anybody approached in a canoe the People

could hide. It would have to be a heather island. It does seem a shame that even on that you could not give them proper houses on the surface. They would still have to live underground, for fear of visitors. I wonder if you could make houses that would sink into the ground when you turned a handle, like a bucket in a well?

If I were rich, I would buy some island like that, and we would live there safely with ourselves. But what about when I died? I suppose I should have to tell my eldest daughter when she was twenty-one, like the Secret of Glamis. But suppose she turned out to be a pig like Miss Brown? The best thing would be to buy a large model submarine, like the liners which the shipping companies put in their London windows, and the People could always sail away in search of Lilliput, if they wanted to go. It would be a terrible dangerous voyage . . .

No, I would not. If I were really rich I would buy some big, shallow loch in Scotland or in Ireland, so long as it had plenty of tiny islands. I mean tiny. As soon as an island is as big as an acre, the humans take an interest, and try to make some money out of it, with a sheep or something. But there must be millions of islands in lochs and in Clew Bay and in places like that, which are not so big as a tennis court, or even smaller. They would be useless to humans. I dare say there are islands in Lough Con which no human being has set foot on for a

hundred years, simply because they are too small to pay. Well then, I would buy this loch with the uninteresting islands in it – they would need to have heather – and, do you know, I would not try to keep it a secret at all? I would buy dolls' houses and toy trains and Japanese plants and all that, quite openly, and I would then set them up on my islands. I would even have a public day, Friday, when anybody could visit them on paying a shilling to the Red Cross. I would get people to think: There is that funny old Miss Maria, whose hobby it is to make sort of Japanese gardens in her loch. And all the time the People would be living there safe. It would have to be a big enough loch to give them proper warning, so that, when the boat set out from the banks, they would have time to hide themselves in the main raid-shelter. They would be warned from the watchtowers. And, of course, they would have to keep an extra lookout on Fridays.

Everything would have to be hidden. They could leave the houses and gardens standing, or anything which I might be supposed to have made myself, but no slops or half-cold cups of tea or tell-tale details of that sort.

We should have to hold raid drills.

When I came out by myself, they would still have to hide, until I blew a certain whistle. We should have to be strict about it. If I ever found a fire burning or a bed

141

rumpled, I should call the magistrate at once, and show him the evidence. Then the culprit would have to be punished, really punished, not to punish him, of course, but to prevent it happening again.

The trouble about punishments, she thought, is that people enjoy giving them. We should have to stop that sort of thing in our islands. I think we would hurt the culprits on their feet, like in China. Nobody feels shy about their feet. And we would not have executioners at all, but it would be done by a machine. All the punishments for all the mistakes would be invariable, just as fire burns when you put your finger in it, and everybody would know what they were.

Well then, I would show the rumpled bed to the magistrate (but I must be careful not to be the queen), and he would show it to the lady who had made the mistake, and she would say, 'Oh, dear me, I forgot', and he would look it up in the Retribution Book and say, 'It says three turns of the machine on the soles of your feet', and she would say, 'Drat!' I think we would have the machine in a room by itself, so that the criminal could go in without anybody to see, and put her feet into the holes, and press the button for herself. I dare say there would be nervous ladies who would prefer to have an executioner, and there would be a public service to supply one, if asked. I can imagine sympathetic executioners

earning quite high fees. 'Oh, Mr Globgruff, I do *hope* you will be able to see me through my execution tomorrow. I always tell my husband there is *no* executioner in Lilliput with a machineside manner like yours.'

And what about murders?

Well, no doubt the People have their own rules about that, and I would not like to interfere with them. But if they did ask me, considered Maria hopefully, I would advise them to keep a special island for murderers. There would be nothing nasty about it: It would be quite as comfortable as any of the others; but everybody on it would just be a murderer. We would tell them: 'We don't want to make you unhappy, but we others cannot trust you any more, so you must live with the dangerous people. If you murder each other, it can't be helped, there it is; but you must keep away from us.'

And we would take away any babies they had, to be brought up on the sensible islands. That would be the worst of it for them, poor dears.

There would be Murder Island and Swindlers Island – what a hard time they would have, swindling each other – and Cruel Island, for people like Miss Brown. All the others would be Happy Islands, and we would only give weapons to the people on them, for fear of wars ...

'But oh,' cried Maria dolefully, out loud, 'I do feel hungry, however much I think!'

15

THE reason why Maria felt peckish just then was because honest old Cook had come hobbling up the stairs with Captain, carrying a bowl of soup with which she hoped to relieve the siege; so that the smell of soup came through the door. But Miss Brown had evidently been lying in wait, for there was a sudden scurry in the passage outside. There was the sound of a door banging, and then Maria could hear poor Cook being given notice on the spot.

'Without a character!' screamed Miss Brown down the corridor.

'Any character of yours, Mum,' said Cook superbly, 'is what I'd not besmirch my own possession of which with the application of.'

The door shut again more gently, the footsteps died away, but the smell of soup remained.

It was growing dark in the shabby little bedroom. The evening breeze had dropped to nothing and all the summery trees on the park stood silent, without moving a leaf. The twilight hush had impressed the birds and beasts. You could hear a rabbit nibbling twenty yards away. The distant coots on the lake gabbled in undertones.

Maria spotted patterns in the darkling wallpapers, drummed on the counterpane, practised whistling, pulled feathers out of the bolster, and listened to the sleepy birds outside the window.

I shall have steamboats, she thought, to ply between the islands: the kind you can buy in toy shops, which are worked by methylated spirits.

One of the islands is sure to have gulls on it, those black-headed gulls who breed on islands in big lakes and murder each other's children. It will be unsafe to use that island for the People, at least during the breeding season, for I am sure no black-headed gull would think twice about snapping up a Lilliputian, considering how they treat their own nephews and nieces.

On the other hand it might not be a bad idea to play a joke on those same birds.

At the time of the year when they were not breeding, we would go to Gull Island in force, and set about a bit of engineering. We would dig shallow pans among

the pebbles all over the strand, like saucers, or like the depressions which are made by the ant lion, and we should put a trap-door at the bottom of each saucer in the earth. Each trap-door would lead into a narrow passage, and the passages would communicate with a central chamber underground, in which I would probably bury a large earthenware crock for isinglass. Then, when the next breeding season was due to come round, a picked gang of Lilliputians would set off for the tunnels of Gull Island, with their necessary provisions, and there they would live like puffins, underground, for the whole season. Every time a gull laid an egg, it would of course roll into the bottom of the saucer, and the gull would sit down on top. This would ring a bell – we should have to put in electric batteries, and one of those indicators which the Master of the Malplaquet Hounds has in his kitchen – and two of the People would immediately run down the corridor, open the trapdoor, and let the egg fall through to the cellarage, where it would be wheeled off to the isinglass for storage. After a bit the ridiculous gull would sit up, look between its legs, say, 'Goodness me, I thought I was sitting on an egg', and settle down to lay another. By this means we would not only be able to keep down the number of black-heads, but we would be able to provide egg powder for Lilliput.

We would need a factory for dehydrating the eggs, or

whatever it is called, because one egg would be enough to feed a family for a week, and thus it would not be an economical size to cook. But if we turned the eggs into powder, the stuff could be used in small quantities, about the size of a salt spoon, and this would be a blessing in the kitchens . . .

Or else, thought Maria, beginning to yawn, we could hatch them out in incubators and eat them as day-old chicks, or we could ring the parents from underneath for the purposes of Research, or we could train the young ones up for seaplanes . . .

Soon she was far away in a sky of dreams, where jet-propelled white seaplanes folded their wings on landing, or stretched them at an angle of incidence of forty-five degrees, when they wanted to take off. It was because she had been short of sleep for the last few weeks. Her hands were together under her cheek; her dark pig-tails strayed on the pillow; the mysterious shadows under her eyelashes were quiet gates into a secret world where things went on which nobody could fathom.

Just before she dozed away, she thought she could hear, half in her dreams, that Miss Brown and the Vicar were talking on the terrace.

She woke in the dark, feeling wide awake at once. She was healthy and happy and alive, and a most delightful thing was happening.

Like a spider on the end of its thread, a six-inch man was dangling lower and lower from the gutter outside the window, in the moonlight.

The fact is that if there are five hundred pairs of bright eyes all around your pleasure ground, fixed steadily on you from under clumps of dock leaves and thistles – if there are five hundred pairs of ears like tiny shells, straining to hear behind the green blackberries and wild parsley – well then, if you will walk about on the terrace telling the Vicar that Maria has been sent to bed without her supper, this development is liable to be discussed in the metropolis of Lilliput before long.

So it had been, and the little People were not the kind who left their friends to suffer. Arrangements had immediately been started. Ropes from the frigate had been spliced together, transport had been organized, and the other needs of the moment had been put in hand. By ten o'clock they had started the journey, and had come to the South Front an hour before Miss Brown went to bed. They knew which the two inhabited bedrooms were, from seeing the windows lit of an evening.

A well-known steeple-jack, who generally did the outside repairs of the Temple of Repose, had gone up inside the nearest drainpipe, using it as mountain climbers use a chimney. That is to say, he had put his back against one wall of the pipe and his feet against

the other, and had walked up slowly like that, in a sitting position, by pressing his back against the walls. His rope had been too short for the immense length of the pipe – he could not have carried enough – and so he had been followed by a second climber, with a second rope, who had spliced the two together when he was half-way up. Then the top climber, who was by now on the roof gutter, had drawn up certain other tackle that was needed. The second climber had joined him to help.

They had thrown down the long rope outside the drainpipe, and willing hands below had been ready to tie it to a stake which they had driven on the edge of the lawn. Now there had been a thread of plaited horsehair stretching from the gutter to the grass. The next thing had been to pass this through a metal loop, forged from a nail, and to tie a second rope to the loop. This had made two long ropes, the fixed one, which was to act like the overhead wire of a rope railway, and the other, which could pull the metal loop up or down on it. It was a bit like a funicular.

When this had been arranged, and Miss Brown was known to be snoring, the steeple-jack had begun to let himself down on a short cord to Maria's window sill.

She opened it stealthily.

'I am so glad to see you!'

He said in a low voice: 'Tie the End of this to your Table, Ma'am, or somewhere inside the Room. Speak softly, or we shall be smoak'd. We have a Pulley at the Top. Do you desire to see the Schoolmaster?'

'Yes!'

'In one Minute, then.'

And he vanished like a tiny monkey, leaving her to fasten the bottom end.

The next thing to arrive was the Schoolmaster, in a breeches apparatus.

He whispered: 'Good Evening, Miss.'

'Good evening, Sir,' she said, in heartfelt tones. 'Your Honour, Mister! You are the best thing I have seen today, and don't I mean it!'

'Your Servant, Miss. Allow me to present the Victuals.'

And there they were, coming down on the pulley: three roast oxen, two barrels of elderberry wine, four dozen loaves of grass-seed bread.

She said: 'Oh, dear!'

She could have squashed him flat.

It was a regular deputation. Apart from the roast bullocks and other blessings, there was the Schoolmaster and the Admiral and the steeple-jack and an aged town councillor, carrying an illuminated address, all of whom had come to visit her on the principle that invalids and

captives needed to be cheered up. They told her that it was past Midnight already. Then, while she consumed the dinner on her face towel, which she spread on the window sill for a tablecloth, they watched her gobble it up.

'I shall eat you out of everything,' she said with a blush.

'We were sent to convey an Address of Gratitude, Miss, for your Constancy in shielding the People, which has been subscrib'd by the entire Borough of Lilliput in Exile.'

'And by the Navy,' said the Admiral firmly.

'It is me that gets shielded,' she said, overcome with shyness as the address was presented. 'At least we are in a horrid muddle. I have such a lot to tell you. I can't help talking with my mouth full. And please excuse me if I read.'

While she was reading, they looked about politely – more politely than she had looked about the island. Her room was as strange to them as the island had been to her, but they tried not to stare.

The Address was written in black-thorn ink on a prepared vole-skin parchment, as thin as India paper, and it explained how present and future Generations were to know that the Female Mountain had kept her Word to the People through Famine and Incarcerations,

etc, etc. It was a splendid testimonial to have, and, as she did not know how to thank them for it, she folded it up and placed it tenderly over her heart (in her pyjama pocket). Then she went on eating.

She said, when she had finished: 'Thank Lilliput for my good dinner.'

'Your Servants, Miss.'

She noticed that they were no longer calling her 'Y'r Honour', but 'Miss', which was the proper eighteenth-century address for girls, and this made her feel pleased. She did not know why.

'Don't go away. Wouldn't you like to see my things? I have not much to show.'

They admired the texture of the sheets, because they had no looms of their own, and gazed over the vast expanse of polished oilcloth with respect. Miss Brown was too mean to let her have a carpet, so there was nothing except this wintry oilcloth, and one cheap woollen mat. The furniture, as we know, was cast iron.

Maria did the honours as well as she could. She found that they were more amused by the looking glass on the dressing-table than by anything else. She tilted this backwards till it lay level, and they stood on it, admiring themselves upside down. The Admiral did a hornpipe, fascinated by his toes.

Afterwards it was time to tell them the whole story of how the sprug had been discovered, of the Professor's views about Law and Slavery, and of Miss Brown's wild-goose chase after the secret room. The Schoolmaster did not seem so pleased as she expected when he heard of the false trail. He, like the Professor, saw at once that the safety of the People now depended on the endurance of one young girl, and, though he did not like to tell her so, he was beginning to think that his countrymen had better migrate while there was still time to do so, and without revealing their destination even to Maria. All he said, however, was that he would have to think things over.

When it was time to part, they kissed the tip of her little finger in turn. The town councillor was put in the breeches apparatus to go first, and all were bowing, smiling, or waving good-bye – when the thunderbolt fell.

The key turned in the lock with a sudden click, the door slammed open on its hinges, and there, in the doorway, stood Miss Brown with a candle, in her flannel night-dress.

Everything began to happen so quickly that the scene seemed to go slow. There was Miss Brown, who had heard talking, first ready to be angry; then amazed and not believing what she saw; then, for the briefest

moment, half impressed, half wondering whether she ought to be polite to visitors; then guessing, then realizing, then seeing plain the opportunity to catch some of them, to appropriate them to herself, to make her fortune. And at the same time there was Maria crying 'Escape!' and there was the deputation tumbling over itself to be gone, the old councillor being bundled into the breeches apparatus and the Admiral drawing his new sword, forged from one of the Woolworth pins, to defend the bridgehead like Horatius.

Miss Brown ran to grab them. She got a dig with the pin which went through her finger. (The good sword stood a hair's-breadth out behind the Tuscan's hand.) It stopped her for a second (she reeled and on the mantelpiece she leaned one breathing space, then, like a wild cat mad with wounds, sprang at the Admiral's face.) She got hold of him by one leg, but Maria charged at the same instant and bit another finger till she felt the flesh turn on the bone. There was a scrimmage free-for-all, with the breeches apparatus going up twice. There was the Admiral climbing hand over hand. There was Maria thrown panting into a corner, like the oak on Mount Avernus. And finally there was Miss Brown left triumphant, with the Schoolmaster in her podgy fist, nearly squeezing the life out of him.

16

THE most famous of the trappers was called Gradgnag. He was a wiry man with grey hair and a taciturn disposition, who seldom spoke to anybody, but could call birds by note. For many moons he had been planning the longest of his treks. He was a kind of Allan Quatermain, and now he had reached the hinterland of a continent, which he had been exploring all his life. It was King Solomon's Mines to him, for the legends of Lilliput in Exile talked of a mysterious house, beyond the vasty borders of the Park itself, from which there could be got a wondrous breed of piebald mice. The skins were of fabulous value, for only one existed on the Island of Repose, and that was used as part of the communal regalia. It was said that this skin had been taken, three hundred moons before, by the legendary trapper who had blinded the fox and passed into history

as the greatest of his trade. Blambrangrill had been his name: a dreamer of strange horizons and of epic deeds; and Gradgnag, although he never talked, had caught the dream.

The arrangements for the trek had taken many days. He always travelled light and alone, living on the country, but it had seemed wiser to arrange for caches as an emergency store, spaced out at intervals of four hours' march. He was a methodical man. Then there had been the scouting for direction, which had extended not only over days but over moons, because, although the mouse-house was fabled to lie some way beyond the western boundary wall, the compass bearing was not fixed. On many and many an expedition he had climbed that monstrous wall by cunning footholds, to stare out with his pale blue eyes across the Great Unknown. He had added one fact to another. He had read the archives relating to Blambrangrill, including the bloody parchment with crosses on it which had been found beside his mummified body in a crevice of that very wall, where he had crept to die of his wounds, while the cat waited outside.

Now Gradgnag himself was there. He had crossed the wall, the ditch, the giant road shining like malachite. He had seen horseless coaches, one hundred and twenty feet high, thundering past with the noise of

stampeding elephants; gargantuan men innumerable, like trees walking; dogs thirty feet tall. He had hidden and scouted and pondered over tracks. By day he had sat philosophically at his minute fire, cooking rashers of rat. Now he had found the Eldorado. He was at the House itself. He was tucked up comfortably in his sleeping-bag on a branch of Virginia creeper on its wall, beside a pointed window, and six piebald mouse-skins were his pillow.

It was the Vicarage.

Thirty years before our story, in the time of the previous incumbent, this inconvenient mid-Victorian house had been full of happy people. Then no wheezing disapprover had hummed along its red-tiled corridors, but a merry old hunting parson had bustled to send port wine and jellies to anybody who had the faintest stomach-ache in all his parish. Then about a dozen tumbling children, covered with mud from head to foot, had pursued in it the numberless delights of childhood. The eldest son had been a falconer, the second a stamp collector, the third a tramping botanist, the fourth had owned a puppet show, the fifth had been a carpenter, and the sixth, a very young one, had kept white mice.

Even now, in the attics which Mr Hater never visited, there was a jumble of dusty fishing-rods and of stage props and of cabinets with well-set butterflies and of

falcon's hoods, and heap on heap of shredded paper, which the mice – the once white mice who had escaped and mated with the grey ones – had used for generation after generation in their nests.

Gradgnag's sleeping-bag was outside the study window. By craning his head, he could see Mr Hater, and the room in which he sat.

The study was a gloomy place with wallpaper the colour of mildew, and one small window, imitation Gothic, in the thick wall. The Vicar's hood, gown, and surplice hung on the door under his scout's hat, which he wore when he took the choirboys to their holiday camp in the summer, at a featureless and wind-swept beach on the East Coast. On the wall beside the door there was a group photograph of the Vicar and friends, at Sidney Sussex College, where he had been a highlight in the Student Christian Movement. There were also two photographs of Pompeii and of Trajan's Column. The desk at which he was writing his sermon was of soap-coloured wood, and the sermon pen was shaped like an oar, with the arms of Sidney Sussex on the blade. On the mantelpiece there was a china tobacco jar, with the same arms. Over the mantelpiece there was a picture of Sir Galahad, who had conducted a cart horse into a bramble bush, and gone broody there. The seating accommodation included two cane armchairs, which

gave a bamboo roar at sitters, and a horsehair sofa which was so slippery that anybody who sat down immediately began to slide off. It was kept for the Confirmation Class, and caused them acute embarrassment.

Gradgnag was accustomed to all this by now, and would have settled to sleep, so that he might be fresh for the mouse hunting that evening, if he had not seen Miss Brown, on Cook's bicycle, come floating up the drive. She was an inhabitant of the Park, whose appearance was familiar to him, so he edged round to the window-sill, to see what she was after.

Miss Brown waddled into the study without a word. Mr Hater looked at her with suppressed hatred, for he disliked being disturbed in the mornings. She put a strong cardboard boot-box in front of him, on the desk. It was tied with several lashings of string and had holes in the lid as if for transporting caterpillars. She undid the string and lifted the lid cautiously, ready to slam it back. Gradgnag was high outside the window and could see into the box. There, pressed against the side in a corner and looking upwards, was the rumpled and miserable Schoolmaster, helpless, scared, captive, uncertain whether to risk a smile.

The Vicar sat motionless, looking at the exhibit from behind his glasses, which reflected the light and hid the eyes, and the wrinkles on his thick neck gradually

went brick red. He poked the Schoolmaster with his sermon pen to make him move. He put back the lid with trembling fingers. He tied it up again. He produced a bottle of Ruby Wine which was kept for the Bishop, from a cupboard, and gave Miss Brown a whole glass.

The window was open at the top, so that the Trapper could hear what they said.

Miss Brown related how she had surprised the deputation late at night, when they had gone to relieve Maria, and how she had missed several of them, and how she suspected that there might be many more. She mentioned that these creatures were probably of fabulous value, better than any treasure chamber, and that in any case the supposed treasures must have come from them. She suggested that Barnum and Bailey, Lord George Sanger, or the Circus at Olympia would offer many thousand pounds apiece, if they could catch such oddities.

Mr Hater breathed one word: 'Hollywood.'

They thought it over slowly, sipping the Ruby Wine.

'The money would have to be held in trust for Maria.'

'There would be nothing to prove that the creatures had not been found at the Vicarage.'

'If they are human it may be illegal to sell them.'

'They are not human.'

'Not one word must be breathed about this discovery, Miss Brown, for fear of competition. Nothing must be mentioned until they are safely trapped.'

'The child refuses to say where they live.'

'Perhaps we can get the information from the midget you caught.'

'He will not answer questions.'

'I hope you did not . . . punish Maria?'

'Although she bit my finger most savagely, Mr Hater, positively like a wild animal, I never raised my hand to her.'

'Very wise.'

'It crossed my mind that she knew where they were . . .'

'M-m-m-m. You have not locked her up?'

'She is in her room for the time being . . .'

'But can be set at liberty.'

Miss Brown suddenly opened her bun face and let a kind of cackle out of it. It might have been the first time she had laughed in her life, and had a startling effect. Even the Vicar gave a wintry twinkle with his glass eyes.

'How fortunate,' he said, 'that she should visit them at night! The cloak of darkness, Miss Brown. She will never notice that she is being followed.'

So they hurried off to Malplaquet, to arrange about Maria's liberty. But first Mr Hater took the Schoolmaster from the boot-box, which did not look too strong, and locked him in a metal cash-box which was used to store the offerings for the Society for the Propagation of Christian Knowledge.

Gradgnag only had to climb the creeper a little higher and to let himself down by the blind-cord. The key was beside the cash-box. He was able to force it round. Miss Brown and the Vicar had scarcely reached the bottom of the village before their captive had been liberated. They were not at the North Front before the Schoolmaster and his deliverer had started the long trek home. Unfortunately, it would take them a couple of days.

Maria, meanwhile, was surprised to find that she was not to be punished for biting. She was more than surprised, she was astonished, when they gave her the favourite pudding for luncheon (chocolate custard) and said that Cook need not be sacked. When they told her at tea-time that she was a good girl and might visit her 'dear little fairy friends' whenever she pleased, she was more than astonished, she was deeply suspicious.

When one comes to think of it, Miss Brown and Mr Hater were pathetic creatures, not terrible ones. It was so long since they had forgotten about being young

that they were powerless in Maria's hands. They were in the strong position of being able to bully her, of course, but their weakness was that they had no idea that she was twice as bright as they were. 'Parents,' says the immortal Richard Hughes, who wrote the best book about children that was ever written, 'finding that they see through their child in so many places the child does not know of, seldom realize that, if there is some point the child really gives his mind to hiding, their chances are nil.'

'I wonder,' said Maria to herself, several times that day.

For dinner they gave her lobster *à l'américaine*, and a *bombe glacée*, after which she pretended that she was ready for bed.

Miss Brown retired early.

At midnight, Maria rose from her deceptive couch. She had lain on it religiously, to save up her energies and was not in the pink of training. She went past Miss Brown's door, with a bit more noise than usual, and made her lengthy way to the Chestnut Avenue. At the bottom of this, she paused and turned round for a look, knowing, like a good Indian, that she would have a dark background for her own body, while anybody who followed would be outlined against the moonlit sky.

There they were, sure enough, actually in black cloaks.

Maria grinned and went her way.

The Wilderness had been a Japanese garden, or something of that sort, two hundred years before. It was now a labyrinth of rhododendrons, laurels, and assorted shrubs, with several useful features. One of these was that the original paths had become over-grown by the evergreens, but not entirely squashed out. There was generally a track of some sort, often as much as four feet high in clearance, like a tunnel, however much the leaves and branches met above that height. A person of ten could get along them fairly quickly, by shielding her face, while a person of later years was confronted by a swishy barrier from the chest up. Another advantage of the Wilderness was one which was shared by all jungles, and that was that a single traveller could get about in it more easily than two. When two people forced their way in single file, the branches, swinging back from the first of them, whacked the second in the face. There were other attractions. For instance, on account of the place having been abandoned to growth and wildness, it needed an expert to know which way the ghosts of paths were leading. It was like the Maze at Hampton Court, but worse: worse because the top of it was grown across with whipping branches.

Maria waited till she was sure they could not miss her trail, then plunged into the rustling gloom.

She did not go too far. After five minutes she sat down, and pricked her ears.

It was pleasant, listening to Miss Brown and the Vicar, as they fought each other among the dark and oval leaves. 'Hush!' 'There!' This way!' 'That way!' 'You crackle.' 'No, I don't.' 'Which turn?' 'M-m-m-m.'

Half an hour later, knowing that they were soundly lost, Maria slipped away to bed.

In the morning she was as fresh as paint. Miss Brown, who turned up for breakfast looking pale, with a scratched eye and twigs in her hair, asked for a bowl of bread and milk. The Vicar, who called in time to say their grace, asked hollowly for brandy neat. Maria, thanking them for all their kindness, begged for permission to take out her lunch in sandwiches, and to go exploring. They rolled their watery eyes, grinned horribly, and wished her joy.

She went by Malplaquet-in-the-Mould to Maid's Malplaquet, turned left through the parishes of Gloomleigh, Marshland, and Malplaquet St Swithin's, cut across the Northampton road for Bishop's Boozey and Duke's Doddery, skirted the famous fox covert at Monk's-Unmentionable-cum-Mumble, doubled back from Bumley-Beausnort to Biggle, and ate her

sandwiches in the gorse patch on the round barrow at Dunamany Wenches, overlooking the drovers' road to Ort.

Here she saw the sleuths go by.

Staggering with fatigue, quarrelling about the route, red-eyed from lack of sleep, Miss Brown and the Vicar tracked her doggedly on. Miss Brown had blisters on both feet, and the long heel from one of her shoes had become detached, causing her to roll as she walked, like a ship of the line in the famous gale of 1703. The Vicar, who had corns, limped behind her in dejection, humming out at intervals that they ought to have turned left at Dumble-dum-Meanly. Miss Brown, with her nose in the air, refused to listen, and Mr Hater could be seen planning things he would like to do to her.

Maria finished her sandwiches and enjoyed the summer weather. All the farmers of Dunamany Wenches were saving their hay. All the farm labourers of Dunamany Wenches were doing the same thing, criticizing the judgement of the farmers. All the iron spikes were charging up the elevators in endless squadrons, carrying the captive grass to the ricks. All the swarth turners were crig-a-rig-a-rig-rig-a-rigging round the edges of the fields, throwing up their bow waves of hay. All the horse rakes were threading the swarths, giving a stately clang each minute, as they delivered the rakeful to its

place. All the headmen, who did the difficult part, were swishing the great mounds which they had collected in the arms of a thing like a snow-plough, to the right position. All the publicans in the Green Man at Muddle, in the Malplaquet Arms at Pigseaton, and in the Duke's Head at Biggleswesterleigh were tapping innumerable casks of bitter, which they knew would be required for the evening. Everybody everywhere was keeping a tight eye on His Majesty the Sun, for fear that He might take it into His head to thunder.

The sun, so far as that went, was in a tyrant's mood. He was burning so hard that Maria could almost see him twinkle, could almost see the javelins of radiation being hurled out in all directions, as he jingled and hammered away like a Siva with a thousand arms, on the cloudless anvil of the sky. She nearly panted as she lay there, on the sheep-nibbled grass, and her pursuers panted in good earnest, as they pottered off through Idiot's Utterly, High Hiccough, Malplaquet Middling, and Mome.

When they had disappeared, Maria dropped her nose into the thyme-smelling grasses; watched a stinking beetle, with wriggly tail and aromatic scent and shining armour, as he scuttled his way under some bird's-foot trefoil; and was shortly fast asleep.

In the afternoon, she woke in time to see them return. They were fifty yards apart, no longer on speaking

terms, and this time the Vicar was in the lead. She hailed them and ran down the hill, to join the march. Somehow they did not seem too pleased to see her. They had to do their best to look delighted. She rallied their shattered energies with bright inquiries about their walk, and led them briskly home to dinner.

After dinner, which was of fresh salmon followed by ices, Maria left them spread out in the drawing-room, and rested on her own bed until dark. But as soon as Miss Brown had retired, she got up and trotted past the door. She could hear the tyrant groan aloud as she went by. She found the Vicar hiding behind a statue of Psyche in the Assembly Room, where he had taken his shoes off and gone to sleep on sentry-go, and she had to cough to wake him up. Then, while he creaked with exhaustion at the effort of getting his swollen feet into the shoes once more, she set her course for the North Front, for a change, and went by the Beech Avenue instead of the Lime one.

This led her up the Arcadian Valley to the Newton Monument, which was a thing like Nelson's Column in Trafalgar Square, except that, instead of having a statue at the top, it had a small glass observatory with a broken telescope. A staircase led up the inside, which, being in memory of Newton, had exactly the same number of steps as there were days in the year.

Maria turned the rusty key, entered the darkness of the little hall, and hid behind the stairs.

Her detectives arrived soon after.

Gasping and hissing from their various corns and blisters, weaving with exhaustion, leaning against each other to keep upright, the Vicar and Miss Brown edged the door open feebly and stood whimpering at the stairs.

'How many steps?'

'Three hundred and sixty-five, point two five six four.'

'Civil?'

'Sidereal.'

'Come,' he said finally. 'Excelsior! They may be worth a thousand pounds a piece.'

'Excelsior,' agreed Miss Brown. They tottered up the stairs.

When they were well away, Maria let herself out, locked the door behind her, and went back to bed.

In the morning, after an excellent breakfast of kedgeree, she took a circumbendibus through the Wilderness, as it was important not to be visible from above, and reached the Newton Monument before noon.

Miss Brown was at the top of it, waving a petticoat out of the observatory window on the end of the telescope. The Vicar was at the bottom, hammering on the door

and whining for help. As the parklands of Malplaquet were about twenty-five miles in circumference, and there was nobody left inside them except Cook, they had little hope of rescue. Horace Walpole had once described these grounds as 'that Province which they call a garden'.

Maria waited for some time, then carefully wriggled her way to the door, hidden by arches of rhododendron. She unlocked it softly, while the Vicar was still banging, and snaked into the shrubbery, to watch.

The Vicar and Miss Brown continued at their tasks till luncheon. Then, suddenly growing maddened beyond endurance, the former seized the door handle to shake it, as a punishment for its contumacy. Of course it opened at once. His hum of fury brought Miss Brown stumbling down the stairs.

Both prisoners assumed immediately that the door had been unlocked all the time. Each of them accused the other of not having tried to open it properly. When they at last dispersed in passion to their beds, they had determined to sleep it out till Doomsday, if necessary, whether Maria visited the hidden manikins or not.

That will teach them, she thought, to let young children out of bedrooms, so that they can track them to the secret places of their friends.

17

THESE matters were fun for Maria, and no doubt they were good for the characters of Miss Brown and of the Vicar, as well as being good for their physical training. But Maria had made the mistake of letting her amusements run away with her.

She had forgotten her outposts, a thing which no general ought to do.

The People were in a worse muddle than the Vicar was, because she had failed to explain what she was at.

They did not know where their Schoolmaster was – they thought he was still a prisoner in the palace – and, from the few glimpses which they had caught of Maria's wanderings, they had got the idea that she was trying to escape her persecutors, but that she had been followed and brought back.

Maria ought to have gone to the island to explain, so soon as she knew that her pursuers had given in for the sake of rest; but she had been tired too. She rested, pleased with the lesson which she had given.

In the evening, when Miss Brown and the Vicar had partly recovered, they sat before the fire in the North-northwest Drawing Room, with Maria sitting between them on the sofa. They were determined to keep her with them all the time, so that she could not snatch a rest between times on her own. The Vicar was showing her his photograph album.

It contained several photographs of the Lake District, together with picture postcards of Wordsworth, Ruskin, and other worthies, with 'A Present from Skiddaw' printed underneath. The portrait of Wordsworth had small views set round in panels depicting a field of daffodils, forty cows feeding like one, etc, etc. There was a view of the Vicar and Miss Brown half-way up the Old Man of Coniston, and there was a photograph of some ladies bathing at Ramsgate in 1903 with the horizon at thirty degrees; but he hid it. All the pictures which were not of Wordsworth had their names and dates written under them in white ink: 'Noodles, Pribby, Poo-Poo, me, and Mr Higgins. Ambleside '36', or 'Nurse Biggleswade (and dog). Kendal '38'.

On the other side of Maria sat Miss Brown, knitting. She had long, sharp, metal needles, which clicked.

The fire was a small one, because it was summer. It was for ornament, not use. The room was comfortably furnished. The electric light shone cheerfully on the deep chairs and the coffee-things, for it was after dinner, and the Vicar kept turning his pages with a rustle. He told them which was the window of the bedroom in the hotel which he had slept in, as if he had been Queen Elizabeth.

They were at Keswick when the noise began.

Outside the window, the acorn drums started to roll, the pipes began to shrill, and hundreds of clear, high voices began to sing together boldly.

> 'And shall the Schoolman die?
> And shall the Schoolman die?
> Five Hundred Men of Lilliput
> Will know the reason why.'

They had come to the rescue of their countryman, whatever the odds against them might be.

The moment the Vicar heard the song strike up, he grabbed Maria by a pig-tail. Miss Brown grabbed the other one.

The window was behind them.

There she sat, unable to look round, and, from the outside, the rescuers could not see that she was held. The back of the sofa hid everything except her head.

The Vicar rose to the situation.

He said, between his teeth, without looking round: 'Miss Brown, please rise to your feet in a nonchalant manner, and saunter to the door. When you are out of sight of the window, you might peep from behind the curtains. Remember that the electric light is behind.'

She gave him the other pig-tail, and slunk off as instructed, on her mission.

It was a wonderful scene which she described.

The army was lined up, where the bars of light fell from the window across the terrace. There were the infantry in mouse skins standing at attention, their officers, in beetle breastplates, standing three paces to the front, with swords unsheathed. There were the cavalry, with the Admiral at their head – waving his sabre and dressed in one of the ancient dresses of Captain John Biddel, so that he looked like Nelson. As with all Admirals, he sat his rat badly. There also were the archers, with their left feet forward as if they had been at Agincourt. Behind these, in orderly ranks, stood the Mothers' Union, the Ladies' Loo Club, the Bluestockings, and other female organizations, all singing lustily and

waving banners, which stated: 'Votes for Maria', 'Down with Miss Brown', 'No Algebra without Representation', 'Lilliput and Liberty', 'No Popery' (this was for the Vicar), or 'Schoolmasters Never Shall be Slaves'. The A.D.C.s were cantering up and down with messages; the bugles were blowing; the drummer boys were beating to quarters; the regimental standards were uncased; the band had changed over to '*Malbroock s'en va-t-en guerre*'; the swords and pikes and harpoons were flashing in the golden light; and, even as Miss Brown peeped, a flight of arrows was discharged against the window 'as it had been snow'. 'Huzza!' cried the infantry. 'Death or Glory,' cried the cavalry. 'The Admiral expects . . .' cried the Admiral – but when one of the A.D.C.s had whispered to him behind his hand, he quickly changed it to the better phrasing: 'Lilliput Expects That Every Man This Day Will Do His Duty.'

Poor little forlorn hope! They lacked the wise counsels of their kidnapped dominie, who would certainly have shown them that the odds against them were too great, but it was brave of them to come to save him all the same.

After the Governess had described all this from her spy hole, the Vicar said: 'M-m-m-m.'

'I will trouble you!' he said later, 'to extinguish the electric light.

175

'And now that we are in the dark,' he added, 'you will kindly shut and latch the window.'

When this was done, they sat down on either side of Maria, each gripping a pig-tail, and Mr Hater hummed.

'This time,' said he, 'there must be no mistake.'

'No confusion.'

'Our object, I presume, is to impound as many of these minnikins as possible, for future profit. How shall we set about it?'

'Might I offer a suggestion?'

'What?'

'The minnikins, as you so ably dubbed them, are, as I know from sad experience, armed with such minified weapons as, though fragile, can make a painful puncture.'

'The fact had not escaped me.'

'Grabbing by handfuls, if we leave aside the fact that hands when full would hold but few at best, might seem an occupation comparable to catching porcupines?'

'M-m-m-m-m.'

'But with a broom, rapidly brushing all before us, they tumbling upside down and separated from us by a lengthy handle, we might roll up a regiment or two without mishap, and clap a bucket on them?'

'Bravo, Miss Brown! We find these brooms and buckets, creep out by different routes, you west, I east. We take the line in flank, one at each end, and sweep towards the middle. Their limbs, though bruised, will not be permanently harmed by bristles. They, in confusion, tumbled up and over, will prove unable to deploy the weapons ...'

'We with our brooms and buckets ...'

'Saucepans ...'

'Anything with lids ...'

'Collect our spoils! And sell 'em! But first, the child must be disposed of.'

They winked at each other for some time over Maria's head, which she had to keep down because they were pulling her hair so, and made wide mouths or big eyes or complicated gestures, in their efforts to discuss the plan. Finally they nodded agreement.

'Our cherub,' said the Vicar sarcastically, summing up the winks, 'must be conducted to her chamber, there locked in. I will assume this pleasant duty. You, Miss Brown, shall look for suitable receptacles, me being absent. Come, dear child, your arm!'

He was dragging her out in the dark, still by the pig-tails, when Maria opened her mouth to yell. It was her last chance to warn the people about the brooms.

But the Vicar could see in the dark, like a cat. Before she could make a sound, his puffy hand was clapped across her mouth. They went in silence.

In the bedroom, her captor proved to be a thoughtful scoundrel. He threw her on the bed with a wheeze, and stood in the middle of the linoleum, tapping his teeth with one blunt fingernail.

'Our pet,' said he, 'is not without intelligence, indeed resource. Merely to lock the door would be to leave her practically at liberty. Now, let me see. Firstly, the troops are camped before the window, although some stories down. We therefore shut the window, so, and to secure the catch, m-m-m-m, we bend the metal with this poker, thus, using a grown-up's strength, and still remembering to remove the poker when we leave. Just so. No child will shift it now, especially without the poker. Next we pause, consider. For instance, a resourceful maiden, m-m-m-m, standing well lighted at a window, though unopened, might by some sign or gesture warn our quarry. We therefore draw the electric bulb from its socket, thus – the merest twist removes it – and we find: why, that the room's in darkness! No amount of clicks upon the switch, manipulated by those childish fingers, will now illumine Lilliput. What more? Locked in, unlighted, windowless, high up . . . I think we may withdraw. Sleep well, Maria.'

She listened to the key being turned in the lock, and waited tensely while the Vicar chuckled out of hearing. Then she leaped off the bed like an arrow, took the water jug from the washstand, and threw it through the window. So far as bending catches went, she was not the fool he thought her.

The glass went outwards with a jangling crash, followed, long after, by a thump as the enamelled ewer hit the terrace. This thump was in the middle of a tinkling shower of musical meteors, made by the falling glass. There was a thin high shout from all the army down below.

She leaned out from the hole and yelled, 'Go away! They are coming from different doors, with brooms, to sweep you up. Don't go together. Scatter. Everybody go his own way, till you meet at home. Go quick! They are coming now!'

She could hear them shouting back, so narrow a sound, but she could not hear the words.

'Yes, I am safe. Quite safe. I am free. But go! Go at once! Spread! Run! If anybody is followed, don't lead them to you-know-where. Stand still, as if they were owls. They will miss you. But go, run, every way, not all together! I am safe. They won't hurt me. They want to track me till I lead them to you. The Schoolmaster is not here.

'And, by the way,' screamed Maria, for they seemed to be fading already, 'don't bring me food! They feed me now! And don't expect me in the evenings!'

She ended on a positive shriek, for fear that she would not be heard, just as Miss Brown and her Führer came charging up the terrace.

Too late.

18

THEY came upstairs with livid faces. The Vicar's was plum-coloured with rage and with the climb; Miss Brown's was pallid, with scarlet nostrils. They were almost too furious to speak. They had heard what she was shouting through the window. They replaced the electric light bulb and sat down. 'Maria,' said Miss Brown, 'listen to Mr Hater.' The Vicar said: 'These dwarfs are worth a fortune in cold money. Do you understand? They are worth enough money to make you a rich girl, and to give an old age of peaceful security to poor Miss Brown here, who is always doing her best for you. I do not mention myself. Where do they live?'

Maria looked at him.

'Do you understand that if they could be sold, the shameful debts of your ancestors would be paid off to many a ruined tradesman, and Malplaquet rescued from disgrace?'

'I thought they were being paid from your allowance.'

'You are a wicked girl. Where do they live?'

She folded her hands.

'Maria, you are to tell the Vicar where they live.'

'I won't.'

'Do you understand that it is evil to look God's mercies in the face? You are throwing a gift horse in His mouth. God has sent these creatures to help us in our difficulties, and by your thankless stubbornness you are giving an insult to God. Where do they live?'

She shut her lips.

Miss Brown stood up and came waddling to stand over her.

'You are a naughty girl. You are impertinent. You had better tell the Vicar, or you will regret it. You know what I mean.'

When there was no answer to this, or to anything else, Mr Hater lost patience. He did not even want to hurt Maria, he was so hot with avarice. He wanted the People.

'If you will not tell, you will be locked up. Do you hear? Locked up without your dinner. And punished. Punished till you do tell. Such obstinacy is sinful, monstrous. It is selfish. You are a naughty, wicked, stubborn, selfish girl!

'Very well,' he said, when there was no reply. 'She can stay in this room till she speaks, and you, Miss Brown ...'

The Governess said: 'Cook comes to this room, Mr Hater, and there might be talk.'

'Then she must be locked in some other room, where Cook won't come, and we must say that she has gone away.'

'To stay with an aunt.'

'That will do very well. What room do you suggest?'

'There is always,' said Miss Brown most sweetly, 'the dungeon.'

Everybody ought to know the dungeon at Malplaquet, the one which historians have mentioned in so many works. It was an excavation extending backwards in time, far beyond the First Duke, far into the misty past which saw the Tower of London rise.

The Duke's ancestors had been some Nova Scotia baronets, who had dwelt since the days of James I in an ancient Norman castle, which had once stood on some of the ground that was now covered by the ballroom floor. They had fallen out with Cromwell, who had blown the castle up, and the Duke had used the stones when he started to erect his place, pulling down the rest. The only parts which he had been unable to pull down had been the dungeons, for they had been down already.

So he had left them for wine cellars, keeping the main one in its original state. He had thought it a curio, owing to its being Gothick.

It was lit by a red light, through a small window which had crimson glass, in a wall about twenty feet thick. The window was barred, and the effect of the colour on the stone arches of the Norman roof was better than anything in the Chamber of Horrors.

The furniture, where it was not red, was coal black. It consisted of instruments of torture, which had not been sold at the sale, because there had been no demand for them. The floor was covered with rushes, except where sand or sawdust were needed, to soak up blood.

In one corner stood the Rack: the improved pattern, perfected by the villain Topcliffe. Written on the side of it, in vermilion letters, were the awful words of the warrant to torture poor Guido Fawkes:

PER GRADUS AD IMA

The opposite corner held a German instrument called the Virgin of Nuremberg, which consisted of an upright coffin, shaped like a woman. Its lid opened like a door, and was covered with six-inch spikes, arranged so that they would run into people at various places when they stood inside the coffin and the door was shut.

184

A third corner held the machine known as the Manacles, which happened to be the one on which Peacham had been tormented in 1614, in the presence of Francis Bacon – when he had been examined 'before torture, in torture, between tortures, and after torture'. Its inscription said:

PAINE IS GAINE

The fourth corner held the Block. It was black like the others, but covered with a pall of scarlet velvet. When this was lifted, the scars in the wood could be seen, where the axe had bitten deep. The axe itself lay across the pall, a ruby flash of steel, and this was the very one which had been used to decapitate King Charles I. It had been wielded by Richard Brandon – or 'Young Gregory', as he had been called, to distinguish him from his father, 'Old Gregory', who had also been an executioner. The same sure hand had used the same axe on Strafford, Laud, Holland, Hamilton, and Capel, all lords, and little can these martyrs have paused to reflect how lucky they were, to get the job done by an artist who took himself seriously. For Young Gregory had trained from earliest childhood, by chopping off the heads of stray cats. It was not so with that scoundrel Ketch, who took five whacks to decapitate the unfortunate Duke of

Monmouth, and even then he had to finish him off with a penknife.

Next to the axe, in a small crystal casket, there was half the fourth cervical vertebra of King Charles, the other half having been stolen from the King's coffin in 1813, by a doctor called Sir Henry Halford.

Across the casket, somebody had engraved the famous quotation:

DE MORTUIS NIL NISI BONUM

In the middle of the main wall, opposite the massy door, there was an enormous fireplace, for heating branding irons. Opposite the window, in the darkest recess, there was a pile of thighbones, skulls, and so forth.

Prisoners had scratched their last remarks upon the walls. The Little Princes, who were finished off at Malplaquet and not in the Tower, had written 'Adiew', 'Adiew'. A witch had inscribed, before they burned her, 'I come, Graymalkin', and some homesick Scot, tired by too much thumbscrew, had suggested, 'East, Quhest, Hame Ys Best'. An anonymous villain had written; 'yis hurte me mo than it hurtes yow'.

They dragged Maria struggling to the gloomy chamber, a secure hold which Cook would never dream of searching, and they actually chained her with one of the

handcuffs, when they remembered her resourcefulness with the water jug. Of course they did not intend to use the instruments of torture on her, but they did intend to find out where the People lived.

'If,' said the Vicar finally, looking at her with a thoughtful hum, 'the child insists on being sullen, she must be punished till she speaks. Naughty children should be whipped.'

19

THE Professor was sitting at the end of his vegetable garden, under a marble monument to the Tragic Muse. He was chopping wood. The other side of the monument was to the Comic Muse, so that he had two wide mouths above his head, one laughing and the other howling. It was to Congreve, or to somebody of that sort. The Professor was chopping with a sixpenny hatchet from Woolworth's, where he did his shopping, and he had a one-and-threepenny metal hacksaw beside him, counting the cost of blades, with which he had managed to fell a small blackthorn for firing. His head was buzzing with schemes.

The first scheme was to work his passage to London as a bus conductor, where perhaps they might be likely to have a set of Du Cange in the British Museum Reading Room. In connexion with this scheme, he was

certain that 𝕿riparium meant either 'trefoliated' or else 'tripartite'; but the trouble was that the manuscript could bear either construction, with different results.

The second scheme was to save up until he could afford a penny fishhook, and then to ask permission from Maria to fish in the lakes at Malplaquet. His mouth watered at the thought of the fishes he might catch – perch perhaps – and of how he would eat them grilled, on slices of bread and butter. He could not afford to buy a rod or line, but he was planning to use a sapling of ash, with some string from a parcel which he had once received, tied to the end, and the only difficulty was to save up a penny for the hook. He felt so greedy when he thought of the hot perch that he almost decided to sell one of his first-folio Shakespeares, to get the money.

The third scheme was about making some parsnip wine in the kitchen copper.

The fourth was about touching the Vicar for a testimonial, so that he could go to Buckingham Palace and ask to be made Prime Minister. He felt sure that a person who ruled the whole nation would be expected to be an educated man, and, as he had been educating himself for the last sixty years, he thought that there would probably be a chance of getting the job. He argued that people who had spent their lives leading revolutions, or killing other humans, or howling out lies

on election platforms, could have had very little time for education, and thus that his own weary life of study might have put him ahead of them in this respect.

Perhaps the maddest of his schemes was that, when he had been made the Premier, he would choose educated people to be his ministers, just as one chooses a trained dentist to pull one's teeth out, instead of going to the nearest quack at a street corner who likes to scream from the top of a tub that he 'opposes toothache'. The Professor was silly enough to think that if doctors had to pass examinations before they could cut out his appendix, then members of parliament ought to pass examinations before they could rule his life.

He was well mixed up with all these schemes when the garden gate was pushed open, and Cook appeared. She was dressed in a brownish-grey alpaca dress, with a serviceable hat pinned on, and she carried a Rexine shopping-bag which bulged. She was on her best behaviour, but determined to do her duty. She had sadly left her beloved Captain at home, with tears on both sides, because she knew that the Professor did not get on with dogs.

He stopped his chopping and hurried along the path between the currant bushes, looking hungrily at the Rexine bag. As he came, he cried out joyfully: 'Ah, Mrs Noakes, good day, good day! You are welcome to the

Ridings! Pray do not ring the bell! It does not ring! We are enjoying very seasonable weather! Yes, yes! Some small fault in the mechanism, I believe! I must buy a gong! It is due to the sun being in Aries!'

Cook said: 'There now.'

'I assure you that I am correct. The Zodiac . . . But I am leaving you to stand upon the doorstep without a welcome. We must enter the cottage before embarking on abstruser themes. Let me see. Just so. The door is locked, we notice.'

'I only come, Sir, if you please, on account of what I was desirous . . .'

'But love laughs, Mrs Noakes, ha! ha! at locksmiths. I have my own methods, Watson, that is, er, Mrs Noakes. The pot of geraniums! Whenever I lock myself out of my cottage, I am careful to conceal the means of ingress in a place known only to myself. Now, Mrs Noakes, if you will kindly look the other way for just one moment, I will extract the key from under this pot of geraniums, where I keep it for secrecy, you see, and we shall be inside the edifice before we can say Tom Robinson. Tom? Perhaps I am thinking of Crusoe. But even then we ought to call him Kreutznaer. The idiom I am attempting is that we are likely to be there in half a Nippy.'

Cook said that she was sure she did not wish to intrude upon a gentleman, knowing, as she hoped, what was

due to such, and being able from a girl to observe her station . . .

The Professor said that it was no intrusion at all, none, in fact a pleasure, an unexpected pleasure, and that, if she could just wait for a moment or so while he tried the key the other way up, as it was, he feared, inclined to be recalcitrant, there was no doubt but what, with a little humouring – which he pronounced without the 'H' – a favourable entry would be effected . . .

Cook said that she trusted not to make herself an Imposition, being as how as which it would do just as well outside . . .

'There! It requires, as you see, a simple sleight of hand. The key has to be inserted upside down, and back to front, owing to some anomaly in the formation of the lock, and then it all goes as smoothly as, as . . .'

'Smooth.'

'Exactly. And now, Mrs Noakes, you must step in from the sunlight. You have walked far and fast. Let me see . . .'

'I fear,' he continued coyly, 'that I am unable to offer you a cup of tea, as I have finished the packet; but there is some excellent boiling water, which can be procured at a moment's notice, by igniting some of these pieces of wood that I have been making, and . . .'

It was true that he could not offer her the tea, for he had finished the last teaspoon a week before, but it was hardly straight to offer the hot water. He would have had to offer it to anybody else, and he would have done so, but this was not his first visit from Cook. He stood on one leg, looking anxiously at the shopping bag, and continued to say 'and . . .'

'Well, there now, Sir! If I did not fortunately think to bring . . .'

He sighed happily.

'. . . knowing your 'Abits . . .'

And Mrs Noakes vanished into the dirty kitchen with her bag, while the Professor peeped through the crack of the door in an agony of anticipation. The whole thing was whether she had brought bloaters or sausages. She always brought one or the other, and today he felt like bloaters. He knew that she would make some tea, out of a screw of paper, and that she would have remembered a bottle of milk and six lumps of sugar, with two buns baked by herself. These were delicious. But, afterwards, she always left behind a packet in greased paper, which was either bloaters or sausages, as if she had forgotten it. The Professor never mentioned the packet any more than she did, nor thanked her for it; either because he was too proud, or too shy, or too grateful to thank her properly. He just ate them next day. Meanwhile,

he wanted badly to know which it was; but he did not like to ask, could not see through the crack, and was rather ashamed of peeping. So he went back to sit on the soapbox and swallowed rhythmically, because his mouth was watering.

When Cook had made them an excellent cup of tea, and they had eaten their buns, sitting side by side on the box, she mentioned the reason for her visit. It was that here Miss Maria, Sir, on account of which she was anxious of, being as how there was neither sign nor parable of her to be seen these two days, as which the one what he knowed of, to wit, Miss Brown, though not accustomed to name names, the same what she had referred to notwithstanding, had, though not in the 'Abit of discussing her employers with the Gentry, as the Professor might be sure, on account of her having been bred at Malplaquet from a girl under Mrs Batterby that was housekeeper to the late Duke, seemingly, if uncharitable to Nourish Suspicions yet Truth will shame the Devil, provided some haction against her, the poor mite, as might be detrementious in a manner of speaking.

The Professor, who had begun to think of other matters while she was talking, noticed from the silence which followed that it was his turn to say something. He observed resourcefully: 'Just fancy!' He had a secret

plan for conversations, which consisted in saying either that or else 'You don't say so!', both of which were foolproof, and could be used in answer to any statement whatever.

Cook said it was a rare shame, and she had been in such a taking since Friday morning as how she scarcely knew which way to turn, what with the goings on and all, and that here Vicar, for you can't make a silken purse out of a sow's ear, not though the Archbishop of Canterbury were to lay his hands on, which she doubted, so it had seemed best that morning, while she was washing the dishes, to put the matter before them as was a gentleman born, which you could see was what the Professor was of the stock of, as she would say and had said to any that miscalled him, and to leave the matter in his hands, being as how as which he would surely know what was rightful for to be done.

A sudden suspicion darted across the Professor's mind. Cook had been saying . . . Surely he had heard . . . Something about . . .

'Where is Maria?' he demanded.

'That's what I'd give a deal to know. I hant clapped eye on her this two days.'

'Good gracious!'

'She's gone, Sir,' said Cook tearfully. 'My Maria. And I always tried to help her little ways.'

195

'My dear Mrs Noakes, but this is most extraordinary! A serious business. Gone? Clapped eye? She cannot have become invisible. Could she be in bed? Under the bed? Up a chimney? At the seaside? Lost? Mislaid somewhere or other? Can she have gone to London? To the British Museum?'

'That Governess of hers give out that she were gone to visit with an auntie, but no auntie has she got.'

'And what do you suspect?'

'She's in the Palace, yet, Sir. That I'd swear to. But hid. Locked up. She's in her durance vile.'

'Dear me. You will, of course, have searched?'

'There's rooms, Sir, more than mortal man has counted. I done me best, a-bicycling along the corridors and ringing of my bell.'

'Well, Mrs Noakes, you rightly came to me. I will assume the search at once. Some matters are best relegated to the sterner sex. Dear me, dear me! Our Poor Maria scotched. Wait till I fetch my hat.'

The old gentleman hurried upstairs, and returned after some time in a tweed ulster smelling of camphor, with a curious bowler which he had worn as a dandy in the nineties. It had a curly brim. He had to wear the ulster when visiting, however hot it was, in order to cover the holes in his clothes.

'We will attack,' said he, 'this governess in her den. You,

Mrs Noakes, had best return in front of me, using some other path. It would be wise if I might seem to come by chance, inquiring for Maria. We must be politic.'

He bustled her outside the cottage, promising to give her ten minutes' start, and pushing her off, along the Riding. Two minutes later, he had caught her up.

'Oh, Mrs Noakes, excuse me for a moment. You would not have, about you, that is, at your home perhaps, a set of Du Cange?'

'Well, no, Sir. That I hant. There's Beeton . . .'

'You refer to the second archbishop of that name, no doubt. Certainly not the Cardinal. The others were unclerkly, as we know.'

'It's cooking, Sir.'

'Indeed? An ancient and a noble art. A continuator of the Goodman, I dare say. But still, you have no volumes of Du Cange?'

'Not that I know of, Sir.'

'A pity. Well, well, well, we can't have everything. But I am keeping you. Good-bye, good-bye.'

After another minute he had caught her up again. 'The word,' he said hopefully, 'is 𝕿𝖗𝖎𝖕𝖍𝖆𝖗𝖎𝖚𝖒. You have not come across it in the course of reading, I suppose?'

'Not as I recollect, Sir, no, I haven't.'

'No. Ah, well. We must possess our souls in patience, Mrs Noakes. The "F" of course, is optional, as scribes

would use their vowels more or less to fancy. "𝕿𝖗𝖎𝖕𝖍𝖆𝖗𝖎𝖚𝖒", with a "𝖄", would do as well?'

'There's tripe . . .'

'Tripe,' cried the Professor angrily, 'is a Gaelic word. Nothing to do with tripe at all. Good day to you. Good day.'

And he stalked off in a huff, until he remembered the parcel in the kitchen. This made his anger melt, and he turned to wave to his kind friend if he could, but she did not look back. Then, to give her the start, he hurried back to investigate the parcel itself. It was bloaters, as he had hoped!

He forgot about Maria and began looking up 'bloaters' in a dictionary, to see if they were derived from the Swedish word 'blöt', which they were.

20

AN HOUR later the Professor tried to scratch his head, found that the hat was in his way, and wondered why he had put it on. He made several attempts to solve this problem, by free suggestion and self-analysis, finally deciding that he had put it on because he was going out. He therefore went out, and looked at the sky. It did not seem to have any message for him. So he went in again, found a piece of paper, and wrote on it the first word which occurred to him while concentrating on hats. This was 𝕿𝖗𝖎𝖕𝖍𝖆𝖗𝖎𝖚𝖒. He tore it up and tried again, getting RATTO, which he thought was probably something to do with Bishop Hanna and the rats. So he tried HANNO and got WINDUP, tried WINDUP and got CAPE, tried CAPE and got ULSTER. He discovered that he was wearing his ulster, and was delighted. This was followed by a longish tour through the provinces of Ireland, the Annals of the

Four Masters, and so forth, which brought him back to Tripharium. He tried this, and got Bloaters, which he connected by now entirely with Sweden, took a short circuit through Gothenburg, Swedenborg, Blake, and Gustavus Adolphus, and suddenly remembered that he was pledged to find Maria. So he balanced the bottle-green bowler still more carefully upon his head, and trotted off to do his duty.

It was a basking day.

The trees trapped the heat until the Ridings were long ovens, the ulster was unbearably hot, the bees droned like aircraft in the sticky leaves of the lime trees, the swallows who had built nests on south walls fanned their babies and gasped for breath, the grass snakes were out in force, making life a misery to the frogs, and the frogs themselves were committing suicide by dozens, under the wheels of any passing motor. The Professor toiled away into the distance, a small industrious beetle under the copper sky, getting smaller and smaller as he plodded off towards Malplaquet.

He was not sure what to do.

To search the Palace legally, as he knew from his studies, he would require several writs of *Habeas Corpus*, together with a *De Heretico Comburendo* or so, and perhaps a *Non Compos Mentis*. On the other hand, he also knew that it was possible for two or three people

to ramble about in the various corridors for several weeks, without meeting each other; so that there seemed little reason why he should not search in an unofficial way, because nobody was likely to notice whether he was there or not. The easiest thing would have been to find Miss Brown, to face her down, and to demand the release of her pupil. Unfortunately, he had no real proof that Maria was still in the house, and, besides, he was afraid of the Governess. She had once been very rude to him, and he was afraid that the facing down might happen the other way round. He felt unhappy, and tried to cool himself as he went, by waving his hat.

When he had passed the Grecian Amphitheatre, and the sixty-foot pyramid in honour of General Burgoyne, the Valley of Concord opened before him, as Capability Brown had always intended that it should, and there was the vast bulk of the mansion at the end of it. Wren, Vanbrugh, Hawksmoor, Kent, and the rest of them had erected its dozen colonnades; Adam, Patrioli, and others had plastered its hundred ceilings; Sheraton, Hepplewhite, Chippendale, etc., had stuffed it with furniture, since sold; and there it lay before the Professor in the evening sunlight, with more rooms than anybody could remember.

He let himself in by a ruined door in the west wing, and began to search.

He searched the Gothick Billiard Room – which had once held a table as big as a swimming-bath, and which still had the coat armour of all Maria's ancestors painted on the imitation wooden tracery of the ceiling. The central achievement had been kindly provided by Horry Walpole, and it had 441 quarterings, including the arms of Boadicea and Herod Antipas. All the bends were sinister and all the wives were on the wrong side of their husbands.

He searched the Orangery, where Gibbon had scratched out a semicolon in the famous last paragraph of *The Decline and Fall of the Roman Empire*, before presenting the eighth volume to the Duke of Gloucester – who had observed affably: 'Another damned thick book! Always scribble, scribble, scribble! Eh, Mr Gibbon?'

He searched the Menagerie, where the Earl of Chesterfield had once been locked by mistake for two days as a monkey, and a pity they did not keep him there for good.

He searched the Chinese Parlour, into which Rousseau had suddenly rushed in 1768, when he had indignantly read out an interminable and incomprehensible letter from himself to Diderot, leaving all hearers completely stunned.

He searched the Rent Room, where the Wicked Earl had once run his estate agent though the body

– the former claimed during his trial by the Lords that it had been in a duel, but the agent still walked on Tuesday nights, with the hilt of the sword in the small of his back, which was a good argument to the contrary.

He searched the Chart Room, where one of the viscounts, an admiral, had been accustomed to keep his sextant and other instruments, on retiring from the service after having lost Majorca, Minorca, Bermuda, Goa, Simla, Hecla, and Alabama, in a series of naval engagements.

He searched the Gun Room, out of whose window the Duke of Orleans had been accustomed to shoot larks with the corks from champagne bottles.

He searched the Fertilizer Room, where the Master of Malplaquet, who had invented three separate potato grubbers, had been accustomed to store enormous quantities of Hypersuperextrainfraphosphates, for the use of his tenant farmers.

He even searched the State Room, in which Queen Victoria had held the only Drawing Room ever held outside a royal castle, and in it there was the very chair in which she had sat, with a glass lid over the seat, to preserve the royal imprint.

The Professor lifted the lid and sat down himself, for he was beginning to feel tired.

Then he got up with a sigh and went upstairs to the Clock Room in the pediment of the North Front, which had a clock made by Christopher Pinchbeck II, which played 'When the Heart of a Man Is Depressed with Cares', in four parts, one at each quarter – people got over it in time, and stopped listening.

His quarry was not there.

The Professor began to lose his head, and to hurry from one floor to another, as the different ideas occurred to him.

He searched the Butler's Strong Room, which had at various times held the Derby, Grand National, and Ascot gold cups, as well as an epergne in the shape of a banyan tree which had been presented to the Sixth Duke by the grateful inhabitants of Bombay.

He tried the stables for 144 horses, the kennels for 144 hounds, the attics for 144 abigails or footmen, and the Card Room, where Charles James Fox had once lost £144,000 in a single night, wearing scarlet heels to his shoes and blue powder on his wig.

He even tried the Armoury, which had once housed the accoutrements of the Third Duke's Own Northamptonshire Fencibles – and also a party of visitors who had been mislaid while being shown round the Palace, in aid of charity, by a forgetful butler, in 1915.

His hostage was nowhere to be seen.

The poor Professor sat down on the bare floor of the Armoury for a second rest. Then he pulled himself together for a final effort, and searched afresh.

He searched the Pavilion, where an absent-minded Lord Dudley had once invited Sydney Smith to dinner with the remark: 'Dine with me today, and I will get Sydney Smith to meet you' – to which Mr Sydney Smith had courteously replied that he was engaged to meet him elsewhere.

He searched the Colonnade, where the great Pope himself had walked with William Broome, on the night when he was persuading the latter to persuade Tonson to publish a letter from Lintot, signed however by Cleland, and purporting to have been written by Bolingbroke, in which Lady Mary Wortley Montagu was accused of having suspected a Mr Green of persuading Broome to refuse permission to Tonson to publish a letter by Cleland, purporting to have been signed by Lintot, without the knowledge of Bolingbroke, about the personal habits of Dr Arbuthnot, under the pseudonym of Swift. (On the other hand, a person named Worsdale, a mere tool, calling himself R. Smythe, was to tell Curll that a certain 'P.T.', a secret enemy of Temple, possessed a copy of the correspondence between Lord Hervey and Colley Cibber: with obvious results.)

He went out of doors at last, and searched the fountain which Boswell had once fallen into, to amuse the Great Lexicographer.

He even poked about under the equestrian statue of dapper little George II, seated on a horse with no girths, and for that reason perhaps the very one which had run away with him at Dettingen.

Maria was nowhere to be seen.

In the garden, the Professor observed Miss Brown on her knees doing something venomous to a bed of geraniums. She was wearing a straw hat, wielding a trowel, kneeling on a carpet mat, and singing bitterly to herself. The Schoolmaster's escape had been discovered.

The Professor took off his green bowler, and said politely: 'Excuse me, Miss Brown.'

'Oh, it is you, is it. What do you want now?'

'Well . . . nothing. Thank you. I was just . . . walking round.'

'You have a fine day for it,' said she. 'The gate is there behind.'

'The gate? Oh, yes, I see. The gate for going away from. Yes . . .

'Well,' he continued after a bit, 'good-bye, Miss Brown.'

'Good-bye.'

'Good-bye.'

'And none of your Nosey-Parkering.'

'What?'

'I said: None of your Nosey-Parkering.'

'No, certainly not. No.'

He turned his hat round several times, and added bravely: 'The geraniums are red?'

'Do you want me,' cried Miss Brown viciously, swinging round on her knees and pointing the trowel at him, 'to set the Vicar on you? Go away. Shut the gate after you. What are you doing here?'

'I was . . . calling on Maria.'

'Then you can call elsewhere. She's gone away.'

'To stay with an aunt?'

'Who told you so?'

'I . . . I was guessing.'

'She's gone away,' said Miss Brown brutally, 'to stay with her aunt on Timbuctoo, tee-hee! I suppose you won't be calling on her there? Buzz off, you bluebottle.'

The Professor scuttled away while Miss Brown laughed atrociously, and the last he heard of her, as he closed the gate with trembling fingers, blushing all over, was when she settled down to sing some private words once more to her geraniums:

'Down among the Dungeons,
Down among the Dungeons,

207

Down,
 Down,
 Down, Down,
Down among the Dungeons,
Let
 her
 lie.'

Incidentally, Miss Brown was fond of flowers, and would tell anybody who chose to listen that the Dear Little Roses were her greatest joy.

THE Professor walked home with tingling ears, inventing appropriate retorts which he could have made if he had only thought of them in time, and worrying about his friend. He felt certain that she could not have an aunt in Timbuctoo, not without being darkish, and he was distressed by the song which the Governess had been singing. It sounded suspicious, he thought, as if there had been something going on. He began remembering Berkley Castle, and the agonizing king.

All the same, he could not think of anything to do. He could search again tomorrow, of course. There were still plenty of larders, laundries, cupboards, closets, still rooms, coal cellars, outward rooms frequented in his early days by Dr Johnson, servants' halls, sculleries, harness rooms, pantries, dairies, cloakrooms, store-

rooms, and so forth, even in the wing which he had already visited, and then there were the other wings as well. Taking cupboards alone, he calculated that there must be at least two thousand. But the danger was that he might arrive too late, however hard he searched. He wished that Miss Brown had not been looking so cruel.

When the Professor got home in the rosy twilight, with a wonderful sunset making the cottage windows flame, and etching one of the obelisks to Admiral Byng in deepest ebony, he went straight to the kitchen and sniffed the bloaters. These cleared his mind, like smelling salts. He saw at once what he would have to do. He would have to get the help of the People. Where one old man might take many weeks in exploration, five hundred searchers working simultaneously, however small they were, would have the advantage.

It was dark when he started once more, for the moon had waned. He was distended with bloaters, at peace with the world, contented with his plan. As it was dark, he did not have to wear the curly bowler. He was thinking about this and that.

Now if the Professor had a vice at all, apart from his glass of dandelion wine, it was the fact that he had never cared for dogs. It was not that he thought them vulgar or mobbish, but rather that he disapproved of them for

being dependent. He thought that people and animals ought to be free and wild, like falcons for instance, and he disliked dogs because they depended on their masters, in what he considered to be an undignified way.

It was the same with the People.

He could not see how beings who were only six inches high could hope to be independent, when they were associated with people who measured as many feet. This was why Maria had never been able to persuade him to visit the island. The very thought of going made him feel awkward. He felt, if you can follow the idea, that the fact of his visiting them would be an inroad on their proper freedom, because he was so much bigger than they were. He agreed with what Gulliver felt among the giants, that it would be better to die than to undergo 'the Disgrace of leaving a Posterity to be kept in Cages, like tame Canary Birds'. In his heart of hearts, he disapproved of their association with Maria. It was, as the same writer has remarked, 'upon such a Foot as ill became the Dignity of human kind'. His idea was that respectable people ought not to be the masters of others, nor their slaves.

Now if I, thought he, pottered down the darkling ride towards the distant Quincunx, if I had my own choice of capturing one of the species mentioned by Gulliver, I would prefer to capture a Brobdingnagian. Think of the glory and the excitement of catching somebody who was

as high as a church spire! But I wonder how high they really were? It says in the book that Glumdalclitch, who was nine years old, and little for her age, was only forty feet high. The Premier was 'near as tall as the Mainmast of the Royal Sovereign'. The horses were between fifty-four and sixty feet. Now a horse of sixteen hands is sixty-four inches high, so, if we do a sum by the unitary method, comparing sixty feet to sixty-four inches, we get the comparison that one inch of theirs would be about equal to one foot of ours. This would make the average Brobdingnagian some seventy-two feet high. Later in the book, it says that a Brobdingnagian on horseback measured ninety feet. That would be about four times as high as my cottage.

But the best comparison, continued the Professor enthusiastically, for at least he knew everything there was to be known about books, is that their largest Folio was not above eighteen or twenty feet long. It would be a Royal Folio, I suppose, which is twenty inches by twelve and one-half inches, and so we get the exact scale of one inch to one foot! They were twelve times as high as we are!

'Now if I were to stand on my own head twelve times,' said he aloud, to the dark form of a beech tree, while the owls of Malplaquet hooted on every side, 'I should be a good deal higher than you are.'

The tree rustled.

'Well, then, suppose we wanted to capture one of these Brobdingnagians that was as tall as you, we should need a ship to reach the country (on the west coast of North America, somewhat above the Streights of Annian) and to bring the creature back. I wonder how deep the well is, in an oil tanker? Probably not deep enough to hold a beech tree without bumping its head. On the other hand, I do not think we should need to take the *Normandie* or the *Empress of Britain*. A P. & O. steamer of about twenty thousand tons would be big enough; or, better still, a middling sort of aircraft carrier. The advantage of having an aircraft carrier would be that we could disguise it as a rowing boat more easily, through its not having too many funnels and things, and that is what we should finally have to do.

'I would have to publish my Solinus, of course, to get the money, as they are probably expensive.

'And another splendid advantage of taking an aircraft carrier would be that we could carry an aircraft.'

He resumed his journey, feeling pleased.

'When we got near to the Streights of Annian, we would make the aircraft fly away on a reconnaissance, and we would hang about ourselves, out of sight of the country of Brobdingnag, until we heard from the pilot, by wireless as I think they call it, that he had spotted

one of these giants in a rowing boat by himself, out fishing.

'The Brobdingnagians do not fish much, because our sea fish are smaller than minnows to them, but sometimes they do go fishing for whales. The giant would think our aeroplane was a large bird, I suppose, if he saw it.

'Well then, when we had a bearing on this lonely fisherman in his boat, we would clear our decks for action. Everybody would have to hide. We would steam up quietly from behind him, pretending to be drifting. When he saw us, he would give us a hail, taking us for a wherry of some sort, and then, when he got no answer, he would row round us once or twice, trying to make out what we were. We should have to leave an enormous cable hanging over the side, which he would take for a rope. After a bit, he would climb on board.'

The Professor began to snap his fingers.

'Now this is where our previous arrangements would begin to come into action. We should have made a big lid in the flight deck, which slid like a sunshine roof on that motor car I once saw, and inside this lid there would be our huge cabin, filling the whole of that part of the ship, fitted up with a chair forty feet high and a table and a bunk to match! Of course, the Brobdingnagian would take the whole thing for the forecastle, or whatever they

call it, of the wherry. And on the table we would have left a specially made loaf, twelve feet high, and a bottle of wine to scale!

'So the poor Brobdingnagian would shout out once or twice: "Is anybody there?" And then he would climb down the outsize ladder, to investigate. He would be inquisitive.

'The moment he was inside, we would push a button – and snap would go the lid!'

The Professor pranced with satisfaction when he got to this; but suddenly he fell into a sober pace.

'We should have to see that this aircraft carrier was solid, he would be bound to bang a bit.'

He thought it over for some time, considering how the plates would have to be riveted with bolts that were too small for the giant to move with his penknife, and then went on with his plan.

'After he had finished bumping and yelling, which might go on for several hours, he would begin to feel faint or miserable, and he would sit down at the table, to consider what to do. That would be the time when he would notice the food. So he would suddenly feel thirsty and decide to take a drink. Now here is where our cleverness would come in for the second time, for the wine would be drugged! Then the poor giant would lie on the bunk, because his head was going round inside,

and in five minutes he would be asleep. We should have to use mandragora.

'The moment we had him under hatches, we should have begun to steam away from Brobdingnag, after turning his boat adrift, and the moment he was asleep we should go down with the chains and handcuffs and leg irons. We could sling them from a crane or something of that sort, until he was properly done up. Then we should have to wait until he woke.'

The Professor grew moody at this, and began to shuffle as he walked. He did not like the idea of chaining people, even when they were giants.

'Anyway, when he awoke, the captain would have to go down to the bunk, and he would walk up his chest, and he would tell him not to be afraid. We should have to have learned the language beforehand. Perhaps there is a book on it somewhere in the British Museum, like Du Cange . . .'

He managed to escape from 𝕿riptarium in the nick of time.

'We would tell him that he was a prisoner for the time being, because we wanted to be safe ourselves, but also that we would not keep him prisoner forever. We would only keep him for one year, after which we would promise to take him home. And we would explain how we were carrying him to England in order to make our fortunes

by exhibiting him, but that he would not be made to do anything undignified, and, if he would be friendly with us, we would be polite to him. All through the voyage we would feed him well, and talk things over in a reasonable way, and then, when we got to Southampton or wherever it was, we would free him enough to let him stand up, so that he could look out of the hatch. Then we would explain to him about anti-aircraft guns, as they call them, and we would have one on the jetty, mounted in a lorry, and we would shoot down some balloons for him, so that he could see it work. We would say: "We are going to free you altogether now. You are in England, thousands of miles away from home. You cannot get back, nor do much harm to us – for, after all, you are only as big as a tree and we have weapons like this one here, which would do for you in no time. This is why we are setting you free. Now, Giant, if you will be sensible and walk with us to London without any bonds or indignity, we will take the Albert Hall for one year, for you to live in, and we will charge five shillings for a ticket to see you having your dinner every evening. We will not ask you to do any tricks, but only to let the people see you having dinner. Perhaps you will be kind enough to talk to them, in the various galleries, if you feel like it. We will feed you and house you and treat you with respect, and we will carry you home after one year".'

He considered this for half a mile, before concluding: 'Perhaps it would be wise to keep the gun pointed at him, from the Gentlemen's Cloakroom or some where like that, just in case. We would not tell him about it, of course, for fear of hurting his feelings.'

'Also,' added the Professor later, still feeling a little uncomfortable, 'we would naturally pay him a commission of ten per cent.'

22

BY THE time these matters had been settled, the old gentleman had reached the Quincunx, and had remembered there was work to do. He pushed his way through the reeds beside the boat-house and stood in an oozy place, where the water quickly climbed his ankles, looking across the glimmering lake. The more he looked, the more ashamed he felt. He was guilty about being bigger. However, he remembered his young friend's desperate case, and pulled himself together as well as he could. He clenched his fists at his sides and shouted in a gruff, uncertain tone, which was half a squeak and half a whisper, because he was unsure of it: 'News from Maria!'

Try shouting by yourself, out of doors, in the middle of the night, in the country, without knowing whether anybody is listening, and you will see how he did it.

He nearly jumped out of his skin when a clear voice near his right ankle said politely: '*Quid nunc, O vir doctissime, tibi adest?*'

It meant: 'What is biting you, learned man?'

The Professor's shyness vanished. Monkish Latin was the one language which could have made him forget his unfair size. It was the Schoolmaster, safe home from the Vicarage at last, who had spoken, and the latter, of course, had been brought up in an eighteenth-century way, to talk Latin with educated foreigners. He had known that he was talking to the Professor, from the description given by Maria's captive.

'*Vir eruditissime,*' explained the Professor joyfully, '*sed solo voce mihi cognite. . .*'

They were sitting side by side on the ledge of the boat-house, jabbering about Pomponius Mela, when the frigate came upon them from the darkness.

The Admiral wanted to know what was the matter, what was the news from Maria? The crew hung over the bulwarks with their mouths open, as if they were to eat it. Even the Schoolmaster remembered that Pomponius could scarcely be the main object of the visit; and the messenger remembered too.

When the story had been told, there was a council of war.

Considering her captors, it was obvious that the

prisoner must be rescued at the earliest moment. The Palace was four hundred yards from the Quincunx. To cover this distance with a pace of three inches, the forces of Lilliput would have taken three-quarters of an hour. But the Professor could do it in a few minutes. It was decided, therefore, that sixty men should be disembarked from the frigate immediately, and the Professor was to carry them carefully but quickly, rolled in his ulster like a sack, so that they could begin to search without delay. Meanwhile, the frigate would return to the Repose for more of the men, and for the saddle rats, and for as many women as could be spared. If the Professor liked to come back for a second cargo in the ulster, they would be ready for him. The searchers were to begin in the East Wing for a change, spreading out in parties from corridor to corridor and from floor to floor, as quickly as possible, and working inwards from the outside, till all met in the middle. The second cargo would begin in the North Wing, the third in the South Wing, and so in order. Where the doors were shut, they were to look under them if they could; if not, they were to call and listen. Probably their keen ears would be able to hear Maria, even if she were gagged but breathing. If and when she were found, the finder was to go at once to the steps below the clock on the North Front, where a first-aid party would be waiting. People were

not to make any noise while they were near the North-northwest Drawing Room. If anybody sent reports, they were to be careful to write the time (in hours) and, above all things, reports were to be copied in triplicate, with capital letters.

One party of desperadoes was willing to wait till midnight, if the worst came to the worst, so that they could try to tie Miss Brown to her bed when asleep, as Gulliver had once been tied in the sleep of his exhaustion. Then they could prick her with pins, until she confessed where Maria had been hidden.

The work of search began.

Meanwhile, in the furnished drawing-room, Miss Brown and the Vicar were sitting on either side of the fireplace as usual, two silent images in their evening clothes. The People could see them through the windows and under the door: the Vicar in his black clerical silk, sipping half a glass of sour sherry because he was too mean to take a whole one, and Miss Brown in a violet fichu, eating chocolates with a kind of disdainful greed. They had nothing to say to each other for the time being. They were thinking, perhaps, about the best way to break Maria's spirit, and dreaming of the vast fortune which they hoped to enjoy when they had sold the little islanders into slavery, for the circus at Olympia or the cine-magnates at Hollywood.

When she had finished the chocolates, Miss Brown went to the piano. She began to play hymns.

Silently and anxiously, while the piano tinkled, the People of Lilliput pattered up and down the corridors, with footfalls quieter than falling leaves.

They peeped under doors according to instructions; they whispered shrilly, 'Maria! Maria!' They mounted the big stairs laboriously with scaling ladders which had been brought by the frigate. For going down, they slid on the banisters. In the corridors, they ran, to save time. Outside, in the inky shadow of a pillar on the North Front, the Professor waited with the first-aid party in an agony of nerves. He was afraid that Miss Brown might catch him and call him a bluebottle, but he was still more frightened for Maria.

At last there was a flutter of mouselike feet upon the marble pavement, and the messenger stood gasping. He had forgotten his forms in triplicate, but he had not forgotten the news. He was picked up, together with the waiting ambulance men, and bundled in the ulster. The Professor scampered down the servants' stairs.

Down they went, past empty pantries and broom cupboards; down wooden steps which sounded awfully beneath the Professor's hobnail boots; down into deeper regions where there were stone walls and cobwebs and the smell of mouldy corks. Past wine bins and dusty

footsteps, past looming vaults with sweeping shadows in the light of the Cook's torch, which he had remembered to borrow, past the heavy safe in which the famous Malplaquet Diamond, 480 carats, stolen by William Malplaquet ('the Great Publican') from the Nawab of Poona, had once been locked in beamed darkness, past bricked-up arches which might have contained any number of sherry tasters buried alive by Montresor; they hurried along past the heavy doorway of the cellars, which had bolts on the outside but no key, until they reached the last massy door of the dungeon itself. It was shut. A small knot of Lilliputians was standing in front of it, pointing out Maria's footsteps in the dust.

23

THE door was battle-axe proof. It was laid together in two plies of wood, the grain of one ply being horizontal and of the other vertical, so that no axe could split it. In its early days, when it had first been set on its hinges by some feudatory of William the Conqueror's, it had been secured by an enormous bar of wood, the size of a yule log, which had run in two wide tunnels left in the masonry in the wall. When this bar had become wormeaten, somewhere in the reign of Queen Elizabeth, the village blacksmith had constructed a wrought iron lock to take its place. This was still there, locked. Miss Brown had removed the key, which weighed two pounds three ounces. There were, from the same period, some handsome iron bolts. These offered no difficulty, because they had only to be drawn, if one happened to be on the outside. Since the days of Elizabeth, various

other people had done their best for security of the hold. Under the Regency, somebody had fixed iron bars, like the bars for windows, but these could be shifted like the bolts. Under Queen Victoria somebody else had put on the kind of chain which people have for front doors. Under King Edward, the expert had come down from the Bank of England, and had provided a circular lock which nobody on earth could open, unless he knew the key word for the combination, which happened to be 'Mnemosyne'. (One of the dukes had won the Derby with a horse of that name: the bookies had called it 'N or M'.) Under King George V, an American gentleman had sold the reigning duke a ten-shilling lock by Yale. Under King George VI, the whole affair had been provided with strips of antigas and black-out paper, by means of which it could be stuck together. The door was shut.

Now the ignorant Amaryllis, who probably knows nothing about anything except cricket bats, may have come to the conclusion that our Professor was an inefficient old person. Because he knew so much about everything at large, it may have been thought that he would not have known anything about housebreaking. Well then, to be absolutely frank, he did not. But, and this is where he differed from many well-known cricket bats, he had a brain. He had used it before when discovering the origins of the People. Now, as he stood outside the

dungeon, his skull could almost be seen to swell and rise like a football being inflated. His white hair stood on end like a thunder-stricken cat's, when stroked; his eyes sank into their sockets with the effort of concentration; the veins on the side of his temples throbbed like a frog's heart beating; the temples themselves lifted like a cockchafer's wing-cases, when about to fly.

The door shook on its hinges.

'Exactly,' said the Professor. 'Now here we have a door. Pray stand in front, most erudite Schoolmaster, to assist my meditations.'

The Lilliputians fell back in awe, not of his size but of his mental powers, and the Schoolmaster stepped forward solemnly to do his best, feeling proud that he had lived to see that day.

'When,' said the Professor, stroking his beard with majesty and glaring upon the lock, 'is a door not a door? This is the conundrum which we, among others, and not for the first time, are called upon to determine. *Hic labor, hoc opus est.*'

While he was thinking, the People tried to imagine a way in which they could take advantage of their size, in opening it. For instance, if the Professor had lifted one of them up, the latter could have put his small arm into the Elizabethan keyhole, and might have been able to

shift the wards, if they had not been too stiff. But there was no way in which their smallness could help them in dealing with the combination lock, which was opened by a secret word, and the Yale lock was also beyond them, because the box part was inside, so there was no hope of unscrewing it. They were talking these matters over in whispers, when the Professor lifted his hand for silence. He had thought.

'When,' he repeated, 'is a door not a door?'

'*Tibi ipsi, non mihi*,' said the Schoolmaster reverently, meaning, 'I will buy it.'

'When it is off its hinges.'

All were struck by the justice of this. The old gentleman might have gone on to point out that most locks and bolts are really a kind of bluff, that fox hunters who are confronted by a chained gate have only to lift it from the other end, and that the human race will generally be fascinated by a padlock as if it were a rattlesnake, instead of going round the other way, or climbing through the window. He only said: 'Produce a poker.'

The hinges were of wrought iron, and had been made by the same blacksmith who had made the ornamental lock. They were T hinges, with hasps like the fleur-de-lis, and they had been put outside the door, so that the prisoners could not get at them. The result was that the rescuers could. They were old and rust-eaten.

Luckily there was an abandoned poker in one of the outer cellars, and the Lilliputians brought it between them, carrying it as keepers at the zoo carry an outsize in boa constrictors.

The Professor set to work with bangs and wrenches; the ancient hinges gave out showers of powdered rust; the bolts began to fall off one by one; and the other helpers stood to watch the Titan's effort, with minuscule anxiety.

In the Drawing Room, the Vicar was thinking private thoughts. Why, he wondered, should we only sell the minnikins to Olympia? Once we have caught a sufficient number of them, say a barrelful, I will take half a dozen to London in a cigar box, with holes in the lid. I will go in the Rolls, or at any rate I will go first class, for the Clergy are expected to set an example to the lower orders. Then I will call, not only at the Olympia offices, but also on Lord George Sanger, Barnum and Bailey, and the rest of them. This will be even better than taking them to Hollywood. I will show my specimens and sell the barrel to each of these in turn, without telling the others. After all, they are commercial people, probably of low moral character, and one has to meet guile with guile. It is a sad thing, but there it is. When in Rome one must do as the Romans do. And by the way, perhaps it would be wiser not to mention the treble

sales to dear Miss Brown? She is a woman, and might not understand; besides, if I do not tell her about them, I shall not need to share. She will have quite enough by getting a share in the first sale, indeed she will have more money than any unmarried woman could possibly want, and I know that her requirements are few. It would be a pity to spoil her simple nature. M-m-m-m-m. Besides, I dare say I might need to leave the country till the fuss blows over, after selling the same article to three separate firms, and it would be useful to leave Miss Brown behind, to handle the business of delivery. She might desire to leave the country also, if she knew about my laughable deception. I understand that women's prisons are extremely comfortable, and I dare say the climate of Bermuda might not suit her. M-m-m-m-m. Palm Beach, Bermuda, Honolulu! I must order travel leaflets from the shipping companies.

Miss Brown was also thinking privately. If, she thought, if – if an accident were to happen to Maria? I don't mean any violence, of course, not premeditated, but if some little accident did happen so that she – well – was very ill – or even – even if she died? Quite by accident, naturally. We should all regret her. And if the Vicar were to be involved in it, so that he felt – well – almost as if he had been guilty of – of a murder? If he should attempt to swindle me of what I've rightly earned? They

say that blackmail is a stronger bond than matrimony . . . But there, murders never happen nowadays. Such thoughts are merely day dreams. And if we found the missing parchment afterwards, and altered it in favour of ourselves?

The Vicar startled her from the reverie.

'Come,' said he, finishing his sherry quickly. 'We have been patient long enough. Obstinacy is one thing, mere naughtiness is another. We must have obedience: it is written in the catechism. Maria must be made to speak.'

'Now?' asked Miss Brown eagerly.

They rose and went downstairs.

The last bolt fell from the top hinge in a little cataract of worm-eaten wood. The Professor took a firm grip of the battered iron and began to heave the door ajar. It creaked and grated on the flagstones, opened an inch or two, then stuck. The ill-treated flanges of the locks on the other edge were bending in their sockets, splintering the old wood in the frame, and shedding screws. He took the hinge again and dragged the door half open. They did not wait to widen it, but squeezed their way inside. The Lilliputians ran between his feet without thinking about being trodden on. They cried: 'Maria! You are saved!'

There she was in the beam of the torch, handcuffed to the wall, looking furious. All the thanks they got was: 'Why didn't you come before?' then she said defiantly: 'I did not tell.' Then she burst into tears.

They found that she was covered with bruises, not because she had been spanked, for she had escaped that last indignity, but because she had struggled so hard in being dragged downstairs that the action had developed into a rough-house. As a matter of fact, if she had not struggled, they quite likely might have spanked her then and there – they were so furious about her feat with the water jug – but the rough-house had put them out of breath. So you see it is always best to go down fighting, and if anybody ever tries to beat you, you should fight them till you die.

She had a splendid black eye.

'Right!' said the Professor. 'That's quite enough of that.'

He was so angry that he was almost shaking.

They told her how proud they were of her courage in not telling, and how much they owed to her. They found the keys on a nail by the fireplace, and unlocked her chains. They asked if she were really hurt, or hungry, or ill. They begged her not to cry.

'To begin with,' said the Professor, 'I shall take her to my cottage. Not one night shall she stay at Malplaquet,

until this matter has been settled. I shall revive her with cowslip wine and bread and butter. Here, have my handkerchief. And then—'

He raised his fists to the heavens.

'And then I shall get on my tricycle and go to find the Lord Lieutenant or the Chief Constable, I am not sure which, and I will see to it that these monsters are made to pay for their outrage, to the last drop of their inky blood! What a heaven-sent opportunity! Do you realize that with these handcuffs and these bruises we can probably get her guardians removed and actually sent to prison, which is the only hope for the people of Lilliput? Otherwise they would always have had the legal right to sell you, and Maria could hardly have kept your secret for ever.

'I must say this is an excellent development,' added the Professor, restored to the best of humours by the idea. 'I trust you are not seriously injured, my dear child? Can you walk?'

'Yes, I am quite safe really. They didn't hurt me.'

'Good. We shall walk to the cottage at once. I suppose you wouldn't like to be carried? I learned rather a good lift when I was a Boy Scout.'

'No.'

'Oh, well, you must please yourself. And let me see. Is there anything we ought to arrange with the People?'

The Schoolmaster asked: 'Do you intend to call the Constable this Evening?'

'Yes. The sooner the better. The quicker we have these villains under lock and key, the better it will be for all.'

'Should she be guarded while Y'r Honour is away?'

'No, I will lock the door. I trust that this will answer. I always hide the key under my pot of pink geraniums, a highly secret spot, known only to myself. Yes, h'm. Besides, they will not know that she is gone, or, should they find she is, will not know where to look for her. Forward to safety! But hark, what noise was that?'

They were in the passage, within reach of freedom. The Professor disentangled the torch from his whiskers and pointed it towards the cellar door – the other one, which blocked the end of the passage. Even as he pointed, it was softly closed. Something suspiciously like a chuckle, though muffled by the wood, echoed beneath the vaulted ceiling of the corridor, while on the outward side, the bolts creaked home.

24

M R HATER leaned against the outer door with a long sigh, which whistled between his pursy lips as if he were letting off steam. 'Got them!' he said. 'The floor was crawling with the creatures.'

Miss Brown lifted the candle to his face and examined it without a word.

'At least fifty. Say at one thousand pounds a piece. I think we may at last allow Maria her supper!'

She held the candle closer.

'And the Professor?'

'We can let him out as soon as the small people are secured.'

'Are you deaf?'

'Deaf, Miss Brown?'

'He has found your ward handcuffed to the wall in a dungeon, and he intends to visit the police. You heard

him tell them. The Society for Prevention, Mr Hater, may have a word to say.'

'Well, we cannot keep him locked in there for ever. Besides, when we have sold the minnikins . . .'

'Did you observe that he and they appeared to be acquainted?'

'Good heavens! You mean a prior claim? But no, they live on our land, not on his. They are the property of the landlord. He has no right, whatever their acquaintance . . .'

'The landlord is Maria.'

'But, my dear lady, do I understand that you suggest . . . It would be impossible to keep them locked in there perpetually . . . The difficulty of feeding . . .'

'Why feed them?'

'Impossible! We cannot . . . It would be . . . wicked. Unfriendly critics might consider that it was tantamount to murder. Besides, even if we did starve them till they died, what of the risk? It is unthinkable.'

'Cook has been told that she is with her aunt, and not one living person knows the whereabouts of the Professor.'

'But the dungeon is a room still visited by antiquarians!'

'We can put off their visits, for a month or two.'

'Miss Brown, we could not, no, we must not, dream of

such a thing. We are Christians. We must not be selfish. Besides, if we kept the big ones locked up, how could we get the little ones out?'

'Sir Isaac Newton bored a hole, to let his kittens through the door.'

'Ingenious. M-m-m-m-m. You mean, to bore a hole and place some wire rat trap on the other side, to catch them. Yes. Meanwhile, the Professor and Maria stay inside . . .'

'The informer and his evidence.'

'It was you who suggested the handcuffs.'

'No, it was you.'

'It means imprisonment for both, whoever it was, if the Society for Prevention should be set upon us.'

'Yes.'

'Miss Brown, we must resist temptation. The idea is far too dangerous. Murder will out. Not, of course, that we should be intending murder, for it is not our duty to feed the Professor for the rest of his life; but we must think of the construction which others might put upon it. No, Miss Brown, we must manage things more carefully. We will bore the hole as you suggest, collect the little men, give food and water to the captives through the aperture, and proceed to make our sale. Once we have cashed the cheques – that is, the cheque – we will set off for Florida, or for some luxury hotel among the

Azores, by aeroplane. When there, we can safely cable Cook to let them out. But murder, no! I am amazed that you should mention such a thing.'

Miss Brown puddled the hot candle grease with a fat finger while she thought. Finally she said: 'You must fetch a brace and bit from the Vicarage, also a rat-trap. Or a bird-cage.'

It was noticeable that she no longer called him 'Mr Hater', in her respectful way, but spoke to him as an equal, or as an inferior.

Meanwhile, in the cellarage, the Professor was trying King Charles's axe on the door. It proved to be of cross-ply like the other, and would not split. The hinges were on the wrong side. They were trapped.

He went back to the dungeon, where Maria was sitting up and taking notice. He had used too much of his brain on the subject of doors and bruises, and was beginning to feel peevish. He wanted to go home and read books.

'Well, here we are.'

Maria said cheerfully: 'I must say it is nicer than being alone.'

'It may be nicer for you, but it is not nicer for me. I like to be alone. Why did we start this fuss in the first place? Scampering about with axes. I had left a bloater for my supper.'

'It will have to keep.'

He swung the torch round the walls.

'There must be some way out. Where is the back door? Where are the windows? What an inconvenient house!'

'There is a small red window there, behind the rack.'

'Then we must simply break it, and climb through.'

'It is six inches wide, and has some iron bars.'

'Why?'

'To prevent us climbing through it, I suppose.'

'How very inconsiderate! They might have known that we should need it. Nobody thinks of anybody but themselves. And where am I supposed to sleep?'

'Y'r Honour and Miss,' said the Schoolmaster, 'the Dimensions of this Window, if I may be permitted an Observation, would not preclude the Passage of my Companions, suppose the Glass to be broken. Once liberated, we might make our Way towards the other Aspect of the Cellar Door, and draw the Bolts.'

'Dear me. Of course!'

'Even if you can't get it open,' said Maria, 'you could bring us some food. I have been feeling rather hungry for the last two days. Miss Brown and the Vicar will not want to come in while they know we have an axe, so I suppose they mean to let us starve, unless you can get us something.'

'Just let them come,' said the Professor.

He gave Maria the torch to hold, and broke the glass with the axe in question, as if the former were the Vicar.

Then the People had to be lifted to the stone ledge, one by one. They went silently and seriously, without looking back, so that the prisoners could see that they had realized the gravity of the situation, and were determined to do their best.

The dungeon window faced a coal shaft, between the Boilerhouse and the Armoury. When they had climbed up that, they found themselves in the open air, under the pared fingernail of a moon, which was almost slenderer than themselves.

They sent a party to fetch provisions for the prisoners, while others went to gather the main body, which was still dispersed about the Palace. The remainder started for the bolted door. They collected two of the ladders which had been brought by the ship, together with ropes and spikes. Getting round the Palace was like mountaineering for them, and this was why they brought the gear.

For Malplaquet was a real mountain to the People of the Island. It was a range of mountains. To imagine their difficulties, we should have to think how we would get about in a house that was as high as the downs at

240

Selborne, and more than six miles long. The countless steps on the terrace were, for them, each one as tall as a man. If the doors were shut, they could not turn the handles. The pavements of the colonnades were aerodromes. Even the smaller columns seemed to be two hundred feet in height; the greater columns, which held up the pediment, were half as much again. The basins of the fountains were great lakes. The statues were collosi. Eight of them could have dined at ease inside King George's head.

The flat cliff of the South Front towered above them, matt-silver in the moon and starlight, boldly slashed with its deep bars of velvet shade, but half in ruin. It was the ruination that made it possible for them to make their way about. Beaded and panelled doors, which would have been impassable if sound, drooped on their parting hinges, or hung ajar. Masonry, once too true and square for foothold, gave purchase now that it was crumbled. Windows, gap-toothed with broken glass, opened on the vasty halls. Spider and swallow, bat and mouse, had long inherited the coigns of vantage.

The obstacles which we should overlook were tedious to Lilliput. Gravel paths seemed bouldered beaches, which might turn an ankle in their desert strips. The long grass was a jungle of tripping roots. They moved,

climbing and jumping, clambering and toiling, where we should stroll.

The ladders were in a dump at the foot of the steps on the South Front. Now they had to carry them round three sides of the Armoury, through an archway, across the Boilerhouse Yard, and down the basement to the cellar stairs. By their measurements, it was as if they had to march three miles; and it was not across easy country.

The first part of it was along what had once been a gravel drive, where the Fourth Duchess, an invalid, had been accustomed to be promenaded in her pony carriage, with a powdered footman at each wheel, and another behind to carry the smelling salts. Now it was a weedy trackway, whose weeds were bushes to the People and whose pebbles were smooth rocks. It was a heartbreaking trail, although it was one degree better than the scrubland of meadowsweet, scutch-grass, scabious, and sorrel which lay on its borders. This part ended at the west corner of the Armoury, where an iron gate, fifty feet high, and a stone step as high as a man, led to the Menagerie Path and the Orangeries.

They turned right, along another strip of gravel which was dilapidated like the first, and struggled on. Here there were toads, who swelled themselves up, lifted their

back ends stiffly, and made strange moonlit faces at the rescuers as they stumbled past. There was also a chance of grass snakes, who used to go to Boswell's Fountain for the frogs.

To reach the Archway, they had to climb six steps. They had to hold the ladders firm, because the stones were slippery. Above them the great Arch, dedicated to the unfortunate Queen Caroline Matilda and ornamented with the royal arms of Denmark, blocked out a section of the sprinkled stars.

The Boilerhouse Yard was an Arabia of stones, between which the nettles vied with the goose grass, and a nettle sting was like an adder's for men so small.

The bats creaked above them, sharper than kingfishers, as they wove their way between the deadly trees. Outside the yard, beyond the Temple of the Graces, a corncrake sawed across its comb. From an abandoned flower bed the smell of stock was sweet.

The basement door was shut and locked, but its upper panes had once been glass. These were now missing.

They had to tie the ladders together, but even then they were a human foot too short. The steeple-jack had to go up with spikes, which he drove into the wood, like the steps on a telegraph pole, until he reached the open ledge. From that he lowered a rope inside the door, and

made it fast. The rest climbed up the ladders, up the spikes, and down the rope. The last man had to help the steeple-jack, while he hauled the ladders up and lowered them inside.

Then they were in the dark in earnest. The basement corridor, four furlongs straight and long enough to stage a modest canter even for us, was gloomy in daylight. By night, with rats about, it was the valley of the shadow. Some of the bats hunted it also, swerving through the broken panes. The dim pipes and the drains above them, and the myriad bellpulls, were no longer lit by the Professor's torch.

However, they were accustomed to working at night. Their eyes were as fine as they were small. After a minute they could partly see.

The flagstones of the basement were as large as tennis courts. They clicked across them silently in skirmishing order, whispers forbidden.

Outside, they could disperse. They could run, hide in the undergrowth, or stand motionless with a concealing background. Inside, within four walls, the case was altered. Suppose Miss Brown were to spring before them, were to step from behind a pillar or to pounce with her candle from a yawning door? How could they hide on a stone floor, or disperse with walls round them, or run away even, when they were locked in, and needed

to climb out by ladders? One stride of the pursuer would cover twelve of theirs. Later, when they were down the steps, their retreat would be cut off by a series of cliffs, which Miss Brown could mount as easily as the stairs they were.

So they advanced in silence, like red Indians on the warpath, with their scouts thrown out. They had to peer round corners, reconnoitre, listen, even sniff. Humans have a pungent smell, which is plain as daylight to the animals. The People could distinguish with their noses as clearly.

If a scout were to wind the Vicar, he would squeak like a mouse, three times. All would then turn in silence, and would fade back into the darkness, since silence was their only hope.

But if the Vicar leaped from behind; if he too had managed to lie concealed without being winded, and had cut off their retreat: in that case they would have to run in all directions, giving as much trouble as possible in being caught. While he was trying to kidnap one of them, grabbing to seize the nimble figure without injuring it too much for sale, why then, perhaps, during that time, another would be able to climb a stair.

The door towards the cellars had left its hinges twenty years before. The cellar steps were worn by countless feet – the oldest steps in the Palace, contemporary with the

dungeons. They had to lower the ladders, climb down two steps, assemble on the third, lower the ladders once more, and repeat the process.

They passed the strong rooms and the wine bins, under the massive Norman arches. They left minuscule footsteps in the dust. They passed the mouldy corks and cobwebs and the bricked-up vaults.

Dimly, through the bolted door, they could hear the Professor and Maria talking. For some reason these two had begun to neigh.

The lower bolt was reached easily from a ladder. A spike was driven in the door, six of our inches behind the back end of the bolt. A rope was tied to the arm of the bolt and passed over this spike. Then, while one of them held the arm up from the ladder, the others heaved upcn the rope. It came out sweetly.

The upper bolt was too high for the ladders, even when they were tied together. The steeple-jack had to go up with spikes, which he drove in slantwise until he was six inches behind it, as with the other. Then he had to reach the bolt arm, by three more spikes, so that he could tie a longer rope to that. He had difficulty in raising the arm from its slot, although it was only just inside it. Before he could get it to move, he had to hammer it with a spike. The rope was passed over the pulley-spike and thrown down to the haulers.

They heaved with all their strength, climbing the rope in order to put their weight upon it.

The bolt was immovable.

The door had sagged on its hinges in the course of centuries, and was leaning on the socket. It needed human strength to shift the metal.

25

THE Professor walked round the walls with his torch, reading the Latin inscriptions.

'Not a sign of 𝔗𝔯𝔦𝔭𝔥𝔞𝔯𝔦𝔲𝔪,' he said sadly, 'though there is an interesting use of "questeur" by this Pardoner behind the block, who dates himself 1389. I see that Dame Alice Kyteler, the Irish sorceress, was here for the week-end in 1324.'

Maria was resting on the rack, with the famous ulster for a pillow.

'A month ago,' she said, 'the People were thinking how much they would like to visit Lilliput, to see if there was anybody there. I said that when you were rich we would buy a yacht, and go to find them.'

'A pleasant holiday. Yes. We might pay a visit to all four countries, kidnap a Brobdingnagian, call on the Balnibarbians and take a distant look at all the Horses.'

'The Balnibarbians?'

'The people with the flying island overhead, the airy island of Laputa.'

'What fun! We could capture it from a Flying Fortress, if we wanted!'

'Why?'

'It might come in useful for something. We could put it over London in the next war, for an air-raid shelter.'

'Unfortunately it will only work over Balnibarbi. It says so in the book.'

'Well, we could use it for a health resort. Or for investigating the stratosphere, like Professor Picard.'

'Its ceiling was not more than four miles. Aeroplanes go higher.'

'We could . . .'

'I don't see why you want to capture it in the first place,' exclaimed the Professor petulantly. 'Why couldn't you leave it to the people who had it? They were perfectly happy.'

'But they were silly people. All those old philosophers with their heads on one side, and one eye turned inwards, and the servants to flap them when they got absent-minded.'

'What was wrong with that?'

'Well, look at the ridiculous things they invented. Look at the projector who wanted to get sunbeams out of cucumbers!'

'Why not? He was only a little before his time. What about cod-liver oil and vitamins and all that? People will be getting sunbeams out of cucumbers before we know where we are.'

Maria looked surprised.

He stopped wandering and sat on the block.

'Do you know,' he said, 'I think that Dr Swift was silly to laugh about Laputa? I believe it is a mistake to make a mock of people, just because they think. There are ninety thousand people in this world who do not think, for every one who does, and these people hate the thinkers like poison. Even if some thinkers are fanciful, it is wrong to make fun of them for it. Better to think about cucumbers even, than not to think at all.'

'But . . .'

'You see, Maria, this world is run by "practical" people; that is to say, by people who do not know how to think, have never had any education in thinking, and who do not wish to have it. They get on far better with lies, tub-thumping, swindling, vote-catching, murdering, and the rest of practical politics. So, when a person who can think does come along, to tell them what they are doing wrong, or how to put it right, they have to invent

some way of slinging mud at him, for fear of losing their power and being forced to do the right thing. So they always screech out with one accord that the advice of this thinker is "visionary", "unpractical", or "all right in theory". Then, when they have discredited his piece of truth by the trick of words, they can settle down to blacken his character in other ways, at leisure, and they are safe to carry on with the wars and miseries which are the results of practical politics. I do not believe that a thinking man like Dr Swift ought to have helped the practical politicians, by poking fun at thinkers, even if he only meant to poke fun at the silly ones. Time is revenging itself upon the Dean. It is bringing in, as real inventions, the very ones which he made up for ridicule.'

'What would you do,' asked Maria suspiciously, 'if we called at Laputa?'

'Hire a flapper there, and settle down.'

'I thought so.'

'In any case, I do not fully believe in Laputa. I suspect that Gulliver was drawing the longbow a little. So many of these travellers are inclined to be like Sir John Mandeville . . .'

'Why don't you believe?'

'Do you remember how it was supposed to be kept in the air?'

'It had an enormous magnet inside, and one end attracted the earth and the other end repelled it. If they wanted to go up, they put the repelling end downwards.'

'Just so. I do not think it would work. Sir Thomas Browne discusses this very question in his *Pseudodoxa Epidemica*, in relation to Mahomet's Tomb and other articles, like the iron horse of Bellerophon, which were said to be suspended in the air by magnets. He says that it cannot be done.'

'Why?'

'If a magnet is pulling hard enough to pull you up, it will also be pulling hard enough to pull you upper. The moment you are up, you are nearer, and consequently you get pulled harder. That was one reason. Another one was that, if you hung a thing between two equal magnets, the balance would be so infinitely delicate that the least breath of wind would disturb it, and so the object would fly to one or to the other. By the way, do you remember the size of the flying island?'

'It was on a plate of adamant two hundred yards thick, covering ten thousand acres.'

'What is adamant? What is it, then?'

'It was one of the old words for diamond. If you must have a reason for capturing Laputa, Maria, I think that

a diamond five miles long and two hundred yards thick ought to be sufficient.'

'Gee!'

'I wonder why Surgeon Gulliver did not steal a bit?'

'Perhaps he could not break it off?'

'Perhaps.'

They thought about the huge blue fire scintillating in the air, the light from the waves reflected and refracted from its flashing bottom, as Gulliver first saw it, till their minds were awed.

'Tell me about the Horses.'

'What about them?'

'Tell me,' she said guiltily, 'how they ought to be pronounced.'

The Professor threw his head back firmly and began to neigh.

'What?'

'Can you neigh?'

Maria tried, to see if she could.

'How did you do it?'

'Let me see. I kept my mouth shut, and I don't think my tongue moved, and I sort of kept on huffing out a wriggly squeal, through the back of my nose.'

'How would you spell a neigh?'

'You couldn't spell it very well, because you do it with

your mouth shut. So there can't be any proper letters, really, not real vowels.'

'Well, Dr Swift used a "hou" for the huffing part, and a Y for the squeally part, and the N's and M's are the part in the nose, Houyhnhnm. It is what a horse says.'

'It isn't very easy to pronounce it in the book, not when you are reading aloud.'

'It is only a question of practice,' said the Professor grandly. 'Practice and self-confidence.'

He began neighing merrily, saying that he was quoting a passage at the end of Chapter Nine. Maria started also, each thinking his or her own imitation to be the best, and the Lilliputians wondered outside.

'It is a pity,' said he, stopping suddenly, 'that we cannot visit them.'

'Why not?'

'We are Yahoos.'

'But I thought the Yahoos were horrid hairy creatures, who made messes and thieved and fought.'

'That's what we are.'

'We?'

'Dr Swift was thinking of human beings, my dear, when he described the Yahoos. He was thinking of the politicians I was telling you about, and the "practical" people, and the "Average Man", for whom our famous

democracy exists. Just so. Do you realize that the Average Man probably cannot read or write?'

'Oh, surely . . .'

'If the Average Man means anything, Maria, it means the average human being in the world. He lives in Russia and in China and in India, as well as in England. Less than half of him can read at all.'

'But the Yahoos had claws . . .'

'We have tommy guns.'

'We do not smell!'

'We do not smell ourselves. They tell me that a European smells quite horrid to an Asiatic.'

'I don't believe it.'

'No.'

'And anyway, the Horses could not turn us out.'

'Why not? They turned out Gulliver.'

'Why did they?'

'Because he was a human, like ourselves.'

'What cheek!' exclaimed Maria. 'I'd jolly soon turn out mere animals.'

'There,' said the old man calmly, 'speaks the young Yahoo. Exactly. There speaks our budding Homo sapiens.'

26

THE Palace kitchen was rather too small for an aircraft hangar, but its appointments had been praised by Dartiquenave, and the Prince Regent's chef had there conceived his famous Sauce Chinoise which had been composed mainly of red pepper, as the Prince had by then become incapable of tasting anything else.

In a gloomy corner of the kitchen, with a tallow candle which threw enormous silhouettes of titanic ovens, of spits for roasting bullocks, whole, and of braziers for devilling small whales, on a broken rocking-chair which she had inherited with Captain from her deceased husband, with her steel-rimmed spectacles slipping from the end of her nose and a copy of *Mirabelle's Last Chance* slipping from her knobbed fingers, with her head nod, nod, nodding, and jerking up straight again, with

a bundle of Maria's black stockings on the workbasket beside her and Captain's head upon her knee, old Cook sat snoozing off. It was long past midnight, but she was sitting up to make Miss Brown her nice-hot-water-bottle.

Captain, with his head on the knee, was gazing soulfully at his mistress with his eyes turned up like lollipops, while he gently dribble, dribble, dribbled on her apron. He used to get a sugar biscuit every night at bedtime, and this was why he was doing so. He was also thinking what a charming person Cook was and wondering how on earth he could get along without her.

Alas, my poor Miss Maria, thought Cook between her nods; alack, my dowsabelle. But Rule Britannia is my motter, and while there is life there is hope. Supposing as which her old gentleman was lucky enough for to lay his hand upon her nest, according to the Scriptures, before them tryons has her imbrangled, which is what we must imprecate the Almighty Powers for the accomplishment of before the expiration of which, I wouldn't be surprised but what there was some of them eternal hope-springs for the deliverance of whom, not with the aid of them Glorious Shiners which we wot of. Dearie me, dearie me. I'm sure I didn't hardly have the heart to darn her little stockings . . .

She jerked her head upright for the fifth time, looked around with an expression which said: 'I wasn't asleep, so there', and laid her spectacles on the workbasket.

These saved, the sixth nod brought the tired head upon her chest, and she began to snore.

Poor Cook, thought Captain, I must be kinder to her. She makes a splendid pet. How faithful she is! I always say you can't get the same love from a dog, not like you can from a human. So clever, too. I believe she understands every word I say. I believe they have souls, just like dogs, only of course you can't smell them. It is uncanny how canine a human can be, if you are kind to them and treat them well. I know for a fact that when some dogs in history had died, their humans lay down on the grave and howled all night and refused food and pined away. It was just instinct, of course, not real intelligence, but all the same it makes you think. I believe that when a human dies it goes to a special heaven for humans, with kind dogs to look after it. It may be sentimental of me, but there it is. Poor things, why shouldn't they? For that matter, I dare say there are humans in our own heaven even, for the dogs to make pets of. It would scarcely be heaven to some dogs, if they couldn't take their humans with them. I know I should want to take Cook . . .

Captain suddenly lifted his head from the knee and looked at the distant door. The hackles rose on the

back of his neck, and there must have been some setter blood among his ancestors, for he froze with his tail straight out behind him. His nose went whiffle-whiffle-whiffle.

In the huge arch of the doorway stood the miserable Schoolmaster, holding out a Lilliputian biscuit about the size of a daisy, and saying hoarsely: 'Poor Fido, a good Fellow then! A fine Pug, Fido. A Comfit for poor Fido . . .'

The Schoolmaster was always chosen for difficult missions of this sort. His companions stood in the background, waiting to see how he would fare.

'Fido!' thought Captain with disgust. 'Good Lord!'

He walked stiffly towards the door, to examine the intruder.

The poor Schoolmaster held the biscuit in front of him like a weapon of defence, shut his eyes tight, and kept gasping out his store of pacifications for Fido, while he was sniffed all over.

'It is the same shape as a human,' thought Captain, 'in spite of the size, and it smells the same, too, only less. I think I will keep it for a pet, like Cook. I hope she won't be jealous.'

So he picked the Schoolmaster up in a velvet mouth, and carried him to his basket, which stood beside the rocking-chair. The Schoolmaster said faintly, 'A poor

Boy, then, a noble Fellow', as he was transferred. He dropped the biscuit.

Now Captain was an elderly bachelor, and, like many people of this sort, he nourished an unconscious hope that one day he might have puppies. The size of the Schoolmaster must have suggested the matter to his mind, for he sat down carefully on the basket and arranged the Schoolmaster on his stomach. He prodded him with his nose several times, to shovel him into the right position, and the Schoolmaster said indignantly, 'Leave me go, you nasty Br . . .'

But, before he could say 'Brute', Captain's tongue was slapped across his face like an outsize in custard pies, and before he could say anything else, he was being given a bath. Captain knew very well that the proper thing with the puppies was to lick them all over instantly, and this he proceeded to do, while the exasperated midget kept spluttering about Br-br-brutes. He even punched Captain on the nose, he was so annoyed, but his new mother took all in good part, and held him down with one paw, since he seemed to be fractious.

'Oh, you Creature! Down, Sir! Put me down! A bad Dog, Fido! Leave me down this Instant!'

Long afterwards, while Captain snoozed contentedly in a loop, the damp Schoolmaster crawled cautiously from under his chin. He stood on tiptoe by the side

of the basket and tugged the grey curtain of Cook's skirt.

'Yes, dear,' said Cook, without waking up. 'You shall have it in a minute, my sparrow. Not before bye-byes.'

She thought that Captain was asking for his biscuit.

At the second tug she opened one eye.

She next opened both eyes, rubbed them, put on her spectacles, and looked at the Schoolmaster, shrieked in a determined way, and resourcefully threw her apron over her head. Two minutes later, she lifted a corner, peeped out with the eye which she had used first, found he was still there, and replaced the apron.

'Madam . . .'

Cook began drumming on the floor with her heels, to show that she intended to have hysterics if he did not leave off and go away.

The Schoolmaster stroked his clammy hair. 'The Sex!' he thought wearily. 'La! A very little Wit is valued in a Woman, as we are pleas'd with a few Words spoken plain by a Parrot.'

He turned his back, so that she could get accustomed to him in her own way, without meeting his eye.

Presently his sharp ears heard the apron being lifted the third time, but he stood still, without speaking, and waited.

'Lawks!' said Cook.

'Madam, if you will pray compose yourself so soon as may be Convenient, I have the Honour to present myself upon Business of the most pressing Urgency.'

'A fairy!'

'A Sylph, Sylphid, Fay, Fairy, Genius, Elf, or Daemon, Madam, which you please, if you would kindly relieve me from the Attentions of Fido here or Shock, whatever the Animal may be named, and deeply oblige.'

Cook took her scissors out of the workbasket and lifted the tallow candle.

'I bid you begone,' said she, 'by the Power of Iron and by the Might of Fire, for ever and ever, by Christopher Columbus, and Whatsobe, Amen.'

The Schoolmaster turned round cautiously.

'The Effort to convince you of my Reality, Ma'am, would prove a Task beyond my moderate Powers at present. You will, however, permit me to observe that, whatever my substance, I am the Bearer of an urgent Message from Miss.'

'By Snip-Snap-Snorum and High-Cockalorum . . .'

He stamped his foot with vexation, causing Captain to give a growl.

'The Professor and Miss Maria are bolted in the Cellar!'

'Ladybird, Ladybird, fly away home. Your house is on fire, your chillun . . .'

'What the Devil!' screamed the Schoolmaster, who had, after all, been tried rather high. 'Z–ds! D–n the Ladybird! Plague on't, Madam, can't you understand plain English? We wish you to unbolt the Door!'

'Maria in the cellar?'

'Don't you hear me, Ma'am (with a Pox), when I tell you that the Bolt is stiff? Must I e'en be slobber'd to death with Spittle and stifl'd by a filthy Carkass of your Monster, to be deafen'd with the Follies of Domesticks and exorcised under the Appellation of an Insect? Miss is in the Cellar, I say, and the Devil fly away with it!'

The Schoolmaster's indignation was more convincing than any explanation could have been, and, as Cook felt certain that fairies were not accustomed to swear, she began to pay attention to his news. When she realized that it was about unbolting the dungeons for the Professor and Maria, she gave up trying to understand why the visitor should be six inches high. Were he a spirit of grace or goblin damned, she felt prepared to follow him, if it meant the rescue of her mistress.

She produced the bicycle from one of the smaller ovens, which she used as a garage, and seemed resigned when more and more of the Lilliputians began to filter into the kitchen. They had watched the proceedings of Captain from a safe distance, and now came forward, seeing that the embassy had been safely accomplished.

There was a basket on the handlebars of the bicycle, into which she put several of them, at their request.

Captain wanted to carry the Schoolmaster in his mouth, and was dissuaded from this with difficulty. He ran behind when the expedition set off, anxiously watching the basket, for fear that his new puppy might fall out.

Cook pedalled down the Service Corridor at full speed, carefully ringing her bell at the corners. She propped the machine against the wall at the top of the cellar stairs, and hurried down the ancient steps as fast as her bad leg would permit. A crowd of the People were grouped around the bolted door. They had smoky torches made from rushes dipped in mutton fat.

She was able to draw the bolt.

When the door flew open at last, it was to show the Professor and Maria at the end of the corridor, seated on the rack in the fading light of the electric torch, eating a hearty meal of small sheep and smaller loaves, which had been brought for them by the other party, through the broken window. The Professor was in high good humour, and had forgotten about being locked in.

'Ah, Mrs Noakes,' he cried, waving a leg of mutton. 'Come in, come in! Just in time to share our miniature repast! Something quite in your line, Mrs Noakes, a piece

of cookery which would interest the Goodman himself. The mutton positively melts in your mouth. Take a chair. No, there is no chair. Take a block, Mrs Noakes. Allow me to help you to a couple of these hoggets. You will remember the extraordinary miscalculation made by Dr Swift, when he was estimating the number of sheep that would be eaten daily by Surgeon Gulliver, on the island of Lilliput. I fear that the poor Dean must have confused himself with his cube roots. Sufficient, he says, my dear Mrs Noakes, for one thousand seven hundred and twenty-eight Lilliputians. Yet, if a hungry Lilliputian could eat, say, one leg of mutton in a day, one thousand seven hundred and twenty-eight of them would eat the equivalent of two hundred and eighty-eight entire sheep. Do you suppose that you could eat two hundred and eighty-eight larks in one day, Mrs Noakes? No, no. Twenty-eight is more like it. The estimate must be ten times too high.'

Cook took no notice of all this nonsense. She rushed to her long-lost Maria, and folded her to the ample bosom.

While the hugging was being done, the Professor trotted off to find a convenient block for his old friend. He was determined that she should sample the mutton, and, after trying various makeshift seats, he fixed on an ancient chest which stood beside the Manacles. When

he began to pull it across the floor, the lid opened. It was full of parchments.

'Dear me,' he exclaimed. 'What a find! Somebody hold that torch. Why, here is a charter-hand script, Maria, which says that your ancestors were seized of the Castel of Malplace in the thirteenth century! And here is Castellum Male Positum, in a late Carolingian minuscule. But wait! What is this? My goodness, can it be . . . I wonder . . . Suppose one were to sue out a suit of *mort d'ancestre*, on the basis of this charter, with perhaps just a touch of *praemunire*, but particularly the *mort d'ancestre*, and suppose . . . Dear me, this is extremely interesting! I think I will just take the liberty of putting this document in my pocket, Maria, so that I may work it out in full, at leisure.'

27

IT WAS late at night, and the two expeditions were plodding across the province which Maria's ancestors had called a garden. The Vicar was pacing back from the distant Vicarage with his brace and bit, while Maria and the Professor were making their way in the opposite direction, along a different path, to the cottage. What with the rest which she had enjoyed, and the nourishing meal, she had flatly refused to be carried in the Boy Scout lift, to the Professor's grief. He was consoling himself by telling her the names of stars, as they went. The moth wing of the Milky Way was gently glowing above their heads, which he claimed to be really the Milky Wey, except that people had got it muddled.

The time was nearly one o'clock in the morning, so that Sagittarius the Archer was lowly crossing the meridian, and the old gentleman told her how the hub

of the Universe was situated near that constellation. They themselves were spinning round the sun, and the sun was spinning round the hub ten thousand times faster than an express train, and the hub at that moment was in its right ascension. Maria felt quite giddy with all the spinning, particularly as she had to walk with her head craned backwards in order to admire the zenith. She felt as if she would soon begin to spin herself, till she whirled away in a powdery blue, to join the mealy bloom of nebulae.

At the cottage she was given a good dose of dandelion wine, and put to bed.

The Professor wheeled his tricycle from the coalshed when she was settled, fetched the curly bowler hat and the faded ulster to cover his shabby clothes, locked the front door, and hid the key as he had promised under the geranium. He looked at the window where Maria was already sleeping peacefully, and told himself that all was safe. It was high time to claim police protection on the score of bruises and handcuffs, and to lay an information against the villains of our story. Even if the Lord Lieutenant were in his Garter or his Bath, or in his bed itself, he would have to be waked without delay. 'Speed!' cried the Professor, as he pedalled away. 'Expedition! A stitch while the iron is hot! Never put off tomorrow without a hap'orth of tar.'

When the Vicar reached the Palace at last, after his

double journey, he and Miss Brown went down to the cellars at once, to set out the work of capturing the People. They stood staring at the open door in the light of the guttering candle, and the hum died to silence in the back of his nose.

'Gone!'

First he looked at Miss Brown, convinced that she had double-crossed him. But as she was looking at him with the same expression, each with a face as wicked as the other's, they trusted one another instinctively.

They went in hastily, and poked among the instruments of torture. They searched the other cellars. They sat down in the cobwebs on an empty barrel, and were silent for so long that the grey mice crept out once more to scamper through the dust.

Miss Brown spoke first.

'However they went, they are gone.'

'And the midgets.'

'He has taken her to the cottage, as he said he would when we were listening, and has gone for the constable on his tricycle, to lay a charge against us.'

'It was you who suggested the handcuffs.'

'Fool,' said Miss Brown.

She continued evenly: 'The old dolt said that he would lock her in, and hide the key under his secret pot of pink geraniums.'

'What does that matter where he hides it? If we are to be arrested, and the dwarfs are lost . . .'

'No need to be arrested.'

'How?'

'Nobody knows that Maria was here. She was thought to be away on a visit. We thought so outselves.'

Her pebble eyes challenged him to contradict.

'We thought so ourselves. We told Cook. Yet we find that he has somehow or other managed to decoy her to his cottage. If she were found dead in that cottage, Mr Hater?'

'I refuse to have anything to do with it! I will not be mixed up in an affair like this. It is too dangerous. It is impossible.'

'He locked her in when he left,' pursued Miss Brown, 'and hid the key under the pot of pink geraniums, *a secret spot known only to himself*. His finger-marks are on the key. Suppose the key were in its place when he returned, with the police, and that the cottage were still locked, the key still finger-marked? We only need to lift it carefully, in gloves.'

'I will not help.'

'In the locked house, which he confesses to have locked himself, the kidnapped child lies dead.'

'It is preposterous.'

'He will be judged insane, because he fetched the constable.'

'But, Miss Brown, this is a nightmare! There can be no possible reason for killing Maria, no chance of escape for ourselves if we did.'

'It is that or prison. If he is sane, there is his charge against us, with her evidence. If he is mad, and she is dead, we are at liberty.'

'But the minnikins!'

'You and your minnikins.'

She held the candle close to his face again, and the purple veins and the blue lips went pale.

'We could not do it.'

'We must go at once, or it will be too late.'

'I refuse. It is all too hurried.'

'We must get there first, whatever happens. Perhaps we can think of something better on the way.'

They stood up simultaneously, and left the cellar.

The dauntless Gradgnag – as usual, like Allan Quatermain, a dependable Watcher-By-Night – stepped from behind a wine bin when they had gone, and made all haste to climb the stairs. Everything depended on speed. The Schoolmaster and the Admiral would have to be found at once. Plans would have to be made for warning Maria, even for guarding her if possible, since

the secret of the geranium pot was out. It seemed beyond the bounds of possibility that they could really mean to kill her, but the Professor would have to be warned also, wherever he was, and the police protection would have to be hurried.

Fortunately the main body of the searchers were still inside the Palace, for things had been happening quickly. The Schoolmaster was in the kitchen with Cook, where he was trying to explain to her the difference between himself and a fairy, now that the danger seemed to be over.

He took the direction of affairs when the crisis had been reported to him, and did his best to arrange a plan.

Speed was the main object, and speed was a multiple of length. One could not go at so many miles an hour unless one covered the miles. In the first place, owing to the difference in stride, it would be impossible to keep up with the assassins on foot, once they had started for the cottage, and this they had probably done already. They were twelve times faster than the People, by stride alone, and that was leaving out the question of country. What was walking country to them was generally climbing country to the Lilliputians, and, where they could go straight, their pursuers would often have to make a detour. Fortunately there was a cavalry squadron of

guards, mounted on fast rats, and he sent a message to these that they were to gallop hell-for-leather to the cottage, where he would join them on one of the rats which were still about the Palace, once he had arranged the rest of the campaign. They were to detail a troop to harry the enemy as they walked, were to wake Maria up and hide her if they should get there first, and, if not, they were to take whatever action they could.

This brought up the question of size once more. Lilliput had none of the aircraft carriers, anti-aircraft guns, and other paraphernalia with which the Professor had been proposing to capture his Brobdingnagian. It was a question whether even a squadron of six-inchers could do much against a towering human. The Admiral had arrived while the operations were being arranged, and he and Cook made a kind of defence council with the Schoolmaster, to discuss the difficulty. They could skirmish round the prowlers on rats, charging in like kerns to prod them with the needle swords, and cantering away again for safety, but this might not prove to be more than an annoyance. Their archers could shoot also, but both the Vicar and Miss Brown, like Gulliver, wore spectacles. On the whole, the best hope seemed to lie in stratagem. What form it might take would have to be dictated by the circumstances of the field. By some means or other, taking advantage of whatever might

turn up, they might be able to lead their adversaries astray, or to trick them, or to defeat them by cunning. All this would have to be left to the psychological moment. If necessary, if no trick presented itself, they were willing to give them battle, face to face.

The worst problem was how to reach the Professor.

It was evident that he would have to be recalled as fast as possible, so that he could bring the police upon whom Maria's safety really depended. The best that the People could hope to do against such desperate characters was to delay them until help arrived. But all the telephones of Malplaquet had long ago been disconnected, in the general ruin of the family; the Cook's bicycle had developed disastrous punctures on the way back from the cellars; and the People themselves had never been outside the grounds. They did not know the way to the Lord Lieutenant's, and could not have reached his home in the time available on rats – for these animals were not accustomed to distances.

It seemed an insoluble problem, and there was no time to think about it properly.

The Schoolmaster seized Cook by the little finger, for he was standing on the workbasket beside her, and squeezed it hard.

'Madam, we must resign these Circumstances to your Sagacity. Some Message, somehow, must be sent. Pray

cogitate, Ma'am. Pray rattle your Brains. 'Tis a Matter which concerns her Life and Honour. We must leave the Message to you. So, so, a Gallop, a Gallop. Faith, may we come in Time!'

Meanwhile, on the dark Riding, Miss Brown suddenly shrieked with vexation, and clapped her hand to one ankle, as Maria had done before. She was still hopping when the Vicar put his foot in a trap made by tying two bunches of grass together, and fell on his nose.

Indeed, it was a strange sight to see them thereafter, as they blundered up the midnight avenue under the cobalt light of stars, wrangling about Maria. The miniature ratmen were charging unseen, and thrusting with their needles, which the villains mistook for thorns. The glint of small accoutrements flickered in the long grass. Every now and then the giants fell over a grass trap. Every now and then they hopped about. Sometimes they paused to upbraid each other for their clumsiness, sometimes to hiss agreement or dissent about their schemes.

And all around them, in the darkness, there were the smaller and vengeful denizens of the island world. It was like a rodeo, to see them gallop in and out.

Shortsighted badgers, at the din, faded their starlit streak of snout into a deeper darkness. Foxes, with concave eyelights, peeped at them and pondered.

Inquisitive rabbits stood on their hind legs, with ears erect, to see them go, and said: 'Good Lord, what's the matter now?' The owls of Malplaquet, on silent wing, glided about the centre of commotion.

In the doomed cottage, Maria slept in peace. In the vaulty kitchen of the Palace, brave Cook sat writing hard. Her nib was rusty, her ink was only sediment in a penny bottle, and her pink tongue was sticking out. It carefully made the curls that she was turning with her pen.

'Kind sir come back at onct as them as what you knows of sir is up to triks again . . .'

28

THE Professor had found the Lord Lieutenant out of bed. The latter happened to be the Master of the Malplaquet Hounds, the one with the electric bell-indicator which Maria had coveted for Gull Island, and he had evidently been having a Hunt Ball or a Farmers' Dinner, for he was dressed in a scarlet tail coat with violet facings, and was wearing the buttons of the Hunt awarded only For Valour. He had changed into mauve carpet slippers with his monogram worked in gold.

He was a tall man with an anxious expression, and he had a walrus moustache which he had to lift with one finger, when he wanted to eat.

He took the Professor into the Dining Room, and gave him a glass of port, while the latter told his story.

The Dining Room had a polished mahogany table with a sideboard to match, and fourteen chairs ranged

round the walls, where the servants had to say their prayers every morning. The wallpaper was dark red and there were oil paintings on the walls. There was a picture of the Lord Lieutenant on a Borzoi-looking horse, by Lionel Edwards, with a lot of hounds wandering about among its legs. There was one of the Lady Lieutenant, on a roly-poly one, by Munnings, and another of some of the little Lieutenants, on anatomical ones, by Stewart. There was a baby Lieutenant, on a rocking-horse, and several generations of Grandpa Lieutenants, on mounts called Mazeppa, Eclipse, or the Arab Steed. Some of the pictures were of mares and stallions by themselves, and these included honest creatures by Romney, fiery creatures by Delacroix, sagacious creatures by Landseer, and dotty animals with distended nostrils by anonymous eighteenth-century artists. The only person not on a horse was the Hon. Lettuce Lieutenant, the eldest daughter, who had made the mistake of being done by Augustus John. He had left it out on purpose, out of spite.

The Lord Lieutenant said: 'But I say, I mean to say, do you mean to say, old boy, that this vicar of yours and that Charming Miss What's-her-name have been maltreatin' the gel in the what-do-you-may-call-it?'

'I have been trying to tell you ...'

'But, good Lord, my dear chap, you can't do that sort

of thing in the nineteenth century, or the twentieth, or whatever it is. I mean, you take the first two figures, and add one, or subtract one, I forget which, for reasons I never could fathom, possibly owin' to these X's which those chaps are always writin' on monuments, and then it is different. Now, take horses . . .'

'Whether you can or can't, it has been done. I tell you . . .'

'My oid Granddad, or his granddad, I can't remember which, used to ride a hunter in a long point until it foundered, old boy, died, absolutely *kaput*. Now you couldn't do that sort of thing nowadays, not in this century, whichever it is, without getting the Society for Cruelty to Animals after you. Absolutely couldn't do it. Not done. Out of date. I heard it was the same with dungeons?'

'It may be out of date, but it happened. They locked Maria in the old cellar, because . . .'

The Lord Lieutenant poured himself a glass of port, inserted it neatly under his moustache, and eyed the Professor warily across a silver horse full of walnuts.

'Did they torture you?'

'No, they didn't. It so happened . . .'

'There you are, you see. All hearsay. Now, take horses. You are always meetin' chaps who say they know of a horse that trotted thirty miles an hour, but when you

ask them was it their horse, they say it was some other chap's horse, and there you are. Now . . .'

'Good heavens . . .'

'Here, have a cigar. We keep them in this filly here, for parties. Look, you just press her tail down, like this, and the cigar comes out of her mouth, like that, oh, I'm sorry, and at the same moment her nostrils burst into flame, so that you can light it. Neat, isn't it?'

The cigar shot out of the gold-plated steed, hitting the Professor on the nose, while a musical box inside the creature's stomach played the last bars of 'A-Huntin' We Will Go'.

'I came to ask . . .'

'My dear old boy, look here, be advised by me. You drop the whole thing. You've got it muddled up. Perfectly natural, of course; no criticism intended. Anybody could get muddled on a thing like that, I should have done myself. But when you've been a Lord Lieutenant as long as I have, or a Chief Constable, or whatever I am, you'll know that the first thing a Lord Lieutenant has to get hold of is a motive. Can't have a crime without it. I assure you, it's an absolute fact. First thing a criminal must do is get a motive. It's in a book I read. Printed. Now what motive could Miss What-you-may-call-it possibly have for wanting to handcuff young Thingummy in the what's-it?'

'There was a strong motive, but I am not at liberty to disclose it. It concerns the identity of other people.'

'Ah, I see. Very proper, I'm sure. No names, no pack drill. H'm, yes. It couldn't,' whispered the Lord Lieutenant breathlessly, 'be dear old Lottie Catamount gone off again with one of the footmen?'

'Certainly not. Nothing of the sort. Maria was aware of the whereabouts of certain people whom Miss Brown wanted to trace, and she maltreated the child to make her disclose it.'

'Roundabouts, eh? Gipsies, I dare say. Wonderful chaps with horses. Now...'

'Not roundabouts!' shouted the Professor. 'Whereabouts...'

'Here, have some coffee. We keep it in this copper horse here, with the methylated lamp under its tummy. You just twist his near fore, like this, and it pours out of his ear, like that, oh, I'm sorry, and the sugar is strewed about in this silver-plated stable here, to represent bedding. Pretty, isn't it?'

The Professor mopped the coffee off his knees despairingly, while the coffee-pot played 'John Peel'.

'I have a right as a citizen of this country to ask for police protection, and it is your duty, as the Lord Lieutenant, to investigate the grounds...'

'Good Lord, old boy, you can't have police protection here. What's the good of sending old Dumbledum to protect you? Besides, I happen to know he has a lumbago. His wife sent up to borrow a smoothing iron only this evening. And who, may I ask, would stop all the motor cars, and take their licences and that, if Dumbledum was protecting you all the time?'

'Dumbledum . . .'

'Here, have a chocolate. We keep them in this china hunter here, for convenience. You just lift its tail, like this, and chocolate comes out there, like that, oh, I'm sorry, and he plays the "Meynell Hunt", only some of the notes are missing. Useful, isn't it?'

The Professor fished the chocolate out of his coffee with fury.

'And another thing, old boy. What about witnesses? That's one of the first things you have to have in a crime, believe me, as a Lord Lieutenant – unless you go in for circumstantial evidence, as we call it, or whatever they call it. Witnesses! It's vital. You can't do anything, hardly, without them. Look at that fellow who blew the other fellow up, unless it was himself, in the garage, or swimmin' bath, or whatever it was, only the other day. He had dozens of witnesses. Blew them all up as well. You see? I mean, you could almost say that you can't do a crime without 'em. And where are yours, do you suppose?'

'I have a witness, Mrs Noakes.'

'And who is Mrs Noakes, when she's at home?'

'Mrs Noakes is the cook at Malplaquet.'

'Good Lord, not Mrs Noakes! Mrs Noakes is Mrs Noakes. Why, I know Mrs Noakes as well as me own mother. That's an extraordinary thing, I must say, I mean that she should be her! Well, I remember her quails in aspic, in the old Duke's day, poor fellow, yes, and her oyster soufflé. An invaluable woman. Often tried to get her to come over to us, but she preferred to stay. Family feelin'. Now, take horses . . .'

'Not horses!'

'Well, hounds then.'

'Not hounds!'

'Yes, hounds. Take hounds. A hound will eat almost anything.

'In fact,' added the Lord Lieutenant blushing, 'they often eat horses. Boiled, you know. In a sort of soup. Cruel, really, when you come to think of it. But there, it's their nature. So far as that goes, they often try to eat me. Desperate animals. It comes of living in the open air, I suppose. Makes them hungry. And horses too, they eat all sorts of things. Hay and that. But human beings, they want quails in aspic. Makes you think, doesn't it, what, don't you think?'

'I don't think anything at all about horses or hounds, and, once for all I insist . . .'

'Good Lord, I believe you're back again on those dungeons. You ought to think about something else, old boy, or it will become a fixed monomark with you, like when the wind changes. Here, have a cigarette. We keep them in this platinum polo pony here, for sentimental reasons. It's an old pony of my own, poor chap. Dead, of course. Must have been dead about forty years by now. You just lift up the polo stick, like this, and he opens his mouth, like that, and out comes a cigarette, oh, I'm sorry, use a napkin, and, as you see, he plays "Old Faithful". Sad, isn't it?'

The platinum pony had shot out a stream of about fifty cigarettes, knocking over the coffee and the port into the Professor's lap.

He leaped to his feet, banged the table, and shouted wildly: 'I demand a hearing! I refuse to be pelted with these articles!'

Then he folded his arms and sat down on a comic cushion, which began to play 'Boot, Saddle, to Horse, and Away'.

'Good Lord, old boy, what are you sitting on that for? You aren't supposed to sit on that. It's supposed to be a sort of trick, to catch people . . .'

The Professor hurled the cushion on the floor, which

made it play again, swept several horses out of the way, and shook his fist under the Lord Lieutenant's nose.

'No good browbeatin' me, old boy. Everybody always browbeats Lord Lieutenants. Doesn't do a bit of good. To tell you the bitter truth, I simply don't believe a word you say. Tryin' to pull me leg. Won't work. Now, if Mrs Noakes was to tell me all this about dungeons and things, I'd believe her like a shot. I'd believe her if she told me that a mince pie was a ham omelette. But when a chap like you comes along, jabberin' about roundabouts . . .'

'But I tell you that Mrs Noakes will corroborate what I say . . .'

'Produce her, then. Produce your witness. That's what we say, in the law, you know. Produce your witness.'

'How can I produce her when she's an old woman with a bad leg five miles away in the middle of the night?'

'There you are, you see. As soon as we get down to brass tacks, you always say it can't be done. Like trottin' at thirty miles an hour. I say I'll believe Mrs Noakes, you say you can't produce her. I say I don't believe you, you start chuckin' cushions about. Now, take horses . . .'

The Professor clutched his whiskers.

'Take horses. You can always believe a horse. I always say to everybody, Give me a horse, and I'll believe it. If a horse says there is wire in that gap, believe me, my

boy, there is wire in it. Or take hounds. I always say to everybody, Give me a hound, and I'll believe it. If a hound says there is a fox in that gooseberry bush, or in that hatbox, or whatever it is, believe me, my boy, there is a fox in it. Always believe a horse or a hound.'

The Professor had sunk back in his chair, pulling his hair out in tufts, when there was a gentle scratching on the door.

'That's one of the hounds,' said the Lord Lieutenant happily. 'Let him in, there's a good fellow. I suppose I must have fourteen or fifteen of them round about the house, in various places. They sit under all those chairs at dinner and wait for biscuits, like dear old Lord Lonsdale. Always believe . . .'

A footman, however, opened the door, and announced deferentially: 'A strange dog, me Lord.'

Captain was standing politely on the mat, with a shopping basket in his mouth. When he saw the Professor, he wagged his tail and came in.

The Professor read the letter in the basket and passed it to the Lord Lieutenant.

'Read for yourself.'

'Dear me, a letter from the dog. Interesting, very.'

He produced an eyeglass from his waistcoat pocket, disentangled the ribbon from his moustache, fixed it in his eye, and began to spell the letter out.

'"Kind sir come back at onct . . ." Bad spelling, that. Should be an S in it. However, you can't expect good spelling from a dog. It's not their nature. ". . . as them as what you knows of sir is up to triks again, namely that here Vicar and his fly by nite" – Good Lord, that will be Miss What's-her-name, just like you said – "and have gorn off" – good heavens – "gorn off to cut Maria's throat"! Poor child, poor child, good gracious, this is shockin'! "So please come at onct" – I should think so, too – "as If not it may be two late and Tell His Lordship" – that will be me, I expect – "to bring the Army"! My stars, thank heaven the hound has come in time! Always believe a hound! How clever of him to write it. Must have learned it in a circus or somewhere. Bring the Army, he says. Yes, of course. The Army. Fancy cutting a child's throat like that! Well, we must act. Action. Let me see. Where's Kingdom? Somebody fetch me Kingdom. Oh, there you are, Kingdom. Here, Kingdom, get me some people on the telephone. Get me the Army and the Navy and the Air Force and the Fire Brigade and the Home Guard and the Rural District Council and the St John Ambulance Association. Get me. Here, get me the telephone. I'll do it meself.'

The butler carried in a telephone in the form of a plastic Derby winner, and the Lord Lieutenant began to

shout commands into its mouth, occasionally applying its tail to his ear.

'Is that the Exchange? Where is the Exchange? Why not? Well then, why didn't you say so? Get me Mr Winston Churchill. Certainly I said Mr Winston Churchill. Give him to me at once. Who the deuce are you, Sir? I tell you I'm the Lord Lieutenant. No, I'm not. Yes, you are. An impostor? So are you. That settled him. What? My good man, what's the use of Mr Attlee? Get me Mr Churchill, like I said.'

WELL, they dissuaded him from recalling Mr Churchill at last. After that, he wanted to have General Eisenhower, Field Marshal Montgomery or Scotland Yard. The Professor cunningly went aside and wrote a message, which he persuaded Captain to deliver, saying that though the Far Eastern Battle Fleet might be very useful, yet they themselves being on the spot, would be sure to get there sooner. The Lord Lieutenant was delighted by this second example of canine sagacity, and agreed to send at once for P.C. Dumbledum. The posse was collected without further argument.

It set off to rescue in the early hours of the morning, much excited. The Lord Lieutenant was on a horse, the Professor was on his tricycle, and P.C. Dumbledum was in a wheelbarrow, owing to the lumbago. This was

propelled by his wife, a woman of strong character, who was also the village postmistress.

'Faster, Mrs Dumbledum! Faster, Professor! How can I gallop, old boy and Mrs, when I have to keep up with a wheelbarrow?'

'Faster, me Lord, I cannot go, but ride you on ahead with the gentleman, and Dumbledum shall not be far behind!'

'Faster, indeed! How can anybody go fast with that confounded horse stamping on everything? Have you brought the warrant, the *habeas corpus*, the *de heretico comburendo*?'

'No, no, no. I tell you it will be sufficient for Dumbledum to produce his truncheon. It has the Royal Arms painted on it, dated 1807. How are you, Dumbledum? Can you move at all? Are you still conscious?'

'Oh, me Lord!'

'There you are, you see. He can produce his truncheon. I wish I had a badge to wear, though, or a lassoo or something. Never mind, I can crack my whip. I say! Good Lord! Old boy, I say, can I see something white? Look there, ahead of us! Goodness! Oh, my, do you believe in ghosts?'

'No, I don't.'

'I don't either, really. Could we keep closer together?'

'There is something white. I can see it.'

'Good Lord! I say, shall we go home? I mean, we should come again in the mornin'. Now don't tinkle your bell so much. You might frighten it.'

'Take horses,' added the Lord Lieutenant faintly. 'Horses believe in ghosts, you know. In fact, they frequently are ghosts. Headless ones, with hearses and that. Don't you think it would be best if we . . . I say, do you think it is walkin'? You know, out for a glide? Do stop tinklin' your bell, old boy. I mean, if we could just sort of pass by without lookin' at it, it might go on with its walk, mightn't it?'

'There is a hound with it.'

'Yes, I see it. Now, take hounds. Hounds are frequently ghosts also. Headless, of course, with the hearse, and generally black. I say, must we keep talking about hearses? Oh, Lord, do you feel all right?'

'It is Mrs Noakes.'

It was, and Captain was with her, as she limped on valiantly through the long grass, for the second time during that long day. He had returned home at once, after delivering the two vital messages so magnificently.

'Mrs Noakes! Hurrah! Hullo, Mrs Noakes! Bless me, you did give us a turn! We thought you were a ghost, only, of course, we don't believe in them. Well, well, well! I think we ought to have a biscuit now, to revive us after

the scare. Fortunately, I have brought my biscuit box, which I take with me when I am out huntin'. I keep them in this chromium steeplechaser here, for safety. You just turn his tail to the left, like this, and his saddle swings open, like that, and a kind of machine inside him gives you a biscuit, like this, oh, I'm sorry, never mind, we will have some others when we get home, and of course he plays "Reynard the Fox". Convenient, isn't it?'

They left the biscuits where the machine had scattered them, in a wide circle, and hurried on beside the new recruit. They passed by peeping fox and shadowy badger, by inquisitive rabbit and soft-winged owl. The stars of the short summer night began to pale as they went and the small wind that goes before the dawn rustled the treetops with its single sigh. They could already see the outline of the cottage chimney, dark against the dimness, when the second ghost appeared.

It was outside the cottage itself, dancing gravely in the dew. When it saw Mrs Noakes it gave a shout of joy, and rushed to hold her to its bosom.

'Maria, my lamb! So they ain't cut your throat arter all! Oh, dearie me, I've come all over queer of a sudden, and I can't find me ankercher!

'Whoo-hoo-hoo,' added Cook, weeping happily down Maria's neck, 'and you a-dancing in the dewdrops without any shoes on, my cherubim, and in the pore

Professor's nightie! Glory hallelujah, is what I say, begging His Lordship's pardon, I'm sure, but such a day as it's been for old bones with this and that is more than some could suffer the endurance with what so willingness as they was sustained by whithersoever! And, oh, my precious pet, them villyans that was arter you, they may still be about us notwithstanding!'

'I got 'em,' said Maria. 'We . . .'

The Professor coughed.

'I got 'em,' said Maria, catching on. 'I locked them in the cellar. Come and see.'

The Professor used to keep his homemade wine in the wooden coal shed, so he hurried the party round to the back of the cottages, to see what damage had been done. There was profound silence inside.

'Now then, Dumbledum. Produce your truncheon. Good Lord, he's left it behind. Never mind, produce your armlet. It has blue stripes on it. Yes, yes. It will do splendidly. Mrs Dumbledum, tip him out of the barrow. Are you alive, Dumbledum? Good, good. Try to prop him up, Professor. Don't groan so, Dumbledum, or it won't be a surprise. Now then, Mrs Noakes, you open the door. Unlock it first, of course. Maria, take horses, I mean take my horse. I mean, hold it. You hold it by this thing here. That's right. I shall stand behind you, Mrs Noakes, with my huntin' crop, in case they turn nasty.

Excellent. Now then, when I say One, unlock it, when I say Two, throw it open. Then we shall all rush in and overpower them, or they will all rush out and overpower us, of course, since it depends how it happens, and Dumbledum must do his duty. Don't let him fall down, Professor. He is sagging in the middle. That's better. Now, are we all ready? Keep calm, everybody. Don't get excited. I shall begin to count in half a minute, when I can get my breath. Desperate characters. Oh, Lord! On the word Two. One, two, three, four, five, six, seven, eight ...'

The door swung open, revealing the silent prisoners seated side by side on a barrel. They had so many expressions on their faces, of anxiety, of outraged dignity, and, yes, of triumph, that their features moved like water with the wind on it, formless. The Vicar's mouth was fluttering at the corner. He could not stop it.

'Now,' said the Lord Lieutenant, taking control of the situation, 'I arrest you in the name of the Lord. Dumbledum, the handcuffs.'

'I protest,' said the Vicar. He was husky, scarlet in the face and shaky. 'I insist on making a statement. Before witnesses. This barrel contains several hundred people, six inches high. Found by me and Miss Brown on our own property. We insist on opening the barrel before witnesses.'

'D.T.s!'

'I am a beneficed clergyman of the Church of England, wrongfully detained in this coal shed, and I insist . . .'

'Now, now,' said the Lord Lieutenant, 'none of that.'

The Vicar pushed him away with a fumbling gesture.

'But you can't push me, sir! I'm the Lord Lieutenant. You have insulted the King's Uniform. This blue-and-white thing of Dumbledum's. It's an indictable offence. Probably High Treason!'

'We insist,' cried Miss Brown in a shrill voice, 'on opening our barrel. Our own barrel. We call you to witness!'

They trundled it out with painful care, and knocked the lid in.

It was empty.

'D.T.s,' said the Lord Lieutenant. 'Obvious case. Think they see little men wanderin' about. Blue elephants and that. Well, well, sad thing really, I mean considerin'. We shall have to arrest them, of course. Can you move Dumbledum, Professor? That's right, I give them in charge for High Treason, drunk and disorderly, obstructing the Police in the discharge of their duties, that's the push they gave me, and for attempted manslaughter of Maria, though that seems hardly accurate, as it ought to be girlslaughter, but perhaps we can think of a better word

on the way home. Yes, and everything they say may be used in evidence against us, so you can't say I didn't warn them. Now, then, Dumbledum. Shove him along, Professor. Clap 'em in irons. Hanging too good for them. I say, what an exciting evening! Hold up, Dumbledum. Here, give me the handcuffs. I'll do it. Look, you just put your hands in this nickel stirrup thing for interest's sake, like that, and I press this knob, like this, and there must be some sort of machine in it, I suppose, because a kind of bar comes out to lock you up, like that, good Lord, it worked, but unfortunately it doesn't play anything at all. Ingenious, isn't it?'

'You stole them!' screamed the Vicar and Miss Brown, recovering simultaneously, and, already handcuffed together, they clutched each other by the throat.

Mrs Dumbledum removed them in the wheelbarrow, with the aid of the Lord Lieutenant.

In case you would like to know what happened to them afterwards, perhaps this is the best place to tell it. Most of the charges preferred by their captor were found to be valueless, much to his annoyance, but the cruel treatment of their ward was proved to the hilt, and it was also discovered that they had been embezzling the little money she ought to have had. They got heavy sentences for these things. The last that was seen of them in the Northampton district was when they were taken to jail

in a third-class carriage. The Vicar crouched in a corner seat, holding a two-day-old copy of the *Daily Express* in front of his face, upside down, with trembling fingers.

It was reported some years later that they had married each other, which was about the worst fate that could befall them, and one of the locals who came back from a holiday at Whitby said that he had seen them in that district, being booed by the small boys, refused drinks by the publicans, and made to walk by the bus conductors. The Professor does not think they would really have murdered our heroine, but it served them right for all that, say I.

Maria told the others her own story in the game-keeper's cottage, over a filling breakfast of boiled water and the remaining bloater.

'The Schoolmaster got here long before they did,' she explained, 'but you had locked the door and he couldn't reach the keyhole. He managed to scramble up the plum tree to the window sill, but then the glass was too thick for him to break, so he had to go down again for a stirrup, and he managed to smash it, in the end, with that. And luckily the doors inside were all open, and he told me I had got to hide, and we went all round looking for a place, and in the end he said it would be best in the wood. And we were going out when he looked into the coal shed, and he said it was a pity I couldn't hide

in a barrel like him, and he went in and knocked the barrels with the stirrup and one was hollow, and he had a brilliant idea. It was simply brilliant. And we could hear them quarrelling near the Byng Monument, and I unlocked the front door, and we put your candle so that it would light the steps, and we opened the cellar door, and I hid behind it. And in the end the People arrived, all skirmishing and galloping on rats, and he drew them up on the step so that they would be seen, and when those two silly asses opened the gate he made them all shout rude remarks and wave their swords like anything! And Miss Brown and the Vicar forgot about me, and they ran to and fro like mad things making grabs, and the People kept withdrawing according to plan, without being caught, and in the end they rushed into the coal shed, and Miss Brown and the Vicar rushed in after them. And I slammed the door, and I locked it, and I danced on the back step. And I could hear them striking matches and cursing. And of course the People had climbed into the barrel, through the bung hole, where they could not reach! And that was the plan. Wasn't it terrific? But I got it better, you know. I found a brace and bit they were carrying, and I went round behind the shed, and I drilled three holes, and it was a three-quarter inch bit, and they went right through the wall and through the barrel, and the People all scrambled out by the back!

Wasn't it a sell? Wasn't it clever of us? As a matter of fact, they are hiding out there in the gooseberry bushes this minute...'

She got up hastily at the thought of her friends, and went gladly to the window, where she waved the bloater.

From outside, in the golden sunrise, there came a tinkling cheer.

IT WAS nearly five months later that a tired old gentleman in a curly bowler hat and a faded ulster was wheeling his tricycle up the Grand Avenue of Malplaquet, in the snow. A tired young lady was sitting on the saddle, clutching an enormous parcel, and the bare trees were thick with icing. The sun was setting a blaze of scarlet, tinting the white expanse with a saffron tinge between the purple shadows. Various robins hopped about in the correct manner. It was Christmas Day.

They had been long away, staying at a poor hostel in the great metropolis of Northampton, for the Vicar's trial, and now Maria was coming home to the palace of her ancestors, a free girl. She was to have no more governesses or Algebra. It had been arranged that the Professor should teach her instead, at an inclusive fee of sixpence quarterly, which would be of assistance in his

housekeeping. They were tired with the excitements of the trial, with the difficult shopping they had done the day before, and with the long trudge from Northampton, taken to save the fare. Also they were hungry from doing without dinner, for they had saved on that too, in order to keep everything for the shopping, and the Professor was footsore, and Maria was cold.

'Dear me,' he said. 'Here is the Triumphal Arch at last. Only another mile and then I can sit down. It looks noble with the sun behind it.'

The Triumphal Arch was twice as big as the Arc de Triomphe. It had been put up to welcome the First Duke, when he came back after conquering the Nabob of Ooze, at Marzipan, in 1707.

'You scarcely notice it is falling down, not from a distance.'

'No.'

'I hope the People will be safe.'

'I hope so.'

'Do your feet ache?'

'Very much.'

'Do you know,' said the Professor later, 'I fear I must be getting old? I seem to need food nowadays, and a chair to sit on. It would be nice to be able to afford them. Well, well, we cannot have everything. I must say it is nice to have a tricycle. I forget who gave it to me. It was a

301

thoughtful gift. Now you mention it, however, I recollect that I found it in a ditch. There must be several people who have neither food nor tricycles, when one comes to think of it, so one is lucky, really, compared with them. And this new sixpence a quarter will go very far, very far. I shall be able to buy the penny fishhook, and all sorts of luxuries. Quite a plutocrat. Dear me, I believe we shall shortly be able to go freewheel, downhill.'

'There is something in the Arch.'

'So there is. Bless me, it seems to be barred.'

'I think it is something lovely!'

They quickened their lagging steps, to find out what it was.

In the enormous archway there was a banner. It was at least as large as a pocket handkerchief, high enough for them to pass underneath.

It said:

WELCOME HOME!
A LOYAL GREETING FROM LILLIPUT
TO THEIR MARIA!
AND TO HER ERUDITE FRIEND!
VENI, VIDI, VICI!
SIC SEMPER TYRANNIS!

The band was drawn up underneath, dressed in their best eighteenth-century clothes and three-cornered

hats, with a lantern on a pole, so that they looked exactly like the Waits in a Christmas card. The flautists had red mittens to keep their blue fingers warm, and they licked their freezing lips so that they would be able to blow. As soon as the travellers were within earshot, the whole orchestra burst out as fortissimo as they could with 'See, the Conquering Heroes Come!'

There was the usual illuminated Address, and, while the Schoolmaster was reading it aloud, a party of sailors under the Admiral swarmed up the tricycle to attach a harness of horsehair ropes. If there had been any horses they would have taken them out, but, as there were none, they had to do without. Then, with the Address concluded and the band marching in front to the strains of 'Rule Britannia', the haulage party set to work, for the rest of the way was fortunately downhill, and Maria was drawn home in triumph by her devoted tenants! The Professor marched behind with quite a springy pace. He was charmed with the Latin on the banner, which had been put in specially for him.

When they reached the North Front, the whole of Lilliput was drawn up on the top step, in their furs and comforters, and Cook stood in the middle with a second banner of red flannel and cotton wool, which had been used in the old times when the dukes came home from school. It said: HAPPY HOLIDAYS! As soon as

the cortège arrived at the steps, all the ladies of Lilliput produced handkerchiefs and fluttered them, all the children removed their hats, as they had been instructed to do, to give three shrill huzzas for the Squire, and, in the hush that followed, the bells rang out Noel!

A party of musicians had been sent to the Clockroom in the pediment, where they had disconnected the machinery which played 'When the Heart of a Man', so that they could use the bells for a Christmas Peal.

Most extraordinary of all, there was a blaze of light from the Grand Ballroom. They hurried in, to discover the cause of this, and there was an enormous Christmas tree, a whole spruce in a barrel, with hundreds of rush lights all over it and the Lord Lieutenant lighting them with a cigarette lighter in the shape of a filly, while Dumbledum held the ladder. The People had voluntarily disclosed their secret to these two, so that they could get help in moving the tree, and to have them at the celebration. On the tree there were presents for everybody, made by the craftsmen of the island in their spare time. There was a pair of spider-silk stockings for Maria, for which any film star would have given a king's ransom. For Cook there was a moleskin comforter to be worn round her bad leg. Dumbledum got some snake-fat ointment for his lumbago, which was better. Captain, who followed the Schoolmaster about all evening, got

a new collar made of the softest frogskin, beautifully tanned. And the Lord Lieutenant got a carved hound, no longer than his fingernail, which played 'Bobby Bingo' almost inaudibly, and threw out a shower of snuff, which made everybody sneeze. The Professor's present was a masterpiece. It was a Medieval Latin Word List (Baxter and Johnson, 10s. 6d.), which they had obtained by getting Cook to pawn their sprugs in Northampton. They had then written a letter on a piece of graph paper out of an exercise book of Maria's, enlarged it ten times by means of the squares, traced it on a piece of notepaper, and painted the words with a rat-hair brush. The letter and the money from the sacrificed sprugs had brought back the dictionary, in which the Professor instantly found TRIFARIE, trefoil, and he thereupon danced a coranto with Cook.

Maria dashed out for her parcel as soon as she could, which gave the final glory to the tree. During the trial the Professor had managed to touch the Lord Lieutenant for a fiver, and the whole of this had been expended on presents for the People. There were Woolworth silks galore; the finest threads and tinsels sold by the firms who tie trout flies, together with some Greenwell's Glories (size 000) for the ladies to wear in their hats; hack-saw blades for felling timber, and also fret-saw blades; wire traces for the fishermen; ant eggs for bait,

but of course these were really pupae; plenty of pins and needles; plain horn buttons without holes for plates; silver thimbles for drinking toasts on state occasions; a packet of mixed seeds of the smallest rock plants; for the children such things as the charms from plum puddings and some preserved currants, one each; for the grownups edibles such as whitebait, caviar, small beer, and snipe; medicines such as Carter's Little Liver Pills; a toy yacht for taking pleasure cruises; a toy telescope for looking at Maria through the wrong end of, in case anybody developed an inferiority complex; a Penguin book called *Elizabethan Miniatures*; some white mice and a pair of guinea pigs for farm stock; and a little crystal set with earphones, which would do for loud-speakers. No sooner had the presents been distributed and hugged, than the ringers in the Clockroom pealed out 'God Rest You Merry Gentlemen', and the doors of Miss Brown's dining-room were thrown open, suddenly to reveal the Banquet.

There were hors-d'œuvres of small sheep, a fish course of the twenty-pound pike, done by Cook so that it tasted like salmon, entrée of devilled bullocks, pheasants trapped in the grounds, plum pudding provided by Mrs Dumbledum, and a savoury of sticklebacks on horseback for the Lord Lieutenant. Dumbledum had carried down the Professor's barrels in the wheelbarrow,

and the Lord Lieutenant had brought some bottles of port.

Afterwards they had healths. The Lord Lieutenant proposed Mrs Noakes, Mrs Noakes proposed Dumbledum, Dumbledum proposed the Professor, the Professor proposed Maria, and Maria proposed the People. The People remembered to propose Captain, who wagged his tail. All these were drunk with three times three. Then the Lord Lieutenant gave Fox Huntin', and produced a wineglass in the shape of a huntsman's cap which played 'The Horn, the Horn, the Noble Horn', and suddenly exploded, drenching everybody with port. The Professor gave the Supposed Continuator of Ungulf of Croyland. Dumbledum gave Absent Friends, which Cook refused to drink – but the others had already forgiven the Vicar and poor Miss Brown, in prison, for whom they turned down an empty glass.

Finally the carol singers arrived, little boys about three inches high whose mothers had carefully brushed their hair with a drop of water to keep it down, and these sang 'O Come, All Ye Faithful' in trebly treble voices, until Maria cried.

What with the bells and the presents and the banners and the banquet and the trouble they had taken to meet her with welcome so far away in the snow, it was more than she could bear.

She made a speech which was mostly sobs, until she remembered to be tough, and then everybody broke into small groups, to drain a final thimble and to discuss the glorious campaign which they had fought and won together.

At this point Cook remembered that an important-looking letter had arrived the day before, with seven red seals upon it, and she delivered the same to Maria at once, in case it might contain a present.

It would take too long to explain the whole thing. To put it briefly, the letter was from Maria's solicitors. It seems that they had enjoyed a long talk with the Professor during the trial of the miscreants, and, by his advice, they had sued out a suit of *mort d'ancestre* in *trailbaston*, with collateral *praemunire* and just a pinch of *oyer and terminer, in partibus*, based on the document which he had discovered in the dungeon. The result was that the whole of Maria's great inheritance had been restored.

The cheers when this was understood were deafening! At least, they were nearly loud. Everybody shook hands with everybody else; 'Auld Lang Syne' and 'She's a Jolly Good Fellow' were sung simultaneously; the Schoolmaster actually patted Captain; the Professor kissed Mrs Noakes; the Lord Lieutenant promoted Dumbledum to Sergeant on the spot, and all looked

forward, with hopeful hearts, as they made their way through the snowdrifts of Christmas night, to the time when the ancient glories of Malplaquet would flourish as they had in the days of yore.

So that is the end of our simple story, Amaryllis, and now it is time for you to go to bed. But, before you go, it might be best to tell you one more thing. If you take the road from Northampton nowadays, to Monk's-Unmentionable-cum-Mumble, you will pass the stone gates of a gigantic avenue. All the hinges are oiled, all the trees are pruned, and, if you walk up it for five or six miles, you will come to a Triumphal Arch. Out of a side door in this, there will come a seven-foot Beadle in a gold-laced hat, bearing a golden staff and a brass dinner bell, to whom you should present your gilt-edged visiting card. The Beadle will rap three times with his staff, at which two under-beadles will throw the gates wide open, and he himself will ring his dinner bell like thunder, to give notice of your approach. As you wind your way up one of the five remaining avenues, a hundred contented-looking gardeners will look up from the spick tulip beds or from the span alvias, to touch their hats with stately courtesy. Take a peep as you pass at the one-time wilderness, and you will see that it has once more been laid out as a wonderful Japanese garden, shown to visitors each Friday on payment of 1s

for the Red Cross, with stunted trees and little houses and Hornby trains which really run. In front of you, you will see the golden façade of Malplaquet, at the head of its shaven lawns, with every tile in place and every stone repainted. A dozen footmen in scarlet and powder will rush down the steps, when you reach the North Front at last, and will deprive you of your umbrella. A dozen underfootmen, in mere striped waistcoats, will pass it up the steps, hand over hand. That will be the time to say that you have come to see Maria.

Unfortunately, however, you are quite likely to hear that she is out. Everybody will be kind to you. Everybody will give you a claret cup in tumblers or champagne in buckets, whichever you prefer, but, when you ask them where Maria is, they will just seem rather stupid. The fact is that every man on the estate, and there are 365.2564 of them, is, on one subject, sworn to deadly secrecy. If Maria is *you-know-where* they will not say a word.

But go you down past the Quincunx, Amaryllis, as you wind your long way home, and you might see a newly varnished punt, looking bright upon the water of the lake. You might even catch the flash of a skirt, or the twinkle of a long white beard, among the slender columns of Mistress Masham's Repose.

MISTRESS MASHAM'S REPOSE

The Backstory

Take the Mistress Masham quiz and find out
why this is Anne Fine's favourite book

VINTAGE CLASSICS

Who's Who in *Mistress Masham's Repose*

Maria: a ten-year old girl with dark hair and glasses. She is pretty fearless, except she doesn't like to be alone with cows or Bonfire Night.

Miss Brown: Maria's governess. She is podgy all over except for her sharp nose and she has an evil master plan to get her hands on Maria's vast inheritance. In the meantime she is habitually cruel to her young ward.

Vicar (Mr Hater): Maria's official guardian. A deeply repulsive man both morally and physically. He is in cahoots with Miss Brown and is already suspiciously rich.

Cook (Mrs Noakes): an old employee of the vast house where Maria lives. She has to ride a bicycle up and down the long corridors as she has bad legs.

Captain: Cook's intelligent, fat collie dog.

The Professor: as poor as a church mouse and utterly eccentric. The Professor is Maria's closest friend and companion, even if he is completely unpractical and immersed in the world of his books.

The Schoolmaster: the brave messenger and guide from Lilliput with whom Maria first converses. They become friends and he acts as spokesman for the Lilliputians.

Gradgnag: a famous Lilliputian trapper who is instrumental in foiling the plot of Miss Brown and the Vicar.

The Lord Lieutenant: the local horse-mad, and generally mad, keeper of the peace.

P.C. Dumbledum: the local policeman who helps put things to rights.

A message from children's book writer Anne Fine...

Suppose it was you, not Maria, who had found them – the tiny, finger-high Lilliputians Gulliver once met on his famous travels. Suppose, for the last two hundred years and more, they'd been busily and peacefully living hidden on a tangled, half-forgotten island in a lake somewhere in your vast, overgrown estates.

In the neglected old summer house where Mistress Masham once reposed.

Thus starts one of the finest, most magical and extraordinary children's books ever written. As we know from his masterpiece, *The Once and Future King*, T. H. White was unrivalled as a story-teller. But was it because he wrote this particular book the year I was born, and set his imaginary tumbledown palace of Malplaquet in Northamptonshire, the county where I spent half my childhood, that I feel he must have written it especially for me?

If I was his perfect reader, he wrote my perfect book. It has everything I could possibly have wanted: a resourceful

orphan heiress, a hidden will, a sneaky and grasping vicar, a spiteful, kitten-drowning governess, dangers and chases, imprisonments and revelations.

Children's writers are so often asked, 'Which other book in the world do you wish you had written?' By now, I must have read tens of thousands. But I still answer, truthfully, 'Oh, this one. Definitely, this one.'

Anne Fine

Who was T. H. White?

Terence Hanbury White was born in India in 1906. When he was fourteen he moved to England and went to boarding school, an experience he hated. Corporal punishment was common at that time and Terence suffered under the brutal discipline of the prefects and housemaster. In his diary he wrote that the housemaster used 'to beat us after evening prayers'. Some of the teachers weren't so bad though and one encouraged the young T. H. White to become a writer. White later said, 'I shall be grateful to him till I die.'

After school White went to Cambridge University where he graduated with distinction and after that he went to work as a teacher. During this time he wrote many poems and books, including his first bestselling book, *England Have My Bones*. The book was a memoir and all about White's experiences learning the arts of hunting, fishing and falconry (training hawks). All his life White believed in the importance of really living – being outdoors and doing manual work – in order to have interesting things to write about. He thought you couldn't write about something well unless you'd done it yourself.

England Have My Bones was such a big success that White

was able to resign from teaching to concentrate on his writing. Whilst he was a teacher, White had chanced across a book called *Le Morte d'Arthur* (*The Death of Arthur*) by Thomas Malory, all about King Arthur and the Knights of the Round Table and, unexpectedly, it captured his imagination. Once he had quit teaching, White started writing his own book about Arthur and in 1938 *The Sword in the Stone* was published. The following year, White moved to Ireland to avoid fighting in the Second World War – he was a conscientious objector – so it was there that he went on to write two more Arthur stories. These books, now usually published together as *The Once and Future King*, made White very successful and famous.

White went on writing for the rest of his life. He wrote non-fiction books, children's books, novels and memoirs. *Mistress Masham's Repose* was published in 1946. On the 17th of January 1964, aged 57, White died suddenly, whilst on a boat bringing him back from a lecture tour in America.

What inspired T. H. White to write *Mistress Masham's Repose*?

Gulliver's Travels: T. H. White took as his starting point for this book, the classic of English literature, *Gulliver's Travels*, by Jonathan Swift. He imagined that *Gulliver's Travels* was really true, and that, although it isn't mentioned in the original story, the Lilliputians were brought back by Gulliver's colleague on his return to England.

At the beginning of *Gulliver's Travels*, a man named Lemuel Gulliver is shipwrecked and washed ashore on the land of Lilliput, where he is captured by the Lilliputians. After he convinces the Lilliputians to let him go, he lives with them for a while until he runs into trouble with the Lilliputian king. Gulliver then goes on to have many different adventures in strange, undiscovered lands. In Brobdingnag he lives with a giant farmer in a land of giants. Later on, he discovers a flying island called Laputa. Towards the end of the book he travels to a strange land where a race of beautiful, civilised horses live alongside savage people called the Yahoos. The Yahoos represent humankind, as the Professor tells Maria in chapter 25.

Malplaquet: Some say that T. H. White based the house

of Malplaquet on Stowe School where he worked as a teacher. The first edition of the book included an illustration of Malplaquet, which certainly bore a resemblance to Stowe. However, clues in the book suggest that White was really thinking of Blenheim Palace, home to the dukes of Marlborough. The name Malplaquet is a historical in-joke – the Battle of Blenheim (1704) was the first battle fought by the first Duke of Marlborough, and the Battle of Malplaquet was his fourth and last.

The eighteenth century: the time of Gulliver is always present throughout the story. Lilliputians in *Mistress Masham's Repose* still speak a perfectly preserved form of eighteenth-century English. The house of Malplaquet is filled with lots of eighteenth-century architectural frills: columns, obelisks, cupolas… And in the next section you can learn more about some of those hard to understand old references. T. H. White was obviously having lots of fun combining his knowledge of and interest in history with an adventure story for children.

Colonialism?: it's just a theory, but some readers think *Mistress Masham's Repose* is a fable about power and responsibility. Maria must learn to control her desire to control the People. The message is that just because she

is bigger and stronger, does not mean that she should interfere with the way the People run their lives – they are very self-sufficient. In this way, the book could be thought to be a story about Britain and its colonies. Historically Britain could be brutish in the way it controlled other countries within its power. Perhaps T. H. White was warning us about the dangers of colonialism and becoming too powerful. What do you think?

How well do you know *Mistress Masham's Repose* and the world of Malplaquet? Take our quiz to find out…
(Turn to the back for answers – no cheating!)

1) Which animal does Maria not like to be alone with?

2) Who is Captain?

3) What are the two countries of the tiny people called?

4) Which character is a distant living relative of Maria's?

5) What is Cook's surname?

6) What is the name of the most famous Lilliputian trapper?

7) What is the inscription on the Manacles in the dungeon?

8) At the end of the book, how much is the Professor paid to teach Maria?

9) What two other languages are often used in the book?

10) What do Mr Hater and Miss Brown call the People?

References!
(for those readers who want to appear immensely knowledgeable)
N. B. not necessary to enjoy this book!

As you may have noticed, in *Mistress Masham's Repose* there are lots and lots and LOTS of references to historical people and books. Here's a handy guide to explain who they were and what they were all about.

Pope – Alexander Pope, a famous poet who lived in the eighteenth century.

General Wolfe, **Admiral Byng** and **Princess Amelia** – three historical figures from the eighteenth century: an officer in the British Army, a Royal Navy Officer and a daughter of King George III.

Queen Anne – Queen of Great Britain in the early eighteenth century.

Atlantis – a mythical lost city believed to be under the ocean.

George Fox – founder of the Quaker Movement in the seventeenth century.

***The Pilgrim's Progress* by John Bunyan** – a religious book from the seventeenth century.

Huckleberry Finn – a character from the novels of Mark Twain.

Comte de Paris – Count of Paris during the nineteenth century.

Queen Victoria – Queen of Great Britain from 1837 until 1901.

King Edward – the son of Queen Victoria, he ruled from 1901 until 1910.

Isidore, **Pliny** and **Physiologus** – Isidore was a famous philosopher and church leader, Pliny was an Ancient Roman philosopher and writer, and the Physiologus is an ancient Greek book.

Dr Jonathan Swift – author of *Gulliver's Travels*, he lived between 1667 and 1745.

Solinus – a Latin grammarian from the third century.

***Hexameron* of Ambrose** – a *Hexameron* is a religious book about God's work on the six days from creation. Ambrose was the fourth-century writer of one of the first Hexamerons.

Dr Samuel Johnson – a writer from the eighteenth century and creator of a very influential English dictionary.

Sir Walter Raleigh – a famous explorer in the sixteenth century.

A Rake's Progress – a series of paintings by William Hogarth in the eighteenth century, about the decline of a young man who throws away all his wealth and good fortune.

General Eisenhower – a famous US general in the Second World War who went on to become President in 1953.

Lewis and Short – writers of a Latin dictionary.

Sir Sydney Cockerell, **Dr Basil Atkinson**, **Mr G. C. Druce** – clever men: a museum curator, evangelical scholar and the Mayor of Oxford respectively.

Du Cange – writer of an important Latin dictionary.

Romney – an English portrait painter.

Sophocles – an Ancient Greek playwright.

Empress Amelia – Empress of Brazil in the nineteenth century.

Lola Montez – Countess of Landsfield and mistress of King Ludvig I of Bavaria.

Diana – Roman goddess of the Moon. 'Diana's minions' refers to the creatures of the night.

Titania – a character from *A Midsummer Night's Dream* by William Shakespeare. She is Queen of the Fairies.

Conrad Gesner and **Ulysses Aldrovandus** – founders of modern natural history.

Mr Wells – H.G. Wells, an English writer famous for his science fiction.

Catherine the Great – Empress of Russia during the eighteenth century.

Horatius – a famous Roman army officer.

Sir Galahad – the son of Lancelot in the legends of King Arthur.

Barnum and Bailey and **Lord George Sanger** – famous circus owners.

Richard Hughes – author of a book called *A High Wind in Jamaica* about a group of children captured by pirates.

Horace Walpole – an eighteenth-century writer and politician.

Wordsworth and **Ruskin** – writer and art critic of the late eighteenth century.

Queen Elizabeth I – Tudor Queen of England.

Agincourt – the place of battle between King Henry V and a French army in 1415.

Richard Topcliffe – a villain from the Elizabethan era, he designed his own torture machine for use on Catholics.

Guido Fawkes – another name for Guy Fawkes, who tried to blow up the Houses of Parliament in 1605.

Peacham – a clergyman who was put to death for being a traitor.

Francis Bacon – Lord Chancellor to Queen Elizabeth I.

King Charles I – King of England in the seventeenth century until his execution.

Strafford, **Laud**, **Holland**, **Hamilton** and **Capel** – Lords who had their heads chopped off.

Gregory and **Ketch** – famous executioners.

Duke of Monmouth – he tried to depose his uncle, King James II, and was executed for treason.

Sir Henry Halford – royal physician from 1820 until 1844.

The Little Princes – also known as the Princes in the Tower, Edward V and Richard of Shrewsbury, aged 12 and 9, disappeared from the Tower of London. Many historians think they were murdered.

Graymalkin – a character in *Macbeth* by William Shakespeare.

General John Burgoyne – a British army officer who fought in the American War of Independence.

Wren, **Vanbrugh**, **Hawksmoor**, **Kent**, **Adam** and **Patrioli** – famous architects.

Sheraton, **Hepplewhite** and **Chippendale** – furniture designers.

Boadicea – a Celtic Queen who led an uprising against the Romans in Britain.

Herod Antipas – the ruler of first-century Galilee, he sent Jesus to Pontius Pilate.

Rousseau and **Diderot** – two eighteenth-century French philosophers.

Charles James Fox – long-serving controversial member of the House of Commons in the eighteenth century.

Lord Dudley and **Sydney Smith** – Sydney Smith was a writer in the eighteenth century who sometimes poked fun at Lord Dudley.

William Broome – an English poet who lived in the eighteenth century.

Jacob Tonson – publisher of *Paradise Lost* by John Milton.

Lintot – an English publisher.

Cleland – an English novelist.

Bolingbroke – another name of King Henry IV of England.

Lady Mary Wortley Montagu – an English aristocrat and writer.

Dr Arbuthnot – a friend of the poet Alexander Pope and the subject of his poem 'Epistle to Dr Arbuthnot'.

Lord Hervey and **Colley Cibber** – characters from Alexander Pope's works.

George II – King of Great Britain and Ireland 1727–1760.

Berkley Castle – King Edward II was murdered there in 1327.

Nawab of Poona – a governor of India.

King George V – King of Great Britain and Ireland from 1910 until 1936.

King George VI – King of Great Britain and Ireland from 1936 until 1952.

Queen Caroline Matilda – Queen of Denmark from 1751 until 1775.

Dame Alice Kyteler – the first person accused and condemned of witchcraft in Ireland.

Sir John Mandeville – author of a fourteenth-century travel book called *The Travels of Sir John Mandeville.*

Sir Thomas Browne – a writer and scientist.

Dartiquenave – an eighteenth-century courtier with an interest in food.

Allan Quatermain – a character from the adventure novel *King Solomon's Mines* by H. Rider Haggard.

Lionel Edwards – a British artist from the nineteenth century who specialised in painting horses.

Delacroix and **Landseer** – two painters, one French, one English.

Augustus John – a famous Welsh painter.

Clement Atlee – Prime Minister of the United Kingdom 1945–1951.

Winston Churchill – Prime Minister of the United Kingdom 1940–1945, and again 1951–1955.

Field Marshal Montgomery – a famous British Army officer who fought in the First World War and was an important commander in the Second World War.

A quiz for the brightest brains
of the bunch!

Alrighty then, are you ready to test your knowledge of classical and historical references?! See if you can untangle these anagrams, taken from the words and phrases listed in the previous section.

1) Grr! This sloppier gems

2) Laying Mark

3) A Beetle Hen Quiz

4) A male premises

5) Aunt Corgi

6) A salt tin

A Mistress Masham Activity

If you had little friends, what would you give them? Here are some ideas for making some tiny little objects — suitable for dolls' houses, toys, and the moment when you discover Lilliputians living in your garden.

The matchbox bed

Take a matchbox and line it with cotton wool for cosiness. Leave it partially open for breathing purposes. Small toys can be safely and comfortably put to bed in this way.

The miniature bouquet

Discover your inner flower-arranger and pick a bunch of the tiniest flowers you can find. If you look very closely at lawns and hedgerows, it won't take you long to find some tiny floral beauties. Arrange them in an attractive vase such as a bottle lid or shot glass.

The itsy-bitsy book

Create a book for little people by copying out one of your favourite stories in your tiniest hand-writing. You can write newspapers and sheet music and create works of art in this way, for all your mini mates. Alternatively you could write something using a computer and then print it out in the smallest possible font. Can you still read it?

Some more books about little people

If you love stories about little people, why not try one of these brilliant books…

***Gulliver's Travels,* Jonathan Swift**: just so you know, this is not the easiest book to read. It is quite long and written in an old-fashioned style. But, if you don't mind that, this is a marvellous story about bizarre lands and incredible people.

***The Borrowers,* Mary Norton**: the story of a family of tiny people who live within the walls and floors of a house and borrow from their big neighbours to survive. They put big, human-sized objects to intriguing uses.

Tom Thumb: an old story about a very, very little boy. Merlin the magician creates a tiny child for a couple who can't have children, and as he grows up all kinds of things happen to him, including being swallowed by a cow.

***The Carpet People,* Terry Pratchett**: a funny book about some people who must make a treacherous journey across a vast country. The 'country' is the carpet of a single room.

***The Indian in the Cupboard*, Lynne Reid Banks**:
when a boy is given a magic cupboard, he discovers it has
the power to bring his toys to life.

What does that word mean?

agog – eager to hear or see something

aileron – part of an airplane wing

alder – a type of tree

amelioration – the act of improving something

annal – a record of events

anomaly – an unusual result

antiquarian – relating to the study of antiques

aperture – an opening, hole or gap

appellation – name

arbour – a shady alcove with the sides and ceilings covered by trees and plants

armlet – a kind of bracelet worn on the upper arm

assailant – a person who physically attacks another

avarice – greed

avast – an exclamation meaning Stop!

barbarism – extreme cruelty or brutality

beadle – a ceremonial officer of a church, college, or similar institution

belay – nautical slang meaning 'stop'

beneficed – being the recipient of church pay or a permanent church position

besmirch – damage someone's reputation

bloater – a smoked herring

bole – the trunk of a tree

botanist – someone who specialises in the study of plants

brailed – a binding on the wings of a bird to prevent flight

breeches – short trousers fastened just below the knee

camphor – a substance from some plants with an aromatic smell and a bitter taste, used as insect repellent

careen – when a ship is placed on its side for cleaning or repair; to swerve

caryatid – a stone carving of a draped female figure, used as a pillar to support the upper part of a Greek or Greek-style building

catechism – a series of ideas to be taught in the form of questions and answers

circumbendibus – a roundabout route

claret – a type of red wine

cleg – a horse-fly

comfit – a type of sweet

complaisance – a tendency to yield to the will of others

comte – a French word, meaning a count (an aristocrat)

coniferous – evergreen trees

conquistador – a conqueror

consanguinity – related by blood

conspicuous – stands out

constellation – a group of stars

coranto – informal broadsheets, used before newspapers were invented

coronet – a relatively small crown

corral – a pen for livestock

covert – a thicket in which game (such as pheasants) can hide

coxcomb – a vain and conceited man

cumbrous – cumbersome, difficult to use

cupola – a roof or ceiling that is a dome

cutlass – a short sword with a slightly curved blade

de heretico comburendo – a statute focusing on how to treat heretics

de mortuis nil nisi bonum – (say) nothing but good of the dead

deciduous – trees that are not evergreen

denizen – a person, animal, or plant that lives or is found in a particular place

deputation – a group of people appointed to undertake a mission or take part in a formal process on behalf of a larger group

detrementious – detrimental, tending to cause harm

dissent – disagreement

distended – bloated

dolt – a stupid person

dominie – a schoolmaster

ducal – relating to a duke or dukedom

earthenware – pottery made of clay

elision – leaving out a sound or syllable when speaking

embezzling – stealing

empanel – enlist or enrol

epoch – a moment in time that signals the start of an era

erudite – showing great knowledge or learning

fellowship – a status within a college or society

fender – plastic material hung over a ship to protect it from impact

ferae naturae – wild, untamed

fichus – a small triangular shawl, worn round a woman's shoulders and neck

fleur-de-lis – a decorative symbol like a stylised lily

fractious – irritable

fratricidal – killing one's own brother or sister

Friesian – a type of black and white cow

frigate – a warship

gargantuan – enormous

genteel – refined and respectable

habeas corpus – the right of someone under arrest to go to court or else be released

harpoon – a spear attached to a long rope used to catch large animals, such as whales

hatchet – a small axe

haulage – transport

Helix pomatia – a type of snail

hilt – the handle of a weapon or tool

hinterland – the remote areas of a country

hogget – a young sheep

homicide – the killing of one person by another

Homo sapiens – human beings

imbrangled – to entangle, to mix confusedly

impertinent – not showing proper respect

impetuous – acting without thought or care

impound – to seize and take legal custody of something

imprecate – to curse

incarceration – imprisonment

internecine – destructive to both sides in a conflict; conflict within a group

isinglass – thin, transparent sheets used instead of glass

lapsus calami – a mistake in writing or speech

larch – a type of tree

lath – a thin, flat strip of wood

ld – an abbreviation of the word 'Lord'

lumbago – a type of backache

mandragora – a type of plant that can be used as a narcotic

matchlock – a type of gun

meridian – a line of longitude

mildew – a type of fungi

miscreant – a troublemaker

monopteron – a circular temple with a roof that is supported by columns

mort d'ancestre – an inquest into whether an heir has been prevented from taking possession of some property he should have inherited

motter – motto

mumchance – silent, tongue-tied

murrain – a plague or epidemic

nebulae – a cloud of gas and dust in outer space

nolle prosequi – a legal term, meaning a refusal to pursue a case

non compos mentis – not able to think clearly and be in control of your actions

nonchalant – relaxed or careless

obelisk – a stone pillar that tapers at the top

pacification – to calm down

palladian – a type of architecture that borrows from classical buildings

paraphernalia – equipment

partial – biased

passepartout – a master key

per gradus ad ima – by degree proceeding

perpetual – everlasting

pewter – metal the colour of silver

pince-nez – a pair of eyeglasses with a nose clip instead of earpieces

pinion – feather

plutocrat – a wealthy person with power

pochard – a type of duck

politicks – politics

praemunire – a summons for someone accused of an offence

premeditated – planned in advance

priming – getting ready

prodigious – very great

progenitor – a person, thing or place from which something originates

prudent – wise

pungent – strong

punt – a long, narrow, flat-bottomed boat

pupae – larvae

quadrille – a square dance for four couples

quaff – drink heartily

rapture – a feeling of great joy or pleasure

recalcitrant – uncooperative attitude towards authority or discipline

receptacle – a hollow object used to contain something

reconnaissance – the observation of a region to locate an enemy or ascertain strategic features

redivivus – come back to life, reborn

rent – a large tear in a piece of fabric

repast – a meal

repose – a state of rest, sleep or tranquillity

retainer – a servant, especially one who has worked for a person or family for a long time

rotunda – a round building or room, especially one with a dome

sagacity – wisdom

scabbard – a sword-holder

schism – a split or division between strongly opposed sections or parties, caused by differences in opinion or belief

scintillating – sparkling, dazzling

scrimmage – a confused struggle or fight

scull – an oar used by a single rower

sentry – a soldier stationed to keep guard or control access to an area

sequoias – a type of tree

servile – excessive willingness to serve or please others

sic semper tyrannis – 'thus, always to tyrants', meaning death to tyrants

snuffbox – a small ornamental box for holding powdered tobacco which can be sniffed

steeple-jack – a person who climbs tall structures such as chimneys and steeples in order to carry out repairs

stratagem – a plan or a scheme

supernumerary – not belonging to the regular staff, but being hired for extra work

swindler – someone who uses deception to try to deprive someone else of something

taciturn – reserved or uncommunicative in speech, says little

teal – a type of duck

tench – a type of freshwater fish

thimble – worn to protect the finger whilst sewing

toque – a woman's small hat, typically having a narrow, closely turned-up brim

triplicate – times three

trowel – a small hand-held tool with a flat, pointed blade

truncheon – a thick stick that is used as a weapon by the police

tussock – a small area of grass which is thicker than the other areas

ulster – a type of man's coat

urchin – a young child who is poorly dressed

veni, vidi, vici – 'I came, I saw, I conquered'

ventilator – provides fresh air to a room or building

vexation – annoyance

victual – food

vista – a pleasing view

zenith – the time at which something is most powerful or successful

Answers to the *Mistress Masham's Repose* quiz – how did you do?

1) Cows

2) Cook's fat collie dog

3) Lilliput and Blefuscu

4) Miss Brown

5) Noakes

6) Gradgnag

7) PAINE IS GAINE

8) Sixpence a quarter

9) Latin and French

10) Minnikins